the photographic
portrait

Robin Gillanders

the photographic
portrait

techniques, strategies and thoughts
on making portraits with meaning

David & Charles

Dedicated to the memory of
Murray Johnston and Chick Chalmers

A DAVID & CHARLES BOOK

First published in the UK in 2004

Copyright © Robin Gillanders 2004

Distributed in North America
by F&W Publications, Inc.
4700 East Galbraith Road
Cincinnati, OH 45236
1-800-289-0963

A catalogue record for this book is available from the British Library.

ISBN 0 7153 1651 6 hardback
ISBN 0 7153 1652 4 paperback (USA only)

Printed in China by Hong Kong Graphics & Printing Ltd
for David & Charles
Brunel House Newton Abbot Devon

Commissioning Editor Neil Baber
Senior Editor Freya Dangerfield
Art Editor Prudence Rogers
Production Controller Kelly Smith

Visit our website at www.davidandcharles.co.uk

David & Charles books are available from all good bookshops; alternatively you can
contact our Orderline on (0)1626 334555 or write to us at FREEPOST EX2 110, David
& Charles Direct, Newton Abbot, TQ12 4ZZ (no stamp required UK mainland).

contents

Introduction 6

1 What is a Portrait? 10

2 The Constructed Portrait 20

3 The Found Portrait 44

4 Group Portraiture 54

5 The Tools 70

6 Lighting Options 90

7 Post-Production and Presentation 122

Further Reading 140

Acknowledgments 142

Index 143

introduction

I have had a love affair with photography since I was 18 years old and, like the subject of most love affairs, it can stimulate, excite, perplex and frustrate. As a medium that has sustained me for 30 years, photography's elusive nature has sometimes provoked severe anxiety and occasionally intense elation – especially in the field of portraiture. The portrait is ubiquitous in photography, but it is one of the most difficult subjects to do well. It requires a familiarity with your equipment, a fluency with the craft and, concurrently, a sometimes intense social interaction.

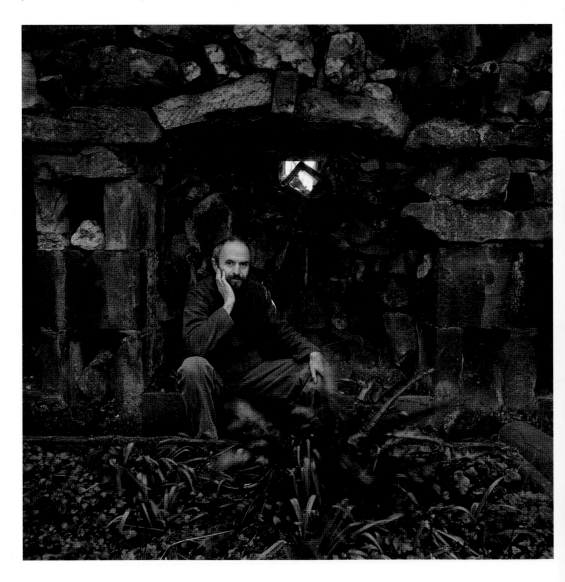

◆ John Blakemore, Photographic Artist and Teacher, 1985
John was a great inspiration to me (as he has been for many photographers), when I first met him at a workshop he was conducting. Although his main concern was not portraiture, for me he presented a new way of reading photographs. I remember feeling strongly motivated to make this portrait, and it is one of my first to be carefully preconceived and constructed. I used a slow shutter speed to provide some movement in the foliage, which is a technique that John used frequently in his early images.
HASSELBLAD; 50MM LENS; DAYLIGHT

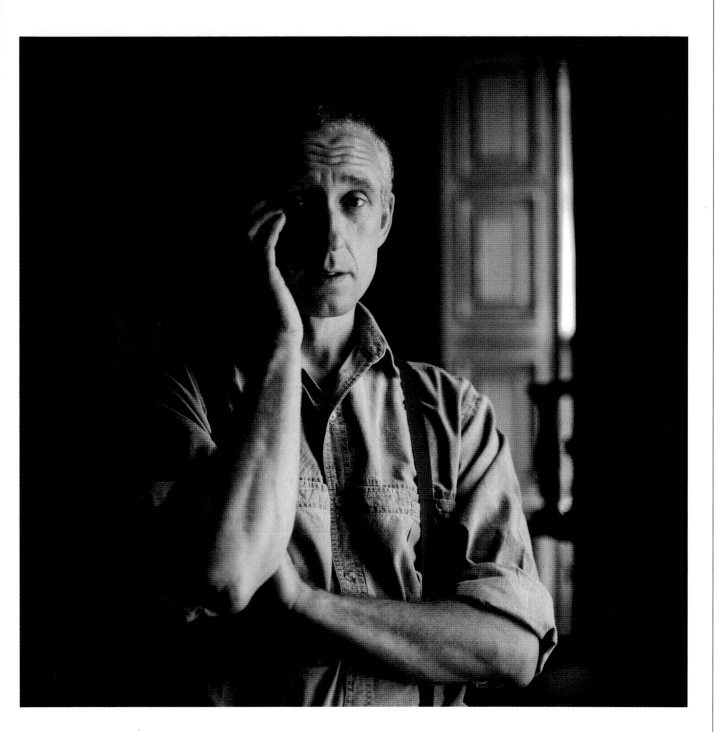

At Napier University, Edinburgh, where I teach, we believe very much in teaching an amalgam of technique, visual and conceptual creativity and critical theory; in other words, in discussing what one is trying to communicate, to whom, and how this can best be done elegantly and eloquently. To my knowledge – certainly as far as portraiture is concerned – there are not really any books on photography that deal with all these issues in a single volume. This book seeks to satisfy an interest in ideas and approaches, and not just techniques, important though these are.

I am writing from the perspective of a practitioner. At an early stage I decided to illustrate the book with my own pictures, so that I could comment on how and why each one was made, with some authority, first hand. As such, what is presented here is a very personal approach to the medium – it certainly is not the only approach and some of the opinions expressed you may find contentious.

⬆ John Charity, Documentary Photographer and Teacher, 1990

This is a personal picture of a friend and colleague whom I admire immensely for his sensitivity, humanity and commitment. The blinds have been adjusted to control the light in the background, with a chink of window showing to provide a reference white, enabling the rest of the print to be printed relatively dark.
HASSELBLAD; 150MM LENS; DAYLIGHT

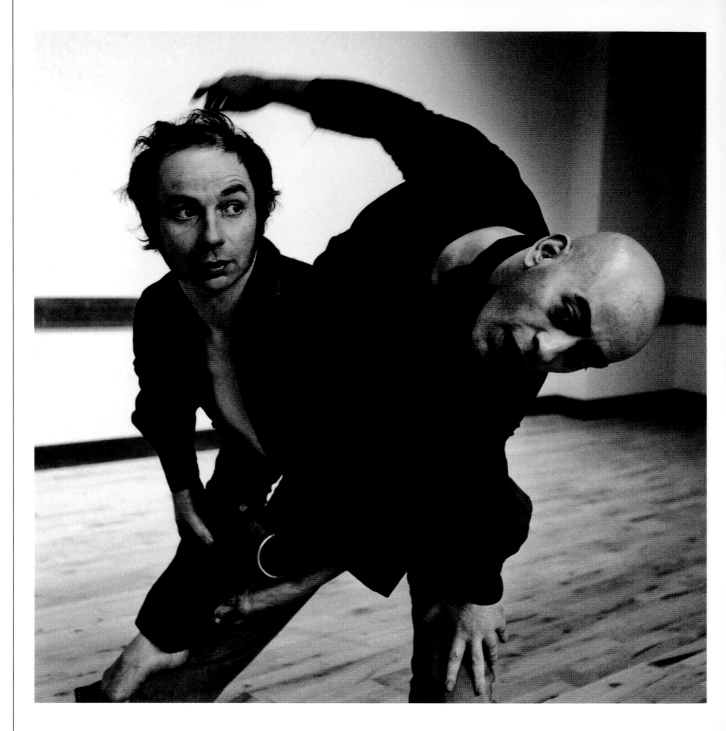

⬆ **Lindsay Kemp and Jack Birkett, Mime Artists, 1970**
This was my first commissioned portrait, at the age of 18, for a theatre organization. It was taken with a hand-held camera with a slow shutter speed in ambient light. I doubt if I would have the nerve to attempt such a thing now for an important job.
ROLLEICORD 120; FIXED 75MM LENS; DAYLIGHT

I have assumed a basic technical knowledge of camera controls, exposure assessment and print making. The Further Reading section (see pages 140–41) suggests where you may look to extend your critical and technical knowledge. Also, since this book contains only my photographs, I have made some suggestions as to which other photographers' work you might consider looking at to provide examples of a greater diversity of practice.

Though I have been a commercial photographer for many years, the main considerations for this book are not commercial but personal, even though many of the pictures here were commissioned and many of the techniques and strategies are commercially applicable. Indeed, perhaps it is invidious to rigidly demarcate the personal from the commercial since I would hope that some personal vision may be evident in even the most targeted of commercial work. I have not been concerned here with documentary portraiture, the representation of typologies, or work driven by political issues, important though these areas are. Rather, I have been concerned with individuals and my relationship with them, however transient. Although I earn my living through photography, I present myself here as an amateur in the true sense of the word: that is, as one who engages with the medium for the love of it.

I imagine that it is the hope of every non-fiction writer that the reader will begin at the beginning and work their way through the book to the end, and this book has been sequenced in a way that expects and hopes that you do so. Ideas come first, followed by the techniques for executing those ideas. In reality, however, you may wish to dip into various sections, and so I have attempted to make each chapter as self-contained as possible.

⊙ David Campbell, Storyteller, 2003
This was taken in David's kitchen (often the location for good conversation), when I visited him to discuss the more formal portrait on page 20. Notice how the red walls have reflected into the shadow side of his face, providing warmth and contrasting with the blue of the flowers.
NIKON F3; 35MM LENS; DAYLIGHT

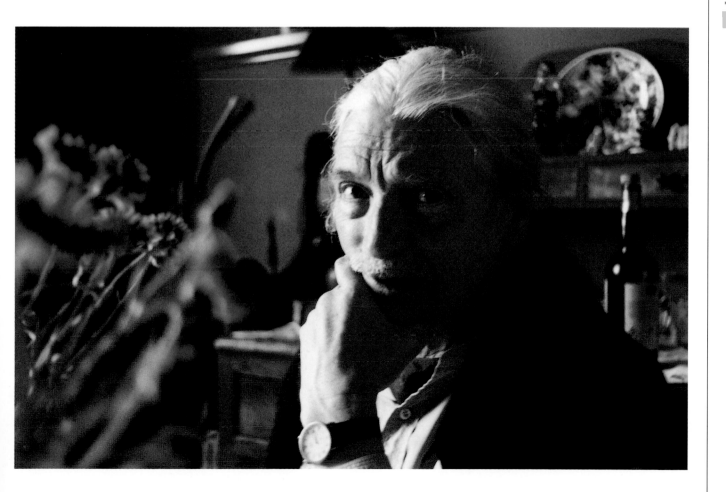

1

whatisaportrait:

towards a definition

Chambers Dictionary tells us (economically) that a portrait is 'a likeness of a real person'. Like many dictionary definitions, this doesn't get us very far, and here I would like to attempt a personal definition and to identify the special characteristics of the photographic portrait.

Can we distinguish between a mere photographic record of a person that simply shows the topography

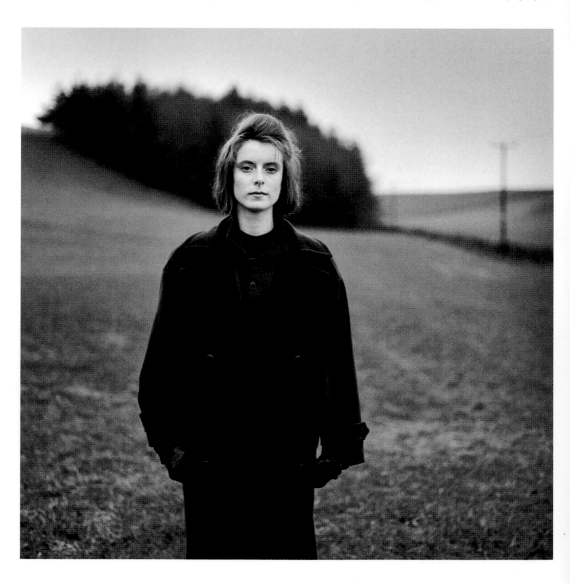

➲ **Louisa Burnett-Hall, Landscape Painter, 1989**
This carefully composed 'contractual' portrait attempts to supply information about the subject and expressively present a point of view.
HASSELBLAD; 80MM LENS; DULL DAYLIGHT

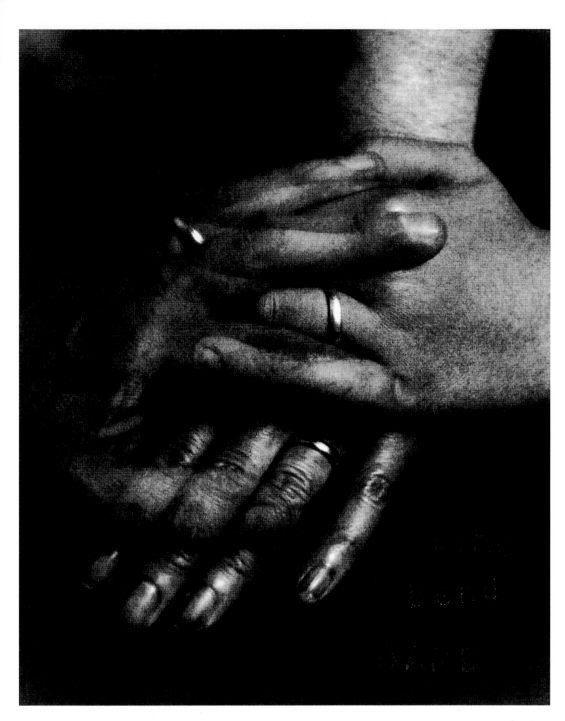

🔄 **Bind, Band, Bond, 1998**
This picture was taken a short
time after our marriage. It's a
long exposure during which
I've moved my hand on top of
my wife and her son's hands.
This could still be termed a
portrait, even though it
doesn't show our faces.
There's a narrative here.
TOYO 5 X 4IN; 210MM LENS;
DAYLIGHT; PAPER NEGATIVE

of the face, such as a passport picture, and an image that gives us more *meaningful* information about an individual or the photographer's attitude to that person? I would argue that there is a difference between a 'likeness' and a portrait. The American photographer Richard Avedon has said that a portrait is a picture of someone who 'knows they are being photographed'. In other words, there is a relationship (however fleeting) between the photographer and the subject, with the implication that, in the process, the photographer will exercise

control, make some sort of analysis or take a stance. One might add that, in the course of making this 'contractual' portrait, the sitter may also take some control over his or her own representation. This is dealt with in more depth in the next chapter.

But the candid photograph, taken without the subject's knowledge, may also fulfil our new criteria for the portrait if it provides us with some analysis of the subject and the photographer's point of view. When the artist Peter Howson painted Madonna, not only was she unaware that the portrait was being

12

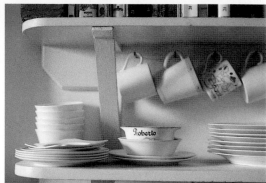

⊘ **Self-Portrait,
Our Kitchen, 2003**
This composite image
gives little clue to my
physical appearance but a
lot of information about
me and our household.
There is a great deal of
material here for a
speculative narrative....
NIKON F3; 50MM LENS; DAYLIGHT

made, she had never even been in his presence. Nevertheless, we would still probably consider his painting a portrait.

We think of the face as an essential element in a portrait. It's through faces that we know each other, that we are given our identity. But can a picture of part of the body be a portrait? If it provides an indicator to some aspect of the person that seems important, or tells some sort of story, then the answer would have to be yes.

What, then, if the subject doesn't appear in the picture at all? The conceptual and minimal artist Sol LeWitt made a work in 1980 entitled *Autobiography*. It is a book with no text and over 1,100 simply made black-and-white photographs of objects in his house: books, pots, pictures, kitchen utensils, and so on – the detritus of everyday life. Is this perhaps a more evocative, informative and eloquent portrait than a picture of his face? The pictures are not very interesting individually, but cumulatively they make a powerful portrait. They are the very antithesis of the single image that pretends to be a profound analysis.

So let's keep an open mind about just what constitutes a portrait, and consider the possibility that *any* picture that enriches, enlivens or elucidates our understanding of an individual, or their relationship with the artist, may be termed a portrait – whether it presents a 'likeness' or not.

the trace

There are other, more esoteric qualities inherent in a photograph of a person in addition to the information

it supplies – qualities that the painted portrait, for example, cannot have. A photograph is evidence of someone's existence. Having even the most fuzzy 'trace' image is like having something *of* that person because the photograph is created by light reflected off the actual subject and forming an image. There is an important causal connection here. Think of the Turin Shroud, thought to be the trace image of Christ, and how valuable that seems to be (but only if it is genuine), even though we can't really make out what he looked like. People often carry a snapshot of a loved one in their wallets, implying their presence at all times, close to them. It becomes iconic. A man may take a photograph from his wallet and say, 'This is my wife', not 'This is a photograph of my wife'. The painted portrait does not seem to provide us with that same emotional bond. The photograph's unique relationship with reality is significant.

memory and mortality

We photograph as a means of possessing something of a person, but also to remember. Photography has always had a close relationship with memory, both distant and recent. We treasure old photographs as a remembrance of people, and often as a reminder of past events. While the photographs can never equal the original experience, with all the multisensory stimuli involved, they do prompt our memory as a representation. The photograph's relationship with time, then, is also important.

Most of the pictures in this book are captioned with the name of the subject and the date. You should be scrupulous about filing such information with prints and negatives, for posterity. The photograph becomes more valuable with the passing of time – the picture that you took of a close relative may not seem important now, but it will do in a few years' time.

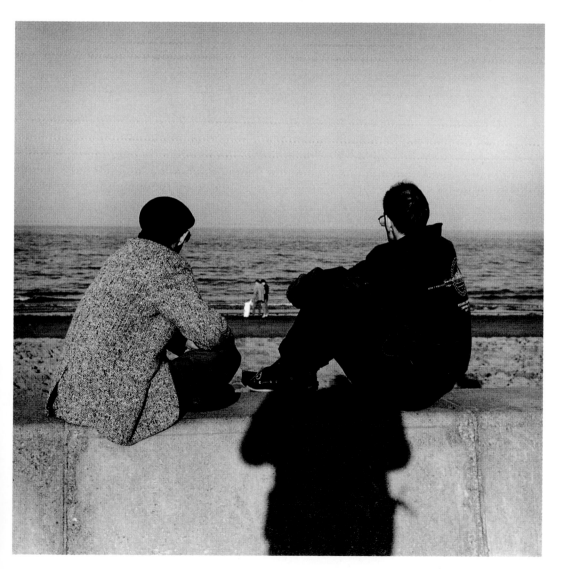

⬅ **David Williams and Murray Johnston, Portobello, 1989**
All photographs are about presence and absence; all deal with a trace of reality, and all portraits are about mortality. This portrait of my two close friends, made a few months before Murray lost his long battle against cancer, is really a picture of six people. The couple with a child on the beach are also friends: Murray's wife, Kate, their daughter Ruth, and Graham MacIndoe. It's a self-portrait too – there's my shadow observing the observers. I am watching them and I am with them at the same time.
HASSELBLAD; 80MM LENS; BRIGHT SUNSHINE

Ian Hamilton Finlay, Little Sparta, 1996

In 1995 I began a long association with the acclaimed artist and poet Ian Hamilton Finlay, culminating in my book, *Little Sparta*, published in 1999. Ian is one of the major figures in a movement known as 'concrete poetry', which had most prominence in the 1960s and 1970s. The major manifestation of his work is his garden, Little Sparta, which is situated on a remote hillside south of Edinburgh in Scotland. It is a modern conception of a neoclassical garden and consists of some 300 works involving words, phrases or sentences set in a variety of materials and placed in the landscape of the garden.

When I originally agreed to do some work with Ian, my ulterior motive was to make a portrait of him. In the event it took me over a year to summon up the courage to ask him – he is well known for not enjoying being photographed. He once growled to a friend of mine who was cajoling him into position with the promise of a good portrait, 'The only good photograph is one that's been taken.'

So, even though Ian and I were developing a friendship, it was with some trepidation that I asked him if I could do this portrait. I had had the luxury of thinking about it for over a year and decided that he needed to be in his little rowing boat on one of the ponds in the garden. This wasn't to be a quick picture at the door of his cottage; rather, it required some time and commitment for him to climb the hill, on a cold March morning, and clamber into his boat to position it carefully in the middle of the pond to my shouted instructions.

The idea at conception was that there should be a reference to the sea and boats, since this is one of his major themes. Also that the boat should be his smallest, as a reference to his 'small boy' hobby of making model boats. The background was to be a relatively wild part of the garden, drawing a relationship between nature and culture, which is another of his underlying themes. In retrospect, the portrait suggests other metaphors. Ian occupies a small space in the frame, implying isolation and solitariness – as an internationally exhibited artist largely unknown in his own country at that time and historically at odds with the art establishment, and as someone who, in 25 years, had never left the immediate environment of his garden.

Recently, Ian confided to me that he really hated doing this picture. I am so grateful that he agreed to it without demur. This is the only picture I have ever done of him, and while I've considered doing more, this picture encapsulates so much that I don't think I can improve on it.
Hasselblad; 150mm lens; available light (overcast daylight); Ilford FP4

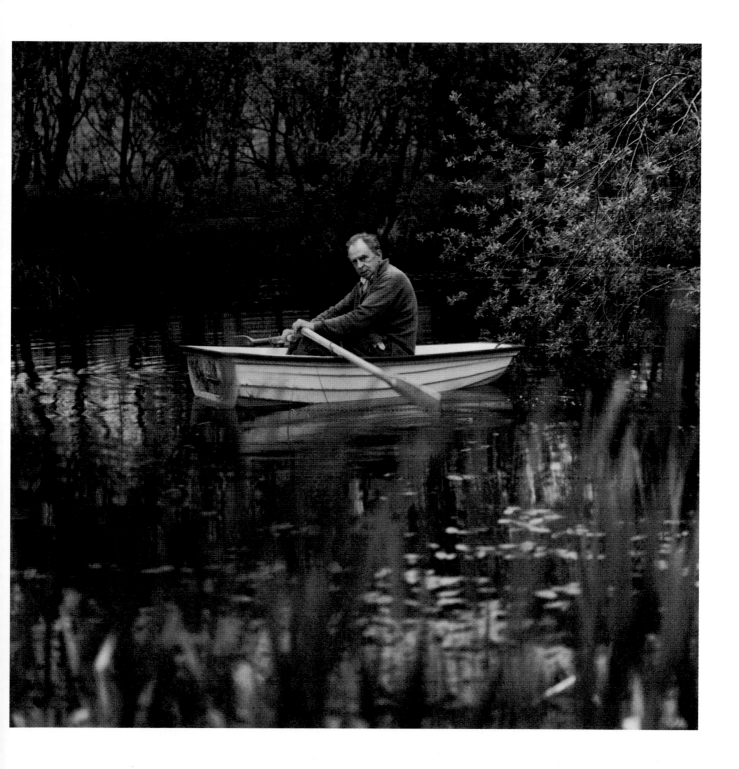

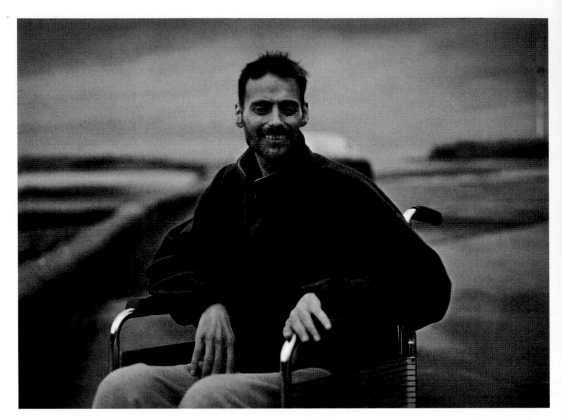

⊙ **Chick Chalmers, Photographer and Teacher, August 1998**
The photographer David Williams and I took Chick out one afternoon, a fortnight before he died of cancer. Chick brought his camera and we took pictures. Somehow making these pictures was the most important thing for us to do that afternoon. There is no direct correlation between the importance of a picture and how skilled the picture-making is. Chick's picture of Dave and me carries the same poignant significance as mine or Dave's.
MAMIYA 645; 75MM LENS; OVERCAST DAYLIGHT

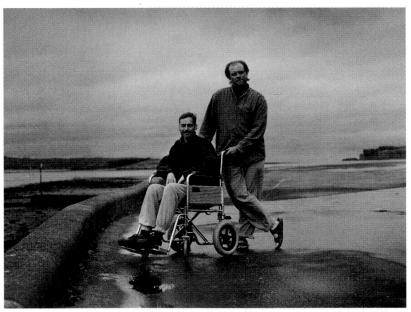

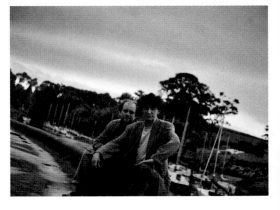

If photography is in part concerned with memory, connected to that is the notion that all pictures of people inherently involve aspects of mortality. Many writers have contemplated the connection between photography and death. Through its relationship with reality and accurate representation, photography fulfils a need to preserve its subject. The photographic portrait will survive after the sitter's demise, and its capacity for immortalization can be a reminder of the subject's and viewer's mortality. A photograph, which captures or freezes a moment, may even be seen to prefigure death, but it also promises survival.

The American photographer Nicholas Nixon began a remarkable series of photographs in 1975. He photographed his wife (to be) and her three sisters, and has continued to do so once a year since then, always with a large-format camera and always with the women in the same position left to right. *The Brown Sisters* has become a powerful essay on the passage of time, capturing the slow, incremental changes of the ageing process, while at the same time commenting on the singular nature of photography itself. And the longer the series continues, the more fascinating it becomes.

ambiguity, context and truth

The portrait photograph is an arena filled with doubt, paradox, enigma and ambiguity. The photograph describes everything but does not necessarily explain anything. Meaning is elusive and changeable. The photograph always requires a context because, without that, it has no inherent meaning. We would read a picture used as editorial content in a magazine differently from one hung on the wall in an art gallery. They have different functions and therefore different meanings – even if they are the same picture. If we are shown a painting in any context we understand that it is meant to be viewed as art. The photograph is an 'anxious object' in that respect (to borrow a phrase from the critic Harold Rosenberg). Even if it is hanging in a gallery there is still a debate, after 160 years of the medium's existence, over whether it is art or not (let's be clear – *any* medium can be art if it's used by an artist).

There is often the additional problem of ambiguous meaning in any context. How can we know what the photographer's intention was? (You could argue that the photographer's intention is less important than what the picture means to the viewer, but as photographers we often wish to make our intentions clear.) One of the fascinations of photography is that it can be about more than one thing at the same time: both metaphor and document; subjective and realist. It's a chameleon

⊕ **Jason and India Miller, Hairdressers, 2002**
The intention was to promote this couple and their business as internationally respected hair stylists. Here the audience and intended context were established firmly at the outset and we can have a clear understanding of the purpose of the picture. We might read it differently if it were to appear in a different context, or if we were to look at this picture in 50 years' time, long after its original function has become redundant.
HASSELBLAD; 80MM LENS; DAYLIGHT

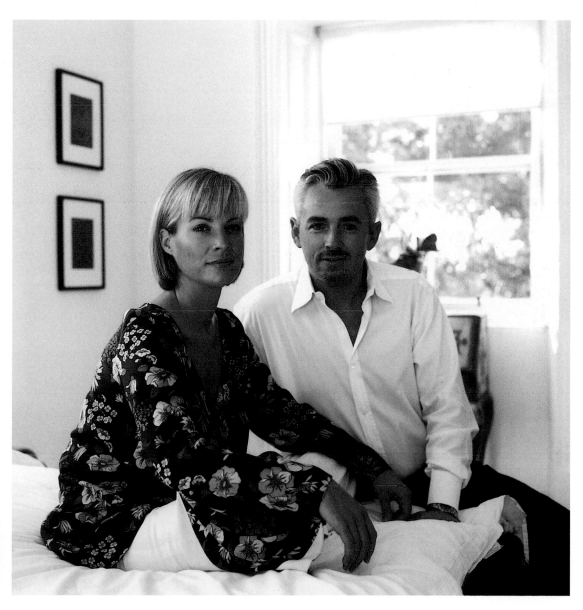

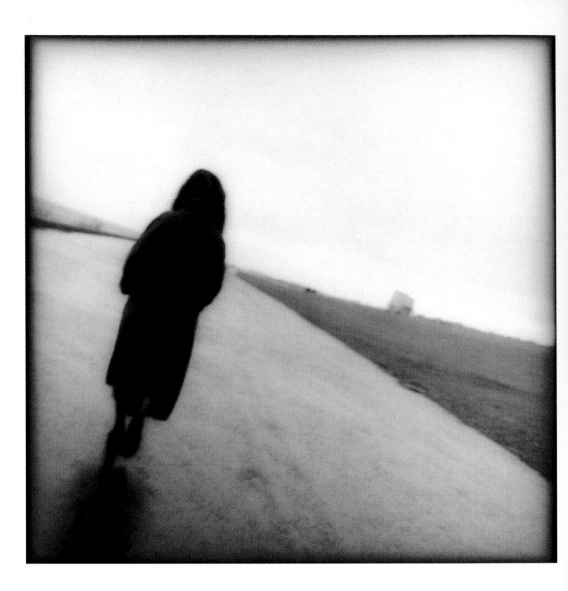

➥ **Cramond,**
17 January 1991
Is it a landscape, social
documentary, a fashion
picture, a portrait?
Certainly the person
is known to me. The
specificity of the date in
the title is essential here to
the understanding that this
picture is about an event.
Without that, and lacking
a context, the only
evaluation we can make
is to consider its formal
picture-making qualities.
HASSELBLAD; 80MM LENS;
OVERCAST DAYLIGHT

medium. The most important signpost to reading a photograph is the caption, which can distinguish a portrait from a fashion picture, or a social document, or a metaphorical work of self-reflection.

If we can now agree a reasonable working definition for the portrait and understand the problems of communicating our intended meaning, what evaluation can we make of our portraits? We attempt some sort of truth – not an objective truth, but a personal one – where we try to make sense of humanity. Much of art has been concerned to describe the world and, in so doing, to strive to increase our comprehension of it. How elusive that is. The human face, for example, can say so much but reveal so little, and it would be arrogant of the artist to suggest that they have exposed the soul of the sitter from the 'bundle of perceptions' (as the philosopher David Hume called it) that is the self. In that sense portraits

can only ever fail – just as the philosopher can only strive to explain the meaning of life. What we attempt, more realistically, is an attitude to our subject, beyond recording their physical appearance. We select what it is we want to reveal of them.

Some of the best portraits imply a narrative: they are pictures about which a writer could create a story. Whereas a radio play provides us with the narrative and we fill in the images with our imagination, the articulate portrait invites exactly the opposite response. There are several examples of pictures of the same person in this book, all telling different stories – which are truthful? All of them – or none of them?

the self-portrait

In a sense, all photographic portraits – indeed all photographs – are self-portraits, and this raises an

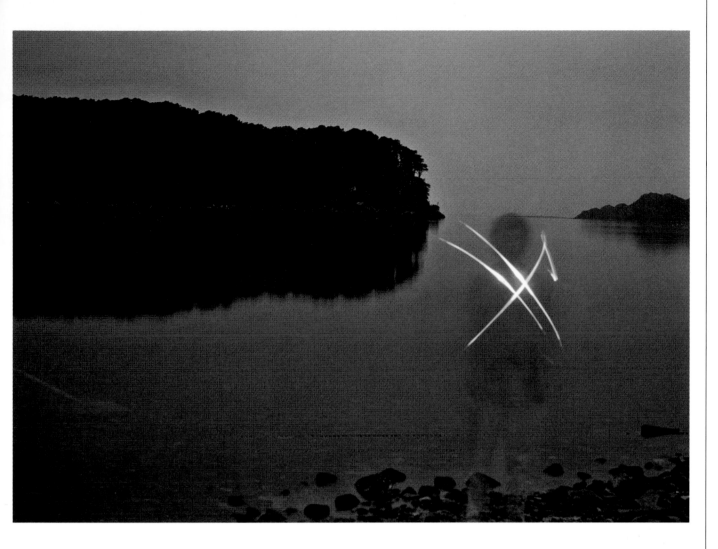

important ethical question. The photographer Paul Strand referred to the 'impertinence' of visiting another culture and imposing one's subjective opinions on it. There is an arrogance in making a personal assessment of the subject and in sometimes transferring one's own persona on to it. In his important exhibition and accompanying book *Mirrors and Windows* (1978), John Szarkowski proposes the idea that all photographs fall on a continuum between mirror of oneself and window on the world. I constantly struggle with the ethics of producing a reflection of myself in something as personalized, specific and realistic as the photographic portrait. It has occasionally happened that I have produced a portrait that I have felt pleased with but by which the subject has been disturbed, and I have realized that I have been transferring my persona on to them – producing not an analysis of them, or even a subjective response to them, but an expression purely of myself. To some extent, many of my portraits probably say more about me than about my subjects.

One may make a photograph of oneself through sheer narcissism and self-regard or, more interestingly, through a desire to attempt an understanding of oneself and one's life. In the self-portrait, the artist is the perceiver and the perceived, and this seems to distil the enigma of the self – to grope our way to self-revelation by self-description.

Photography can also be used as a diary, as a private means of recording our circumstances and clarifying our condition; it can put abstract feelings and emotions into the sort of tangible data that we can begin to make sense of, and that can be retrieved at a later date to remind us of how we were. The self-portrait is a means of introducing oneself to thinking and working analytically and expressively – to producing portraits with meaning.

⊕ Self-Portrait, Shieldaig, 1991
I made this at about 11pm, when it was almost completely dark. I sat the camera on a wall, set it to the T setting, opened the shutter and walked down to the shore, where I made the cross with a small hand torch. Then I walked back to the camera and closed the shutter. Total exposure time would have been about 20 seconds at full aperture. It was more luck than good judgment that it came out, but I'm pleased that it did: it represents the memory of a defining period of my life.
NIKON F2; 50MM LENS; NATURAL LIGHT AND A TORCH

theconstructedportrait

choosing an approach

When the magazine editorial photographer is commissioned to make a portrait of a famous person – perhaps a musician or an actor – they often have little time available and will take what seems to be a quick and easy option. In addition, the pay rates for editorial photography (compared with advertising) are such that they probably are not being paid a great deal unless they are a big name in photography,

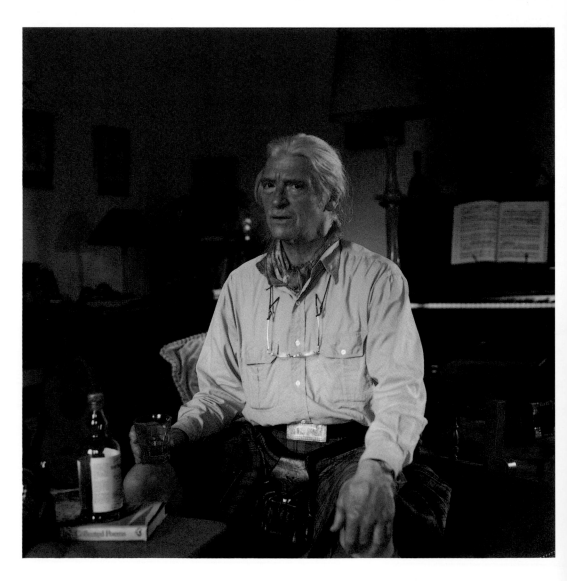

⊙ **David Campbell, Storyteller, 2003**
David is a man of great wit and generosity of spirit, and is an individual. His passionate interests include poetry, music, good conversation and whisky. This picture is lit with natural daylight, except for a flash head placed through a door at the back right, triggered by radio-controlled flash, providing a subtle backlight.
HASSELBLAD; 80MM LENS; AVAILABLE LIGHT AND ONE 400J FLASH HEAD WITH BARN DOORS

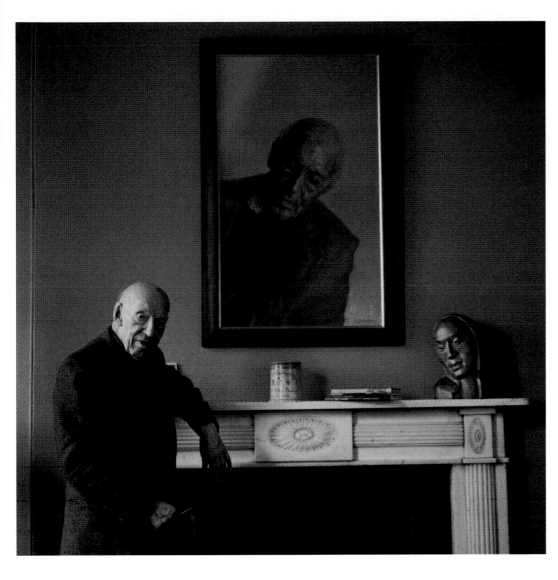

⬅ **George Bruce, Poet, on the Occasion of his 92nd Birthday, 2001**
Here I was interested in the relationship of the three heads and how they lead the eye from one to the other in a circular composition. The painting is of George and, with a neat symmetry, was painted not from life, but from a photograph. The books, which I placed on the mantelpiece, are his volumes of poetry, and the pot belonged to his grandfather.
HASSELBLAD; 80MM LENS; AVAILABLE LIGHT WITH REFLECTOR

or it is for a very prestigious magazine. Emulating a style (one might say a formula) that began with Richard Avedon in the 1950s and continued with David Bailey in the 1960s, they will go in close, filling the frame with the head, and use fairly flat, soft lighting with reflectors for a female subject, and harsh directional lighting if the subject is male. The background will be plain and usually white. That's fine: the picture has a job to do, very often as a design element – it looks good on the page and has initial graphic impact. Nobody is expected to look at it for more than a couple of seconds and since it reveals all its available information very quickly, there is no need to. There are few photographers with the surgical skill and perception of Avedon, however, so it is unlikely that interest will be sustained.

One expects more of a serious portrait intended for the gallery wall or any context where the image will be the subject of contemplation. A more thoughtful, analytical and, dare I say, conceptual approach becomes desirable. Great portraits, rich in meaning and evocation, have been made as the result of a purely intuitive response, where the photographer has had no preconceived ideas whatsoever. But if you are planning an important portrait as the result of a commission or for personal reasons, and the portrait session will be difficult to repeat, you take an enormous risk if you rely purely on your instinctive abilities – intellect has to come into play. And that involves research and planning.

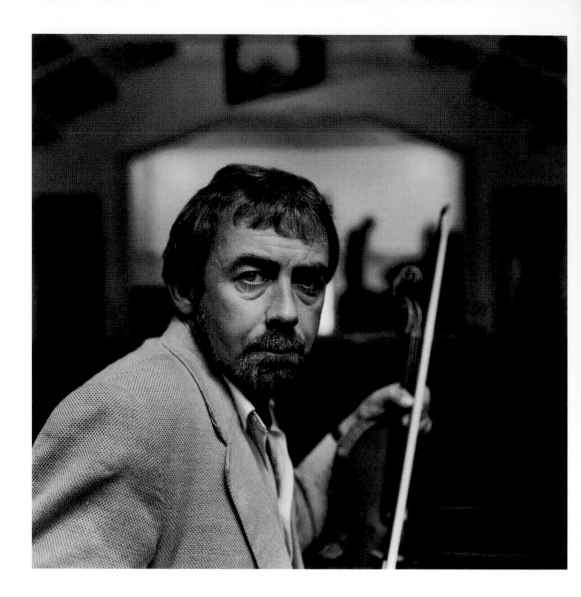

⊃ Aly Bain, Fiddler, 1988
Aly is a well-known musician. Every year he makes time for a tour in the Scottish Highlands, playing in tiny village halls. I made the journey to Skye especially to make this portrait. He was late arriving and could only give me ten minutes, but the picture had been carefully constructed beforehand, using a stand-in. The bright highlight to the right of his face provides a tonal contrast, emphasizing his face, and the roadie on the stage suggests the activity of preparing for the concert.
HASSELBLAD; 150MM LENS; MIXED STUDIO FLASH AND AVAILABLE LIGHT

research and development of the 'plot'

So you are planning to make a portrait. It will be easier if the subject is someone you know, because you will have a clearer mental image of that person – his or her personality, interests, concerns – and there will be a mutual trust. It should be possible to produce something more deeply analytical than if the portrait is of somebody you don't know at all. It isn't surprising then, that most of what I consider to be my best portraits are pictures of friends: people with whom I have a relationship and about whom I can make a meaningful personal statement.

the recce

In the case of the subject you have never met, it is important to do your homework. For famous people, find magazine or newspaper articles on them, look on the internet, try to talk to people who do know them if possible, and attempt to build some sort of profile of them. Try to develop an empathy with them even before you meet. When contact is made, wherever possible try to impress upon them that you are not a 'snapper', that they will need to devote a fair amount of time to the process and that you need to meet

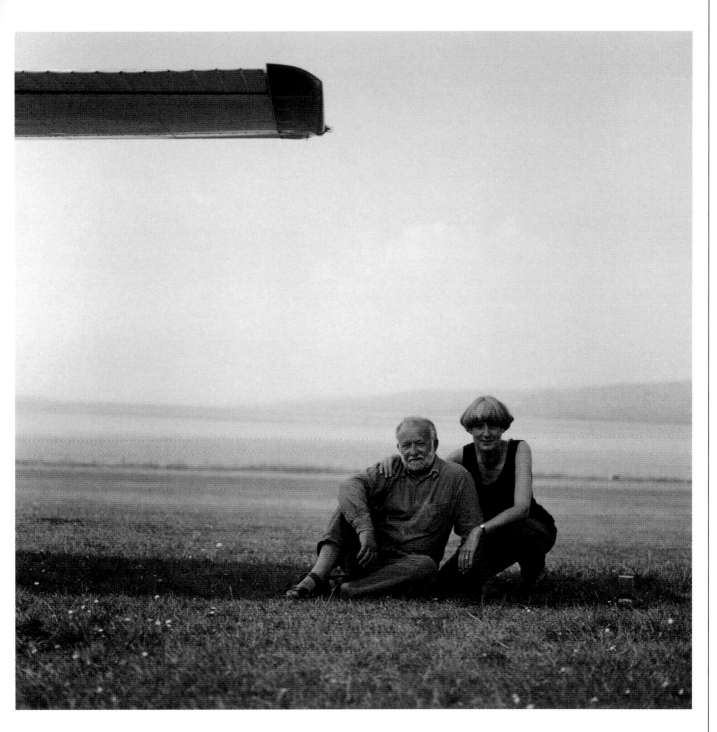

them in advance of the session – preferably a day or so before. Some won't like this, and most won't understand why. Point out to them that they wouldn't expect a portrait painter to dash off a picture in one half-hour session with no preliminary sketches or research.

There is another good reason why I would recommend a prior meeting with the subject. When I am about to undertake an important portrait I am always, even after 30 years of photography, extremely nervous, not just at the problems of

picture-making but at the prospect of the necessary social interaction. A preliminary meeting helps to break the ice for both me and the sitter.

During this meeting, I often take some 35mm snaps of both the subject and possible locations for the portrait, if it is not to be made in the studio. A digital camera is really useful here – there are no film costs and the images can be reviewed immediately. The main object of this exercise, though, is that you are watching for particular mannerisms, looking for a location for the picture, thinking about what the

Patricia Macdonald, Artist–Photographer, Mull, 1995
This is one of two pictures of Pat (here with her husband Angus) taken on the same day. The other is on page 25. The aircraft wing has two functions here – as a clue to their occupation and to provide shade from the overhead sun. Sometimes very simple compositions can be the most effective.
HASSELBLAD; 80MM LENS; DAYLIGHT

Patricia Macdonald, Artist-Photographer, 1995

I was commissioned by the Gallery of Modern Art in Glasgow to make a portrait of Patricia Macdonald, whose work is represented in the collections there. As an artist, Pat makes mainly aerial photographs, which explore aspects of the environment and of natural processes. This work is made in collaboration with Angus Macdonald (her partner in both senses of the word and the Professor of Architectural Studies at Edinburgh University) as pilot and operations manager.

With all commissioned work, one goes through a period of severe anxiety before starting, but all the more so in circumstances where a recce cannot take place and firm decisions cannot be made in advance. In discussion with Pat and Angus, it was agreed that the portrait should be made on the island of Mull off the west coast of Scotland, which is one of their favourite bases for operations. As we flew there in their single-engined aircraft, I really did not have any idea of what I would encounter or what sort of picture I would make, except that it would relate to flying and the natural environment. So I took a lot of film with me, expecting to try various ideas as they presented themselves – flying by the seat of my pants, you could say.

We landed on a tiny, remote, grass airstrip, and after a cup of coffee in the isolated hotel, I began to make pictures – nothing remarkable, and largely concerned with formally making a nice image. One of these is on page 23. As I worked, I tried to find a way of referring to the collaboration between Pat and Angus while maintaining the primary focus on Pat, and including some reference to the landscape.

The resulting picture is a tribute to Angus's skill as a pilot. I composed the picture with the central feature of the white line on the airstrip, positioned Pat slightly to the right of it and then had Angus do touch-and-go circuits. He had to fly over only four times, with directions from me via Pat and the radio, to get the positioning spot on. But then I missed the moment a couple of times...

The radio is symbolically important in the picture as a comment on the necessary communication between them. Each time Pat had spoken to Angus with additional instructions, I had asked her to position it carefully at her feet to help balance the composition.

Her right hand is obviously shading her eyes from the bright sun, but in retrospect it's ideal as it suggests the flight of an aircraft overhead.

One of Pat's many books and exhibitions was entitled *Shadow of Heaven*. I love it when these things happen and you say, 'Oh yes – it's perfect!'

Hasselblad; 80mm lens; available light (bright sunshine); Ilford FP4

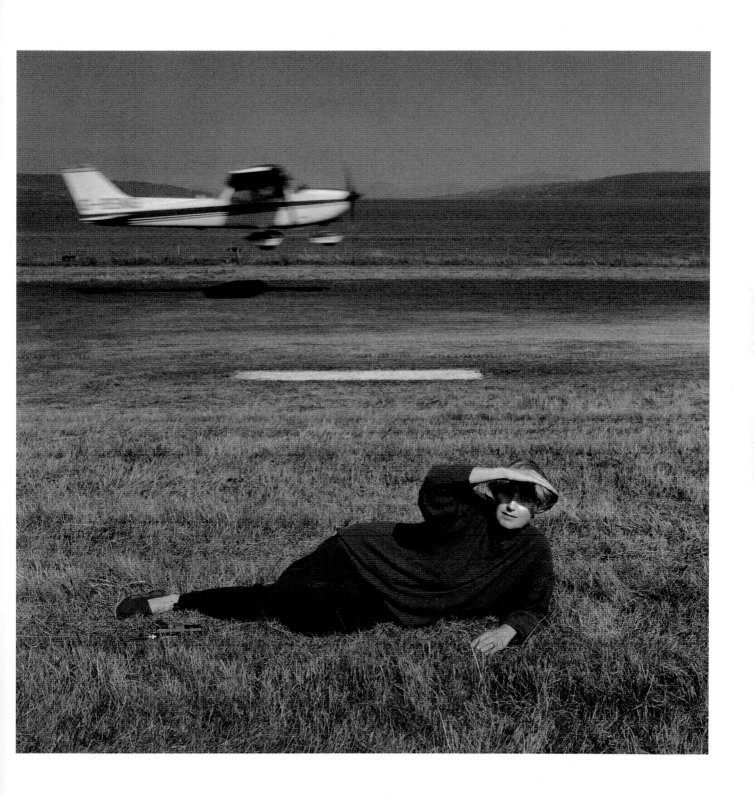

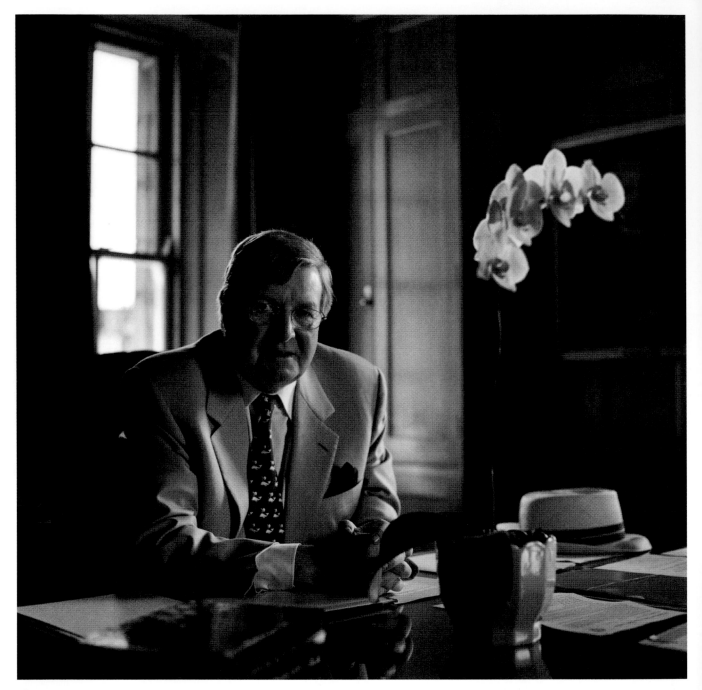

⬆ Professor Struther Arnott, Scientist and Principal of University of St Andrews, 1999
This was a commission from the University as a gift to Struther on his retirement and was one of several portraits that I made of him over a period of months (see page 125 for a more formal portrait). This one particularly encapsulates his personality, I think – rather flamboyant, as indicated by the hat and the flowers on the desk.
HASSELBLAD; 80MM LENS; ONE 800J FLASH MIXED WITH DAYLIGHT

subject will wear and what is going to go into the picture. You may also want to ask the subject (particularly if you are not well acquainted with them) if there is anything they would like to be included in the picture that they feel represents them. This way, they will feel that they are involved, and have some say in the process.

making a plan

In the days (or hours) leading up to the portrait, and after a preliminary meeting with the subject, if that has been possible, there will be a process of

brainstorming. What are you trying to say? Is there a story that you can tell in the picture? The reference snaps (if you have been able to do them) will help here, but also I find that sitting with a blank sheet of paper and writing down key words that attempt to describe the personality and circumstances of my subject helps to focus my ideas.

identifying the 'stage'

Assuming that the portrait is not to be made in the studio, you will also at the planning stage finally decide on the location for the portrait – the possible stage on which the portrait will be made. The decision that you make in terms of precisely where the portrait will be made will be informed by two factors: the *content* within the frame and the *form*, or composition, of the picture. It is always a good idea also to have a back-up idea for a location – Plan B. When you arrive to make the portrait you should have gained confidence from having a clear idea of how you will start the session.

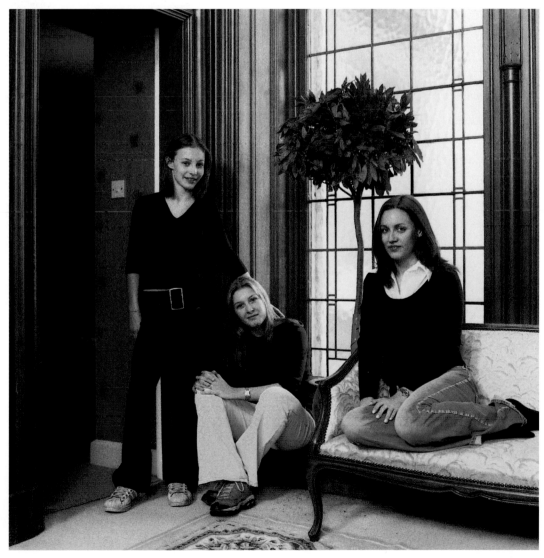

◀ Robertson Sisters, 2003
This was a recent, and rare, social commission. Before the session I made a frantic search for a stage on which to set the performance (above). The camera was positioned and the deployment of the players was calculated carefully before they occupied the space.
HASSELBLAD; 80MM LENS; TWO 800J FLASH HEADS AND DAYLIGHT

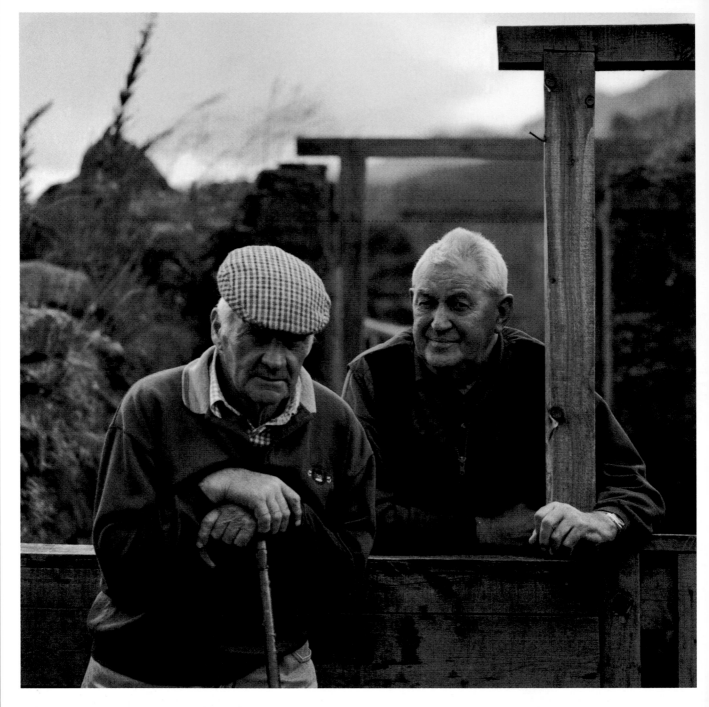

⬆ **George and Donald, Shepherds, 1999**
The stage here is a ruined 18th-century fort near Inversnaid, now used as a sheep pen. The men have been posed carefully. Note that Donald (with the crook) is leaning towards George, while George's left hand comes round the post to break the rigid dividing right angle. A wide aperture has been selected to separate them from the background.
HASSELBLAD; 80MM LENS; OVERCAST DAYLIGHT

content

The content will be determined by considerations of what elements need to be included or placed in the frame to provide a narrative – visual clues to your sitter's interests or personality. This may be an obvious decision; for example if your sitter were a chef, you would probably decide to photograph him or her in a kitchen – nothing very profound about that. But then other elements might be included, like the cookery book that has been the most influential, or the sorts of ingredients that he or she uses most.

Or perhaps you might orchestrate the commis to be moving around in the background, to give the impression of a large, busy kitchen.

Your approach could be more metaphorical or symbolic, and this is where it becomes more interesting. Perhaps your sitter has a very ordered and organized lifestyle, in which case your composition would reflect that by the precise placement of elements within a minimalist frame. Occasionally, in my most consciously constructed portraits, I have included elements where the

relevance is not immediately apparent – perhaps understood by just the sitter – and a wider audience can only speculate as to their significance.

form

Inevitably, how the picture looks formally also contributes to its meaning. One cannot totally separate form and content. Tonality, lighting, contrast, colour, line and shape are not only visual elements but have emotional and symbolic connotations that may be relevant to the subject. For example, you would probably not photograph a blues musician with flat lighting and light tones.

I have always been obsessed by composition and the 'frame' – sometimes to the detriment of effective expression. Nevertheless, you should attempt to control as much of the frame as possible: a visually interesting picture can act as a 'Trojan horse' for introducing ideas. Carefully examine lines and shapes in the viewfinder – watch particularly the edges of the frame. Are the verticals truly vertical or are they irritatingly off? (Sometimes I use a spirit level to

⬇ Bill Paterson, Actor, 1989
I like the idea of providing only hints to a location, and this was made at the top of my stairs in an Edinburgh tenement. As a consciously constructed portrait it's unusually minimal for me, but still suggests the sorts of parts Bill was playing, which were often contemporary and city-based.
HASSELBLAD; 80MM LENS; DAYLIGHT AND A LITTLE FILL-IN FLASH BOUNCED OFF A WALL

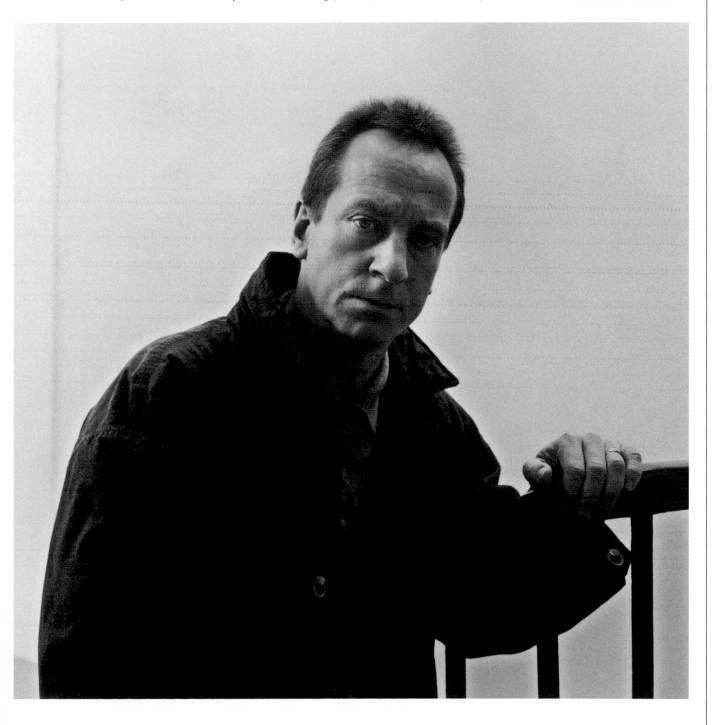

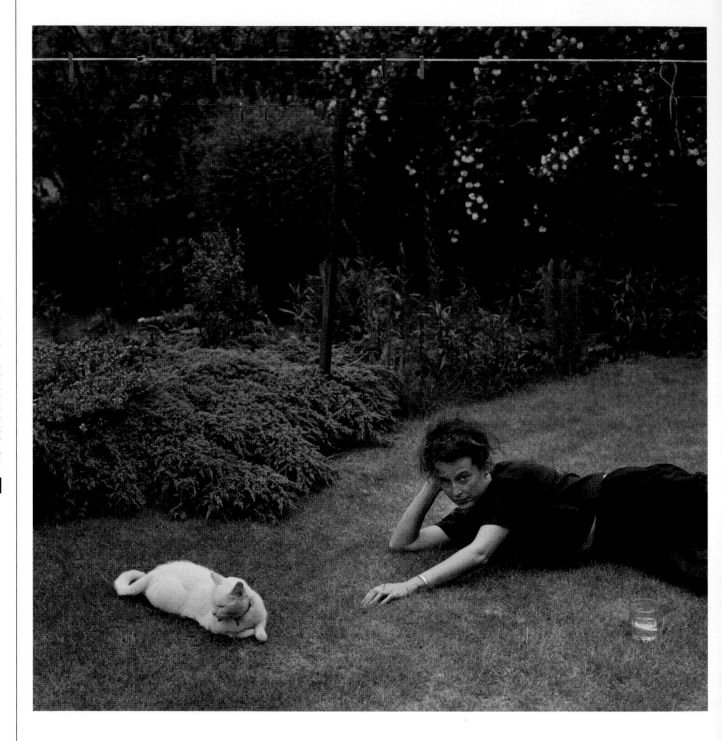

⬆ Sally Scofield, Arts
Administrator, 1989
A personal portrait. The best
portraits form a narrative.
Everything in the picture
contributes to this: the
garden, the cat, the glass,
the outstretched arm... The
function of the clothes line
at the top is mainly
compositional, but also
indicates that this is a
domestic garden.
HASSELBLAD; 50MM LENS;
DAYLIGHT

check this.) Are there areas that are too empty compositionally and need to be filled, or are there distracting objects that need to be removed?

Remember focus, too – are you going to use a wide aperture to put the background out of focus or are you going to keep everything sharp? If you are using an SLR, remember that you are viewing at full aperture, so that the deer's antlers in the background may look suitably out of focus in the viewfinder, but become distressingly sharp when the lens is stopped

down and they appear perched on your sitter's head. It sounds obvious, but we've all done it at some point. Where possible, I take a Polaroid with the camera set to delayed action and me sitting in for the subject.

It is important not to be constrained by one carefully conceived concept, however. As I have said, you should have a Plan B – probably not so carefully orchestrated – and while the session is in progress you should be open to a variety of possibilities as they present themselves.

the 'performance'

This is the difficult bit. You have prepared as much as possible. Your camera is loaded, lighting (if required) checked and in position, camera (on tripod) precisely placed, and meter readings have been taken, ready for your subject to occupy the stage and for the performance to begin. Spare films or film magazines are placed ready to hand, as are any other lenses that you think you may need. There will be no nervous fumbling with equipment and everything will have been thought of before the session. As little as possible will interrupt the flow of the session or disrupt the brief but close and intense relationship between you and the sitter. You will present an air of confidence and of being very much in control even though you may be consumed with nerves – this will be a performance as much by you as by the sitter.

On commercial assignments, I nearly always use an assistant, but for personal portraits I rarely do, because they are a distraction for both the sitter and me. Similarly, I rarely take Polaroids during this kind of session (unless there are complex lighting changes and I'm shooting colour transparency, which is much less forgiving in terms of exposure). Shooting Polaroids disrupts the session, and inevitably the subject will want to see them, with the possible consequence that they may not like what they see,

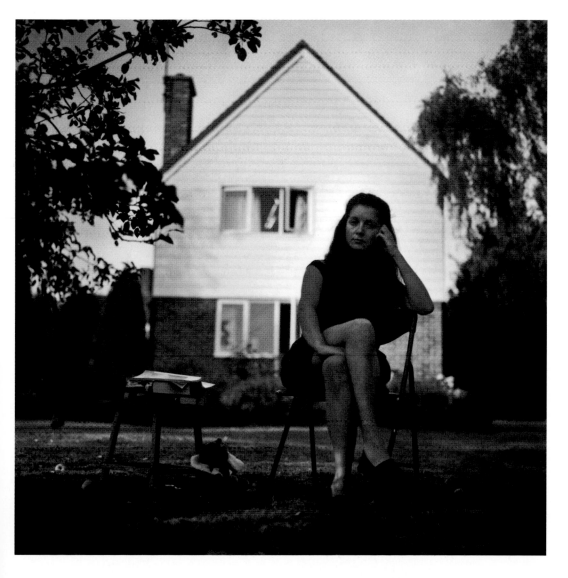

⬅ **Fiona Forbes, Child Psychiatrist, 1991** A highly constructed portrait of a friend. There is a saxophone in the window, a crossword dictionary and medical texts on the table, and sitting on the grass is a camera and a cuddly toy. Psychiatrists often give a small gift to a patient when they move location or change job. They call it a 'transitional object'.
HASSELBLAD; 80MM LENS; DAYLIGHT

William McIlvanney, Author, 1989

A major part of the planning for a portrait is identifying the location and then, within that location, what the stage should be. I had photographed Willie once before in the same place for the cover of one of his books, but this was to be much more constructed and preconsidered.

The chosen location was Clark's Bar, one of his favourite pubs. It's a no-frills bar where there are few distractions from the lubrication of good conversation with beer and whisky. Much of his writing deals with Scottish working culture, and the social aspects of drinking, so this seemed appropriate.

We arranged to meet on a Saturday morning at 11am, which is opening time. I was there at 10.30 to set up a tripod and a studio flash head with a small softbox and make a final decision about the stage. I became intrigued by the shapes – squares, oblongs and circles, and positioned the camera precisely to allow a line of light on the right-hand side of the partition against which he's sitting. That line seemed important to the balance of the arrangement: positioning the camera any further to the left the line would have disappeared; too far to the right and it would have been too broad and dominant. The stool, bottom right, was pushed into position to break an area of darkness.

In the event Willie turned up late, a bit rushed, and probably not keen on the formality of the picture I had contrived. People were beginning to come into the bar and the whole event with camera, tripod and lighting was becoming a spectacle. We got it over with in ten minutes. The time on the clock is 11.45am.

Everything about the picture was carefully orchestrated – but I was unable to control the performance. Can you read his expression? I've just asked him to tilt his head slightly, and he's thinking, 'Oh, for God's sake, get on with it.' I would have needed another half an hour with his willing cooperation, and as many rolls of film as it took, to get the expression of relaxed *sang-froid* that I was looking for. On the other hand, the smart shirt and jumper, along with the four-square position, leather jacket and cigarette, site him well within the milieu of the 'working class intellectual' of that time.

On the title page of one of his books of poetry, entitled *In Through the Head*, he writes:

It is, of course, an operation to unblock the heart but a tricky one,
where you have to go in through the head without getting trapped there.

That could be an axiom for photography – and a critique for this picture.
Hasselblad; 80mm lens; studio flash mixed with daylight; Ilford FP4

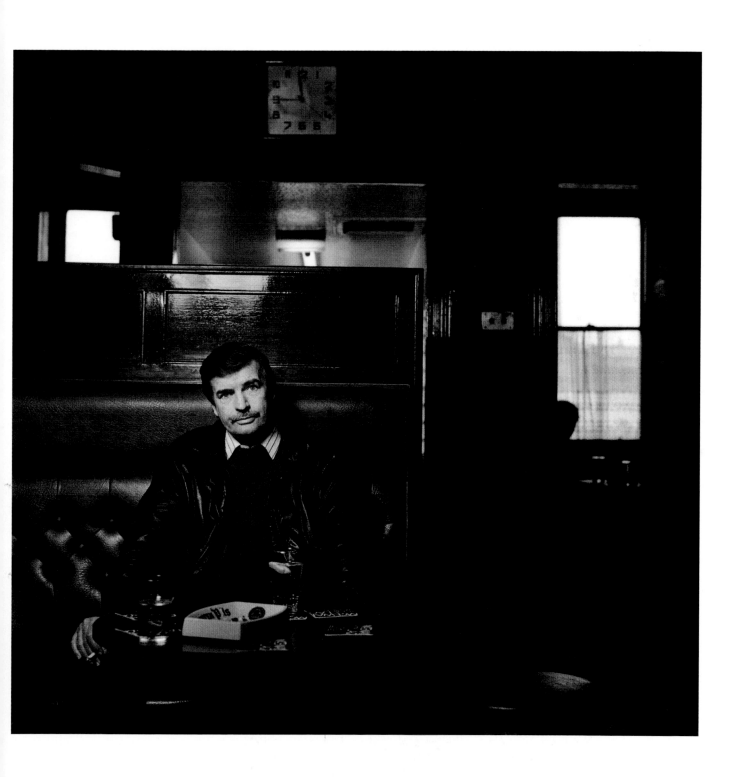

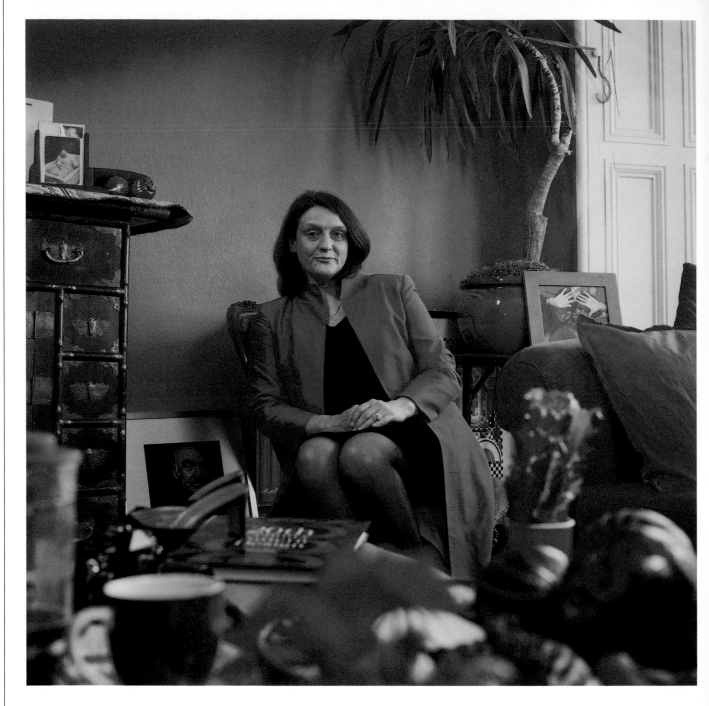

⬆ **Ginnie Atkinson, Producer, Edinburgh Film Festival, 2003**
This picture is principally about colour as a reflection of Ginnie's personality, and demonstrates her wry humour and warmth. All the objects were placed to harmonize with the yellows and purples, as well as giving clues to her interests and concerns. Lighting was kept intentionally quite flat to emphasize the colour.
HASSELBLAD; 80MM LENS; ONE 800J FLASH WITH TRANSLUCENT UMBRELLA, AND DAYLIGHT

for whatever reason. Remember that there is a large measure of trust involved – Richard Avedon once said that people went to him to have their photograph taken as one might go to a psychiatrist. The subject doesn't know that flattery or pandering to their vanity is not necessarily your main criterion for a successful portrait.

ethical considerations

A portrait is essentially a collaboration between photographer and sitter. Some subjects are very aware of the manipulations that are possible by the photographer and will present themselves to the camera in the way that they think represents them best. Marlene Dietrich, for example, knew all about lighting, and demanded high, frontal (butterfly) lighting with a ratio of 1:4 (where the difference in exposure between the main light and the fill-in is 2 stops) in order to accentuate her cheekbones.

Sometimes it is a battle of wills, with the photographer determined to break through defences, while the subject is equally determined to present themselves in the way they wish. The photographer

has one great advantage, however: the subject cannot see what the photographer sees through the lens and cannot control the moment when the shutter is pressed. The most extreme example of this was when the American photographer Arnold Newman made a portrait in 1963 of Alfred Krupp, the Nazi industrialist who used slave labour during World War II. Newman used a wide-angle lens close to the subject and directional side lighting. The print was a sickly green colour and the result was a portrait of evil. In retrospect it is astonishing that Krupp agreed to the sitting since Newman is Jewish, but remember that he couldn't see what the camera could see.

The Newman portrait of Krupp raises ethical and moral issues if it is accepted that the photographer has the upper hand in this collaborative process. Do you as a photographer have the moral right to impose your view of the person and, in the process, dishonestly appear to be party to their aspiration for the portrait? There is no *truth* in photography *per se*, only the factual reality of what appears in front of the lens at the instant the exposure is made. Any

⊙ **Ginnie Atkinson, Theatre Administrator, 1989**
Compare this with the image opposite. Here I was interested in the paradox of representing Ginnie as a strong personality, but surrounded by 'feminine' objects. To accentuate the scale of her huge sofa I used a wide-angle lens. The picture on the wall is also (obscurely) in the 2003 portrait.
HASSELBLAD; 50MM LENS; DAYLIGHT

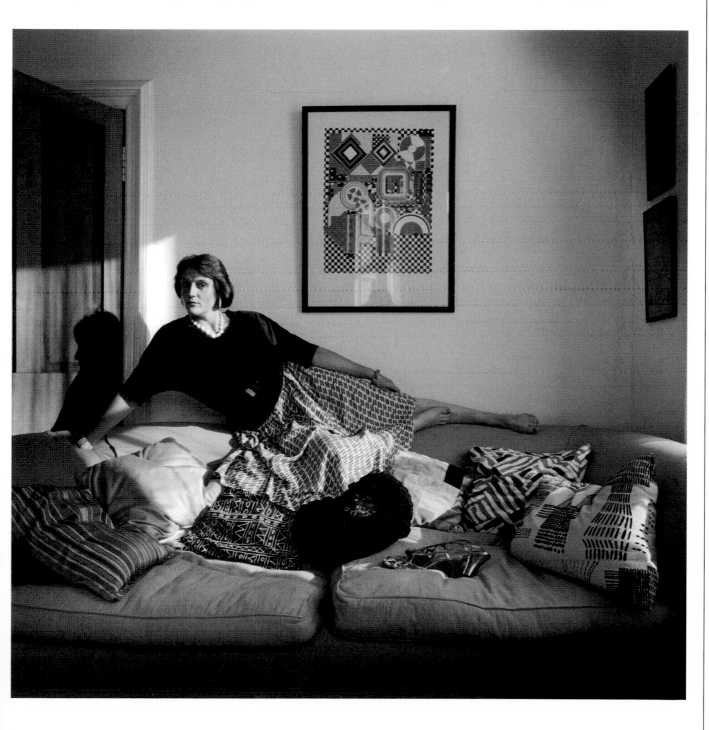

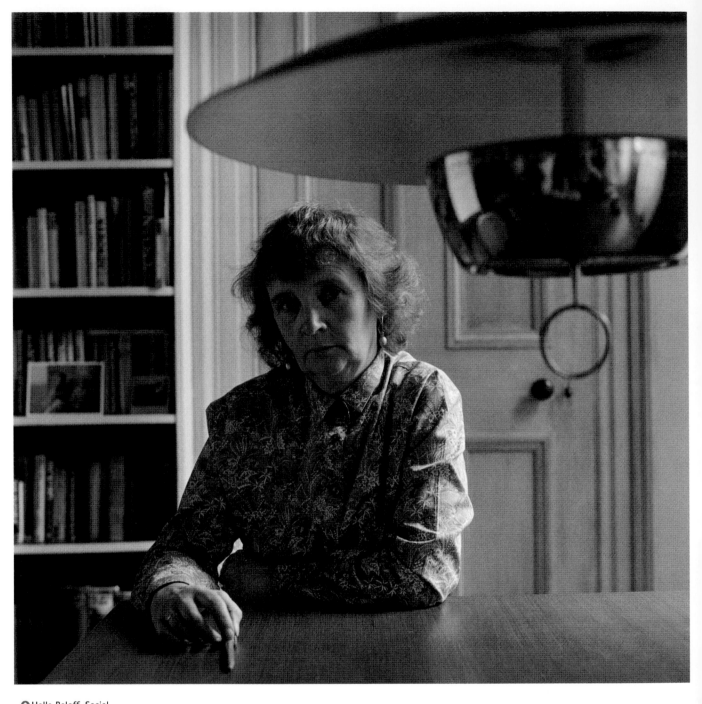

⬆ **Halla Beloff, Social Psychologist, 1989**
Halla, whom I admire immensely, has written widely on photography from a psychologist's viewpoint, particularly self-portraiture. Notice the books, the photographic postcard, the lamp in which I am reflected, the handle of which appears to suggest a feminist symbol. As I was photographing, she was fiddling with a pencil and at one point turned it towards me...
HASSELBLAD; 80MM LENS; DAYLIGHT WITH REFLECTOR AT LEFT

meaning or analysis that arises from that factual, instantaneous record is largely manipulated by the skilful photographer at the time the portrait is made and/or when a particular image is selected from the contact sheets. Free Will only rarely allows the sitter to escape this.

I have one last point to make about ethics. At this time, when style usually wins over content, particularly in editorial portraiture, I am struck by a quote from the photographer Lord Snowdon: 'I've tried to become simpler. Now I wouldn't even mind taking a boring picture if it gave truthful information about a human being'.

manipulating the sitter

As I have said, some subjects, who are experienced at being photographed, or who understand the visual language of the portrait, will allow you to take only the picture that they want. With most people, however, the atmosphere that you create during the sitting and your general demeanour towards the

subject will help to determine how that person will respond to the camera.

Let's take as an example the studio portrait. This is an alien environment for most people – it's like going to the dentist – and they find the lights and general paraphernalia unsettling and perhaps even threatening. If you want to produce a relaxed portrait, you will have to work hard to make the subject feel at ease and confident that you will produce a result that they will feel pleased with. Obviously you would have music playing (probably not Mahler), maybe you'll offer them a coffee or glass of wine, and you will present a relaxed, outgoing and confident attitude towards them.

If you want your subject to smile, never ask them to; they will smile involuntarily if you smile at them and it will be a much more natural smile. You will see that there are very few smiling pictures in this book. I am reminded of an interview with the British photographer Bill Brandt in which he said that a smiling portrait can become very irritating after a while. People don't naturally smile except when prompted by a specific stimulus – often simply when they are having their picture taken.

Similarly you may wish to make a portrait that is more intense, more serious. You would then adopt the opposite strategy. Don't chat away to the subject inanely; speak intimately, *sotto voce*. Allow long silences. This performance really is yours as well as your subject's – perhaps even more so because you are in control.

being in control

Many years ago (when in my early 20s) I was pursued as a sort of pet photographer by one of our young aristocracy and was commissioned to do his portrait with his then fiancée. He was rich, arrogant, self-confident – the worst example of decadent minor aristocracy at play. I was invited for lunch with some of his society friends, after which I was to do the portrait. As a shy, middle-class wee boy from the suburbs of Edinburgh, I spent the meal in squirming discomfort amid the braying inanities of my fellow guests. I remember that my host drank from a goblet with the proportions of a goldfish bowl, which held a whole bottle of wine. When the time came to make

the portrait, I had my lights set up, camera ready on tripod, and my host and his fiancée sat where I directed them. An astonishing reversal came about. Quite suddenly I was the one in control; I was the confident one, and my sitter was discomfited. He lost his self-confidence and looked nervous and ill at ease. It was delicious. And I'm almost (but not quite) ashamed to say that I took full advantage of my new-found power. This was a revelation to me, that a humble photographer could have so much control over powerful or, in this case, self-important people. Suddenly they are naked, with only the reality of their being to confront the lens.

the pose

One of the most obvious ways to manipulate the sitter is by directing the pose. One could write a whole book on just this and the way that body language can be psychologically suggestive. By observation, most of us understand a little bit of this. What does it mean to have one's arms folded and legs crossed? To be four-square to the camera? To adopt a confident pose? As far as head position is concerned, look at the series of pictures on the next two pages, produced as an experiment. The lighting and expression have been kept virtually constant throughout, and yet each one of these images provides us with a different message, ranging from arrogant to empathetic. Consider the different psychological effects provided by having the subject standing, sitting on the floor, or lying on a couch. Is the camera looking *up* to them or *down* on them?

You could consider each of the portraits in this book and attempt an interpretation of the personality represented in each, determined by lighting, expression, pose and camera angle. You will discover that there can be no definitive interpretation; head up, for example, does not always mean arrogance or defensiveness since facial expression and lighting also play their part. I leave it to you to consider the infinite range of possibilities.

⊙ Johan Brand

One of my students agreed to help me with this limited experiment in body language and the psychological effects of head position. Of course, this is subjective and really only scratches the surface of possible combinations. Johan has kept his expression as neutral as possible throughout.

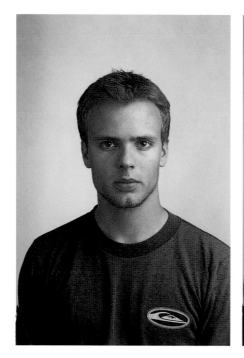

1. Neutral (as far as possible).

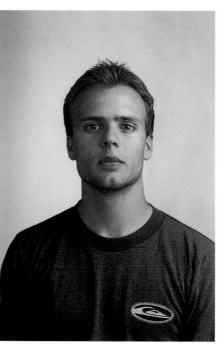

2. Head up – defensive, like a prison mug shot.

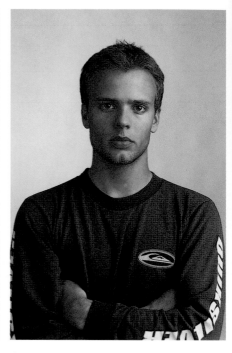

3. Arms folded – again defensive, perhaps nervous.

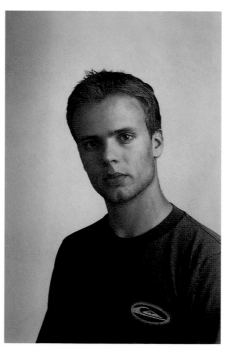

7. Head tilted to one side – empathetic. He's relaxed, listening to you and interested.

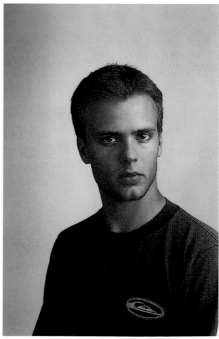

8. Shoulders turned but head full on – you have his full attention, but not in the relaxed manner of 7.

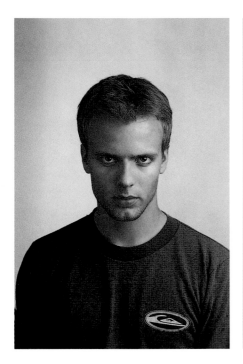

4. Head down and shoulders square to the camera – confrontational.

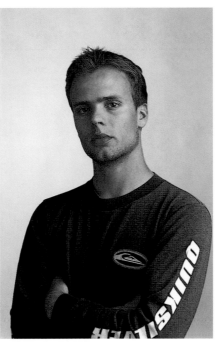

5. Head up, slightly turned away, arms folded – superior, disdainful, unapproachable.

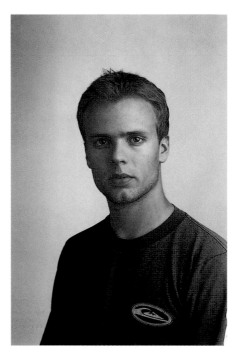

6. Shoulders and head turned away slightly – less confrontational, bland even.

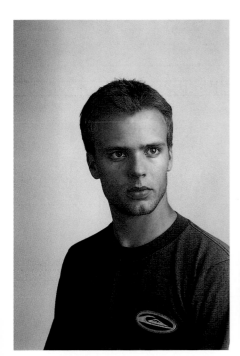

9. Same as 8, but no eye contact – there is no longer a relationship between you and the sitter. You are observing him and his interest is elsewhere.

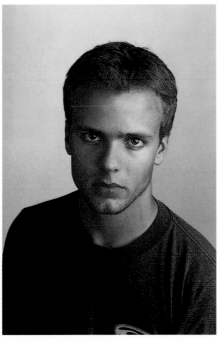

10. Looking up to the camera – diminished status.

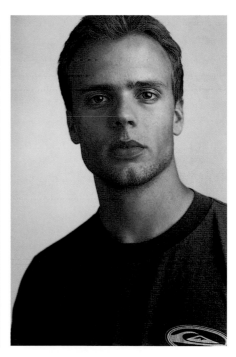

11. Looking down to the camera – elevated status.

logistics

How long should the session be? Naturally there is no simple answer to this. Some photographers are adept at making a good (constructed) portrait in five minutes, although that is usually because it is all the time they are allowed. It is vital that your sitter understands that a good picture requires their cooperation and time. If you are well prepared with your lights and camera in position, and you know what you're looking for, half an hour to an hour should be ample. Any more than that and boredom and/or irritation will set in.

having enough film

How much film you use during a session depends on the format you are working in, how defined an idea you have of what you want, and how long the session is. Working practice on 35mm usually means shooting more film compared to a larger format, say 5 x 4in, which by its nature involves a more considered, consciously posed and formal process (see page 75).

It is important to maintain a momentum in the session – very long periods without making an exposure can make the subject feel uneasy. A top editorial portrait photographer working on 120 film may use several film backs and shoot countless Polaroids and dozens of rolls of film in order to cover all eventualities and possibilities – but then they often work to large budgets. We ordinary folk have to be a bit more careful – and parsimonious. And in the words of an old friend of mine: 'Fail to prepare; prepare to fail.'

⊙ Imogen Gardner, Photographer and Painter, 1992
The mirror has been frequently used in photography as a metaphor for self-examination. Imogen, who has a natural and intuitive talent as an artist, was engaged in a profoundly moving self-reflective body of work, which I was helping her with. This picture, while constructed, was made very quickly. Despite it being a bright day, I selected a wide aperture to concentrate attention on her reflection.
NIKON F2; 85MM LENS; DAYLIGHT

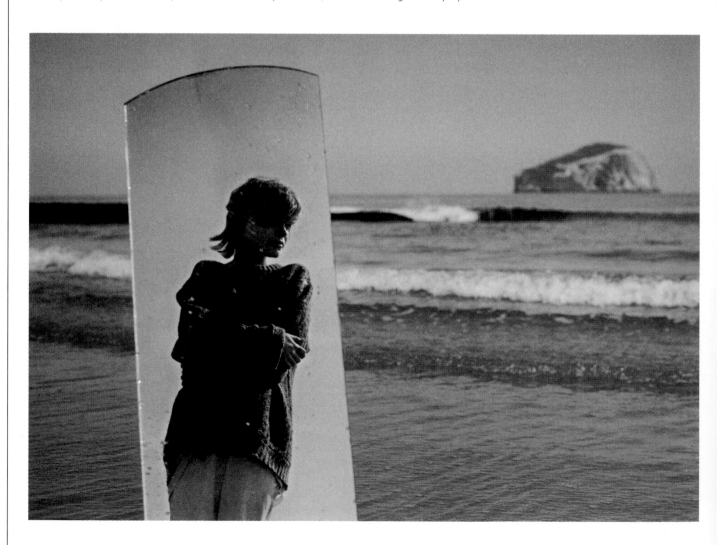

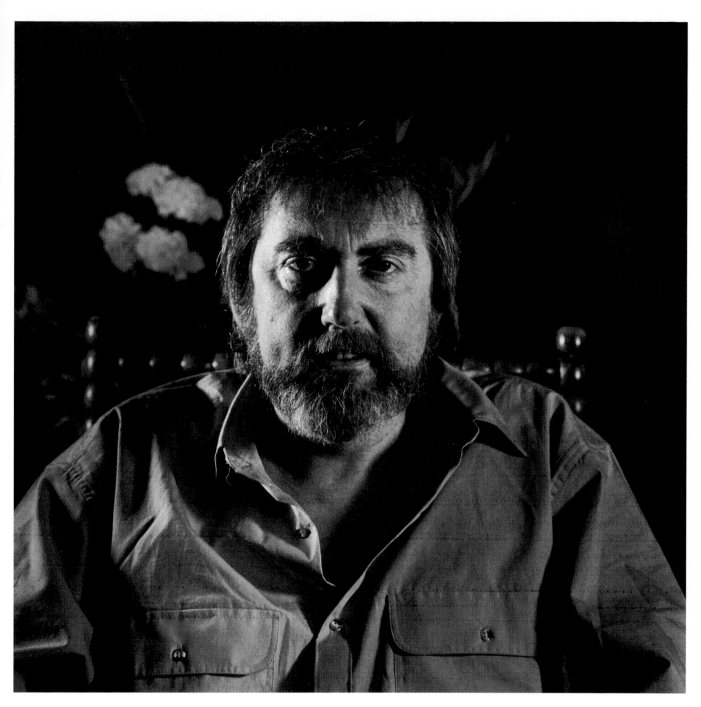

trying again

One last important point: I always say to my sitter *before* the session that I may fail to produce a good result first time and that I would like the option of a second crack at it, if necessary. I am rarely refused this option. Much better to say this before, rather than phone afterwards and say my pictures weren't very good and could I try again, and have them think that I'm an idiot. This also has the benefit of relieving a little of the stress of the session, by removing the imperative to get it right first time.

↑ John Bellany,
Painter, 1989
I have always felt an empathy with John's work. This portrait was made soon after he came out of hospital having had a serious operation. While he was convalescing, he made a remarkable series of self-portraits. This attempts to emulate some of the intensity of these pictures. There has been no attempt here to produce a flattering picture.
HASSELBLAD; 150MM LENS; TWO 400J FLASH HEADS

Dr Duncan Thomson, Keeper, Scottish National Portrait Gallery, 1994

When planning a portrait, it is important not to take the obvious route. For an academic, one immediately thinks of desks, libraries, books – a studious atmosphere and a serious expression – and sometimes this is the only approach that seems suitable. At the time of making this portrait, I knew Duncan only slightly and, after a great deal of thought, felt that the most appropriate context for him was a public one, within the gallery itself.

I decided on a slightly high viewpoint, partly so that the paintings in the background would be given more prominence, and also because I wanted to give the impression that the paintings were looking down on him. A wide-angle lens was used here. This is not normally advisable in a portrait as close as this because of the apparent distortion of the features – the nose looks too large in comparison with the ears. This can be minimized though, if the head is turned to the side so that the nose, cheekbone and ear are all roughly equidistant from the camera. In this case, I used the wide angle so that I could include more of the background, while still being relatively close to the subject. Also, I wanted the background to be reasonably in focus. A chair was found and I got Duncan to lean his arm over the back of it. This gave him something to do with his hands and arms and created a triangular composition.

He was lit with a single flash fitted with a snoot (a cone-shaped reflector that provides a circular pool of light), and the fill-in was provided by the ambient light. The flash reading would have been about f/8 and the ambient light about 1 second at f/8. The ambient light has been underexposed by about 1 stop. The directional light source meant that no light spilt on to the background, which was lit only by rather dim existing light.

I had always envisaged some activity in the background and luckily there were a number of visitors that day. I managed to persuade some of them to walk past to provide an impression of activity in a space that we always think of as being rather static.

Hasselblad; 50mm lens; one 800J studio flash with available light; Ilford FP4

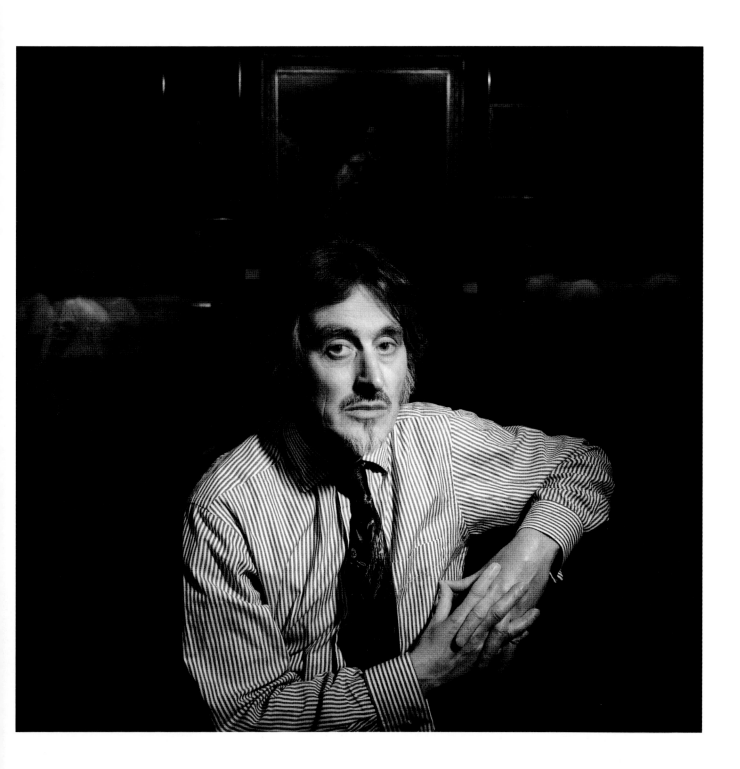

thefoundportrait

using instinct and intuition

In the previous chapter we looked at applying the maximum control over how a portrait looks and what it communicates before the event of making it. This is what Ansel Adams would have called 'previsualization', to which we might add 'preconception'. If some photographs are 'made', so others may be 'taken' and their meaning or significance unearthed later. The picture that has been taken intuitively or naively becomes revelatory: its meaning is 'found'. A large part of the creative process in photography is in recognizing the significance of what you have done at some stage after the picture has been taken. It can also be the case that the constructed portrait may develop significance beyond that which was planned. The best portraits – indeed the best art in general – gather meanings with time and contemplation.

So some photographs are *made* and some are *taken* to be discovered later. I am not suggesting that one approach is necessarily better than the other; however, in my view, some of my best portraits have been made instinctively, rather than in a calculated way. The problem is being able to repeat a process where one has so little control – not to be advised for commissioned work.

being spontaneous

Inevitably most of these 'naive' portraits are shot on 35mm, as snapshots intending simply to record an occasion or a person. Made very quickly, they are often immediate responses, composed intuitively, and with very little thought given to content. This can be a welcome release from the rigour and stress of the formal portrait, where one is always worried about getting a good result. The knowledge that it doesn't matter if the picture doesn't come out means that one can just enjoy picture-making for its own sake, and this allows for a much greater degree of experimentation.

That is not to say that such pictures cannot be taken on larger formats, or for more esoteric reasons: to take pictures because you *feel* you want to, rather than as the culmination and realization of an intellectual process. You can do that with photography more than with any other

⬇ **Imogen Gardner, 2003**
I have taken dozens of pictures round our kitchen table, the epicentre of our household. Wine is drunk, confidences revealed and photographs are taken.
NIKON F3; 50MM LENS; FADING DAYLIGHT, CANDLES AND FAIRY LIGHTS

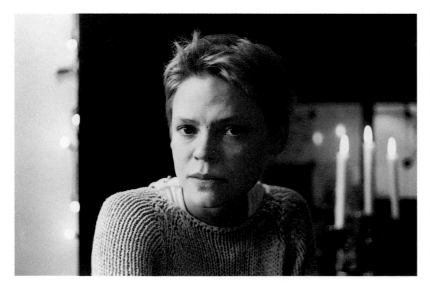

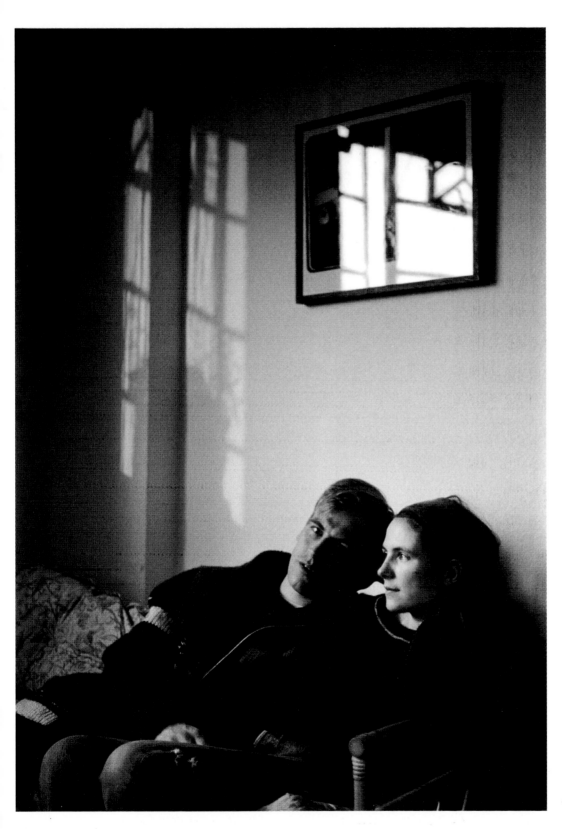

◉ **Graham and Louise,** 1991
When I took this, I saw the white reflection on the picture and the light pattern on the wall, and asked Graham to look at me and Louise to look out of the window. Perhaps it took two minutes from conception to execution. I was vaguely aware of a crucifix right in the corner, top left. In conversation with Graham later that evening, it turned out to be more significant than merely a compositional device. There is another portrait of them on page 53.
NIKON F2; 50MM LENS; DAYLIGHT

medium because it's so immediate and spontaneous. Tap into that right side of the brain occasionally. But be prepared to reject a lot of pictures – and don't forget that it is still important to apply your intellect after the event, to attempt to reach a conclusion over what the picture is *about*. There's a significant difference between a naive photograph and a naive photographer.

photographing friends and family

Central to my activity as a photographer is the need to photograph the people around me as an expression of friendship and love, as a memento, and perhaps as a gift for them. Probably my first successful portrait was made when I was 18 years old. It was a picture of a girlfriend in halls of residence at Stirling University in Scotland (below). Of course I didn't realize it was a good portrait until much later, when I began to analyze the elements of the picture and what they signified – the breeze-block walls, small pictures stuck on with Blu-tack, the heart-shaped postcard, her expression, the unsettling dynamics of the composition, and so on. The portrait meant an immense amount to me at the time, and with the passing of years it has become important in a different way as a memory of that person and of that time and place. I see from my 30-year-old contact sheet that I made only one exposure: I would never dream of doing that today. If I even suspect that what I'm seeing in the viewfinder is interesting, I shoot at least half a roll.

recognizing significance

Perhaps it follows that if the portrait that we have taken naively can be found to be of value at a later time, then we can take some sort of ownership of a snapshot that we have found and that has not even been taken by us, but that we recognize as being valuable. Recently, I came across a photograph of my

⊙Anne Mackenzie, 1970
Taken at Stirling University, this was the first photograph I took that had real meaning for me beyond its compositional 'picture' qualities. After making a print, the more I looked at it, the more it meant. This picture made me understand the possibilities of photography. It was a revelation to me, and one of the main reasons why I became a photographer.
NIKON; 50MM LENS; ARTIFICIAL AMBIENT LIGHT; ILFORD HP5 UPRATED TO 1600 ASA

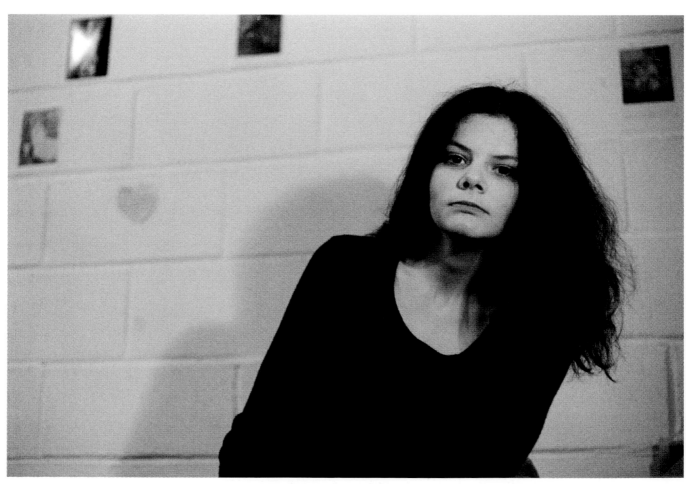

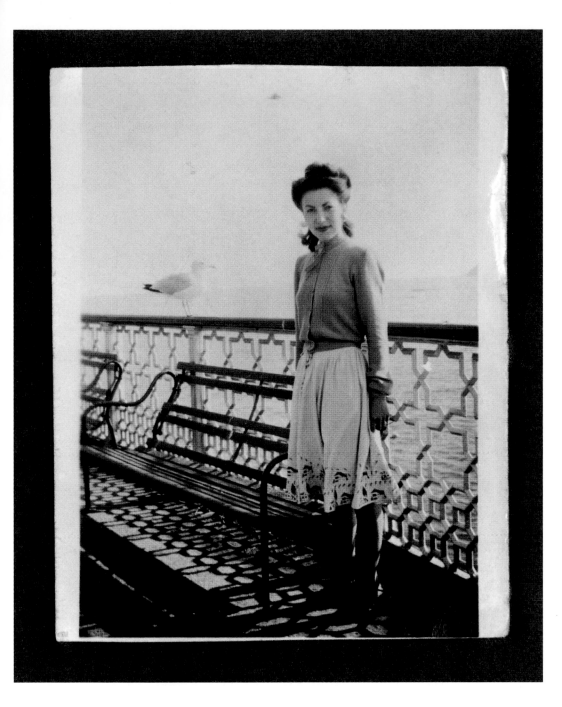

◀ **My Mother's Honeymoon, Llandudno, 1946**
Snapped by my father. He was attempting to photograph the seagull and instead produced a beautiful iconic portrait of my mother. It's a tragedy that the negative is lost – I would love to see what else is on the roll of film.
BOX BROWNIE; BRIGHT SUNSHINE

mother, taken by my father in 1946 on their honeymoon in Wales (above). It's an original 6 x 9cm contact print, and a bit tatty at the edges from decades of handling and sitting loose in a drawer. She was 26 years old. My mother tells me that she is wearing a skirt that she made and hand-painted herself and that my father's main intention was to snap the seagull perched on the balustrade. It's a wonderful picture, formally precise and rich in visual delight: the repetition of pattern in the ironwork and its shadow with the design on the skirt; the arrangement of shapes; and the quality of light.

The picture is virtually an accident, made naively, and has not only been found, but discovered. In the process of this discovery there is a sense in which one adopts it as one's own. This picture has become, for me, iconic of my mother to the extent that I feel that I don't really need any other pictures. For my mother, it has a different significance: as a memory of her youth, and the commencement of her long and happy marriage to my father. The value of this photograph has increased with its age; a mere disposable snap has gathered meanings and importance. (And, of course, one wonders whether its

➲ David Brittain, Writer,
Editor, *Creative Camera*,
1989
This portrait was directed,
but spontaneously and
intuitively. It's a picture
that was taken and
its significance and
interesting formal qualities
discovered later.
HASSELBLAD; 80MM LENS;
FADING DAYLIGHT

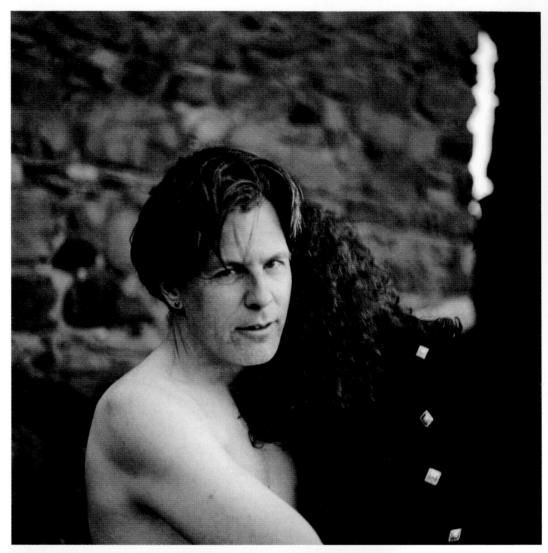

➧ Roberto Wilson, **1996**
This is my son on a day
out with me when he was
nine years old. We all take
snaps of our kids, and it's
important to do so as
a memento of time and
place and a record of
them as they grow up.
But occasionally there's
a picture that transcends
the mere snapshot – it
works on a metaphoric
and symbolic level and
becomes personally
significant.
LEICA CL; 40MM LENS; DAYLIGHT

survival would have been so assured had this been a digital image.)

My portrait of David Brittain (opposite) seems to me to reveal so much. I can say without arrogance that I think this is a wonderful picture, because it is almost as if I haven't taken it, but discovered it. I remember it was after an exhibition opening at Stills Gallery in Edinburgh. Four of us climbed a hill to a ruined chapel. The early evening light was lovely and we took photographs. I have no idea why I had a medium-format camera with me, but I suggested doing a picture of David and his then girlfriend. For some reason I asked David to take his shirt off and I made three or four exposures just for fun.

The resulting picture seems to be full of intrigue – an inexplicit and curious narrative underlying an unconventional aesthetic. For me, it reveals and expresses a great deal. Of course the picture wasn't completely naive; it represents intuitive picture-making based on many years of experience of gazing through a viewfinder, but I had no idea what the picture was *about* until after I had printed it, or that it was going to be so interesting.

These photographs – revelatory, mysterious, intuitive – are for me photography at its most exciting, where you cannot predict exactly what you are going to get, where you don't have total control over the final result, either in formal terms or in respect of what the picture is about. At best, they are epiphanies, and for me the experience is very rare and almost impossible to repeat at will. In fact, the harder you try, the less likely you are to achieve it. It's a sort of magic, and I don't believe that there is another medium that can provide it in the same way.

⬅Jane O'Neill and her Niece, 1991
While taking a series of casual pictures of my friend and her niece, Catherine, I made this picture. I vaguely knew it was interesting at the time, but certainly couldn't intellectualize it. The child has been given status by the low camera viewpoint and her self-important stance, while her aunt has faded into mysterious obscurity. It's an enigma.
HASSELBLAD; 80MM LENS; BRIGHT SUNSHINE

equipment and editing

While it is true that you cannot make successful portraits happen spontaneously, there are certain strategies that you can employ to make their occurrence more likely. The most obvious is to carry a camera with you at all times. You are probably not going to lug a medium-format around with you, so the camera you carry will most likely be a 35mm, possibly even a compact, of which there are many capable of quite long shutter speeds and with very good quality lenses. Long shutter speeds are obviously important if you are taking pictures in low, available light – very often the best conditions for producing portraits that have a certain intimacy. Don't forget to switch off the built-in flash or, if you must use flash, select (if possible) a shutter speed long enough for the ambient light also to record (see page 101). Some of the more expensive models have

rear curtain flash (where the flash will fire at the end of a long exposure, instead of at the start).

acting quickly

Shoot plenty of film. The less experienced you feel you are, the more film you should expose. If you are in an environment that interests you, or with people you feel like photographing, take as many pictures as they will allow you to before irritation or self-consciousness sets in.

Watch the light. If the light is interesting, there will probably be a good picture there somewhere. If you see an event unfolding with possibilities, don't dither about selecting camera modes or taking careful exposure readings or trying to decide which lens to use (if you have a choice) – take a picture immediately. Once you have stolen that moment, you

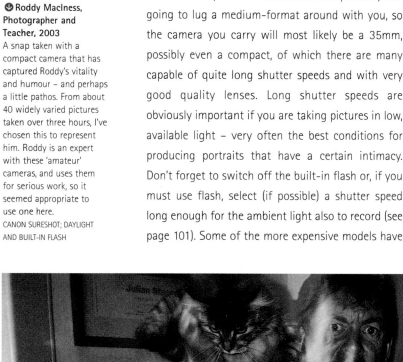

⊕ Roddy MacIness,
**Photographer and
Teacher, 2003**
A snap taken with a compact camera that has captured Roddy's vitality and humour – and perhaps a little pathos. From about 40 widely varied pictures taken over three hours, I've chosen this to represent him. Roddy is an expert with these 'amateur' cameras, and uses them for serious work, so it seemed appropriate to use one here.
CANON SURESHOT; DAYLIGHT AND BUILT-IN FLASH

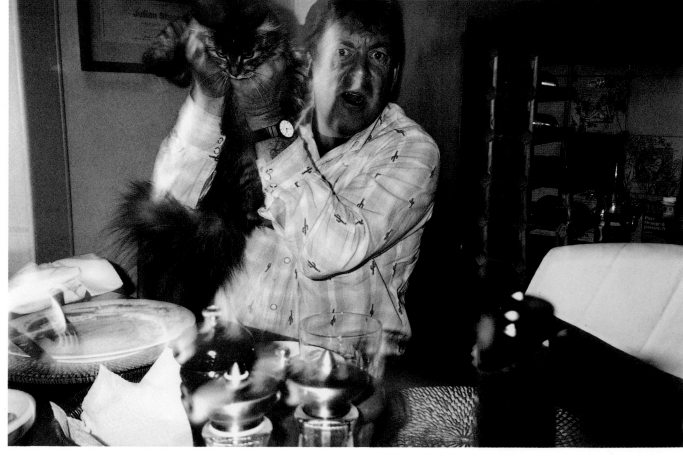

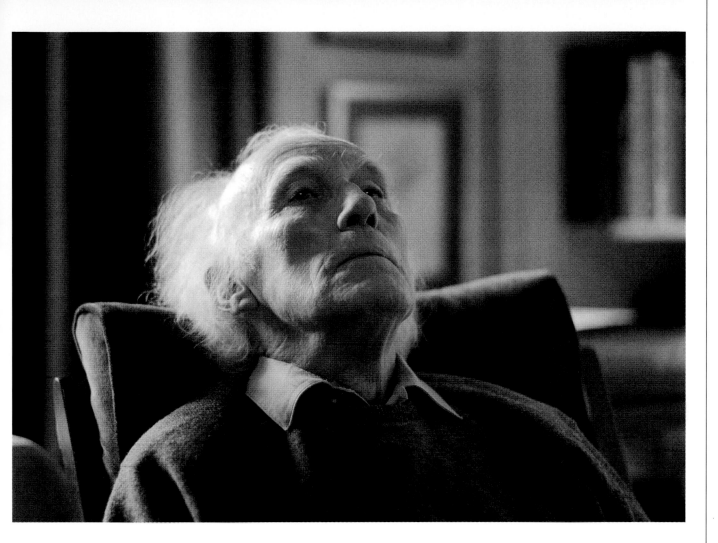

can move position, recompose, check exposure and make any appropriate adjustments to camera settings and so on.

I honestly think that modern 35mm cameras, with their sophisticated range of options, militate against good picture-making, where one should be concentrating on the subject, the composition and the light, and not the equipment. Many experienced photographers like to keep their equipment as simple as possible so they are not forced into making choices – many will not even use a zoom lens for that reason. When the finger points at the moon, as the old Zen saying goes, only an idiot looks at the finger.

making a selection

An important part of discovering meaningful pictures is the process of editing contacts. You should take care over making contact sheets. All the negatives should be the right way round and printed a little on the soft side (if they are black and white), so that they are easy to read and you can see all the available

detail. You need a good magnifying glass, especially for 35mm – cheap plastic loupes are useless. I use a folding magnifying glass called a linen tester. Take your time to examine the contacts carefully and, if you can, revisit them from time to time – it's amazing what you can miss the first time round.

Make work prints of anything that looks like a possibility. As I've said, recognizing good pictures is a creative skill that requires experience and it's not a bad idea to get somebody else (preferably somebody whose opinions you respect) to have a look at your contacts or work prints as well. Sometimes we all get too close to our own work and a second opinion is always useful, however experienced we are.

↑ Norman MacCaig, Poet, 1990
I took this during an interview with Norman by his friend David Campbell. He was 80 years old and widely regarded as Scotland's greatest living poet. The editing process is always important, the more so when using a lot of film on 35mm – you are choosing an image that best represents, for you, the person and the occasion. There is a formal, constructed portrait of Norman on page 124.
NIKON F2; 85MM LENS; DAYLIGHT

Graham MacIndoe
and Louise Allen, 1989

One of the powerful experiences open to photographers, but denied to other visual artists, is the revelation of discovering what you've done after the event of taking the picture – when you recognize some sort of truth in the image that you hadn't seen at the time you clicked the shutter. Or you discover that you really have eloquently encapsulated a moment. This happens to me rarely – you can't make it happen – but when it does, these mysterious, almost spiritual, epiphanies underline for me why I am a photographer.

Graham had been a photography student of the late and highly respected Murray Johnston at Edinburgh College of Art. Murray was immensely influential to Graham and they became very close. Graham graduated from ECA and went to the Royal College of Art in London. When Murray contracted cancer and then became very sick, Graham came up from London with his new girlfriend and stayed in my flat after visiting Murray in the hospice.

It was an emotionally charged evening. It must have been about 1am when I decided that I wanted to do a picture and got them both to sit on the floor behind a coffee table on which I placed three candles. The only other light was from a table lamp far off to the rear on the left-hand side. I propped the camera on books to steady it and hand held it at an exposure of about 1 second at full aperture. Looking at the ground-glass screen I was vaguely aware that I needed some light in the bottom left and moved a wine glass to reflect light from the candles. I often use the device of a strong highlight or light source in the picture to enable me to print the rest of the image darker – without it the print would look decidedly muddy. I made 12 exposures, some with the table light off, but I liked the highlight on Graham's hair, which mimicked the strands on Louise's face.

The next day I developed the film and made contacts, pleased that the pictures had come out. I then made a print from what looked like the best neg. Making the print was like revisiting the previous evening. That *process* is so important for me – it's just not the same if you collect the print from a lab.

I still remember the palpitations, looking at the print appearing in the developer, realizing that the reflections of the candles on the glass had formed the shape of a heart.

Alchemy.

Hasselblad; 80mm lens; three candles and a table light; Ilford HP5

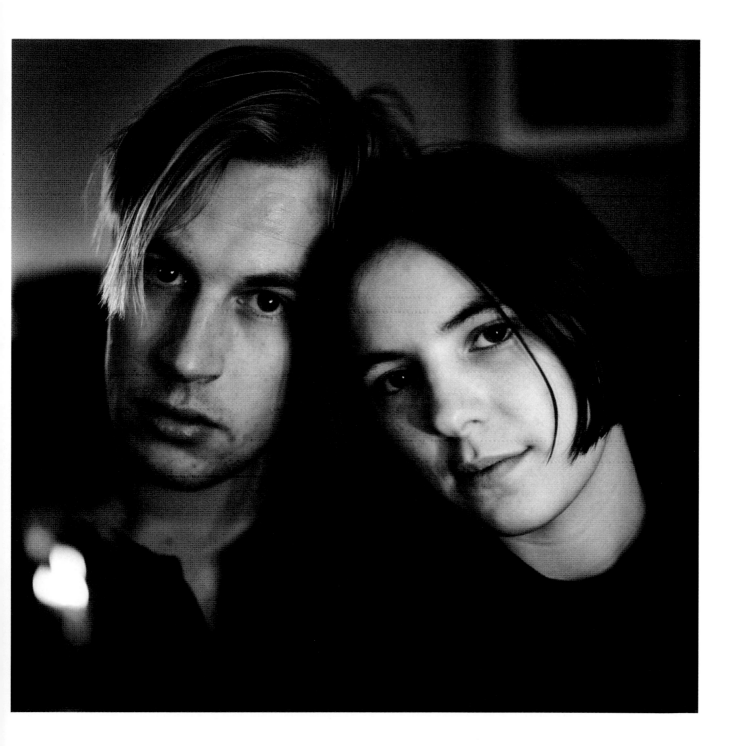

commissioned groups

A group portrait is an important way of marking an occasion that involves the coming together of several people. It becomes a tangible and valuable memory, not just of those individuals, but of an event – a documentary image to keep and to cherish. The obvious example, on an international, historical level, may be the sort of group photograph that is taken at a summit conference of world leaders. On a personal level, it might be the wedding photograph of all the assembled guests. Besides documenting an event, a group may also be brought together that represents members of an organization, club or social grouping. Clearly, though, there are other events and less formal groups that would also be appropriate. I have often been commissioned to make group portraits as well as making them for my own interest.

arranging the elements

Groups have their own particular problems in terms of logistics, lighting and composition, with the latter providing particularly interesting problems. The more people involved, the more difficult it is to make a coherent arrangement that doesn't look like a standard team photograph. For an object lesson in classic arrangement, I often direct students to a close analysis of Irving Penn's remarkable group portraits, in particular his portrait of Hell's Angels in California in 1967. Similarly, with large groups, you must maintain strict control – make sure they are all paying attention – and when you are making

exposures you need to be sure that none of them is blinking. I tell them that I will fire the shutter on the count of 3 to be as sure as possible that they don't.

Let me deal with some of these special problems through a series of examples, illustrated over the following pages.

solving problems

My portrait of the Deans of the University of St Andrews (opposite) is a mixture of careful planning and good luck. It was commissioned by the University as a gift to the retiring Principal. Like a great deal of planned portraiture, the group portrait is a series of problem-solving exercises, the first of which is deciding where the portrait is to be made. Here I've tried to avoid the obvious, which I suppose would have been to photograph them in the main quadrangle of the University. I wanted to combine formality with informality. I decided on St Andrews' famous West Sands for several reasons. First, because they provide an excellent backdrop of the sand, sea and sky from the slightly elevated position of the dunes. Second, because I liked the incongruity (always a useful weapon in your conceptual armoury) of the formal gowns with the informal setting. Third, I knew that the Principal enjoyed the sands, taking regular walks there. Remarkably, each of the Deans agreed to this slight to their dignity.

The next problem was light. I had calculated that the best time for the direction of the sun would be 11am. (This was November, fortunately. Had it been June the best time would have been 6am.) Luckily, on

the day, the sun shone with a slight veil of cloud to diffuse it – perfect.

Arriving an hour before the appointed time, I planned the exact camera position and the area within which the group would stand, marking out the latter with sticks. It was important to plan as much of this in advance as possible – these people weren't going to put up with me dithering about. This was one of the very few occasions when a zoom lens would have been handy, because the camera was positioned on a dune and it couldn't be moved forwards or backwards. I knew that there were nine people, and I had planned a composition that would be asymmetrical. The person with the brightest gown has been placed in the centre – really there is nowhere else he could go. Note that the subject to the extreme right has his head tilted into the picture. The subjects have been positioned so that each is illuminated by the sun, but none casts a shadow on anybody else.

dealing with technicalities

In 2000 a millennium portrait of the Fellows was commissioned by the President of the Royal College of Surgeons in Edinburgh (see next page). This was an interesting commission, not so much for any personal creative input, but for the logistical and technical problems involved. The idea was to recreate and update a group portrait painted in 1889. The President at the time was Joseph Bell, seated at extreme left, who was the inspiration for Sherlock Holmes. The same or similar chairs and tables were found and the set recreated as closely as possible in the same building. Planning had to be rigorous. Each participant was given a number that related to a position on a plan of the set, so that everybody knew where he or she had to be positioned.

One major problem was that, while the painter can take liberties with perspective, the photographer

⊕ **Deans of the University of St Andrews, 1999**
A carefully planned portrait attempting to avoid the obvious location. What could not be planned was the light, which was perfect – slightly hazy sunshine.
HASSELBLAD; 80MM LENS; DAYLIGHT

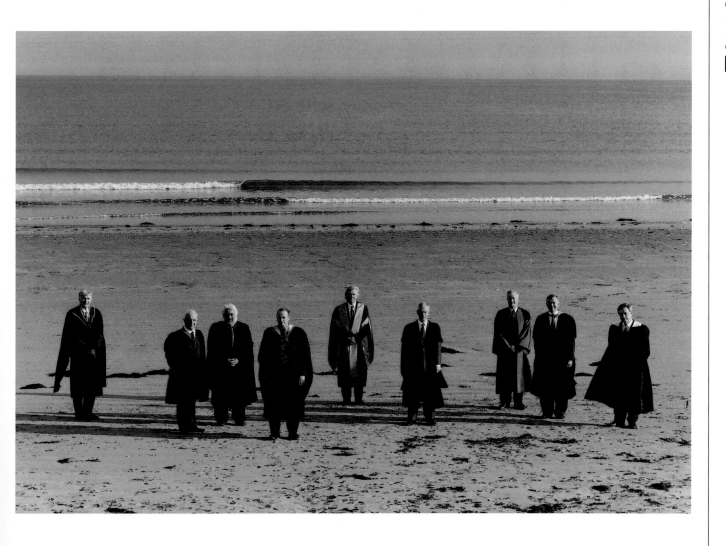

cannot. I was forced to use a wide-angle lens (or knock down the wall behind the camera) so the perspective is steeper than in the painting. Lighting consisted of a bank of five flash heads on the left-hand side, each powered by a 3,000 joule pack and fitted with a large softbox. They were adjusted so that the highest one, on a boom stand, was on the highest power and aimed towards the back row, while the lowest one – on lowest power – was directed towards the front row, in an attempt to produce a reasonably even, but directional, light.

Interestingly, it's highly likely that the original portrait was made from photographs of the individuals, as was often the case. You can see that many of the subjects are facing in different directions and do not appear to be relating to each other – rather like a composite of individual portraits. Inevitably, some of the Fellows could not attend the event of making this photographic portrait. I felt it was reasonable to use digital montage techniques here, and spaces were left in the portrait for five or six of them to be photographed later and stripped in. Similarly, the portrait has been tidied up digitally – wall audio speakers and fire exit signs have been removed. Had this been a document of an event – such as the opening of parliament, for example – rather than a portrait of members of a group, I would never have digitized the picture. As soon as you do that, it calls into doubt its documentary veracity, and if an individual has been unable to participate, it would be a lie to say that they were there at that place and at that time.

⊗ Fellows of the Royal College of Surgeons, Edinburgh, 1889
This original painting by P. A. Hay was most probably painted from individual photographs, as were so many groups with the advent of photography.

⊗ Fellows of the Royal College of Surgeons, Edinburgh, 2000
The updated version, attempting to emulate the original painting, was technically and logistically challenging. It involved some of the Fellows being stripped in digitally at a later date.
TOYO 5 X 4IN MONORAIL; 90MM LENS; FIVE 3,000J FLASH HEADS WITH SOFTBOXES MIXED WITH A LITTLE DAYLIGHT

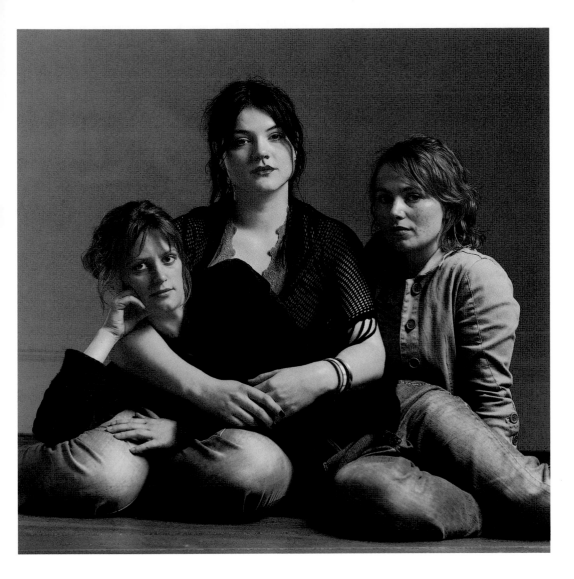

⊙ **Birgitte, Hilde and Astrid, 2003**
We became close to these three exceptional women in the aftermath of a tragedy involving one of their friends. Two of them were leaving university to return to Norway, and it seemed important to make a portrait to mark the closure of a period of their lives and as a gift from me. It's about strength, affection and bonds. There is a black-and-white version of this on page 126.
HASSELBLAD; 150MM LENS; TWO STUDIO FLASH HEADS

personal mementos

Throughout our lives we make a lot of acquaintances, some of whom we might truly call friends. Most people have friends who belong to particular circles – perhaps friends at work, neighbours, old school friends and so on. These circles sometimes intersect, and sometimes change as we move on geographically, or just fall out of touch. I believe that it's important to photograph these groups as mementos, particularly if there is an occasion that has brought such people together.

capturing an atmosphere

The picture at Chris and Jean's cottage (see next page) was made on the morning of a gloriously hot July day. My friend Chris Hall, with whom I shared a studio, and his wife had a cottage in the country where we would sometimes be invited for the weekend. It was one of those occasions when one was imbued with that feeling of total well-being that comes with relaxing among good friends.

It was breakfast time and I decided to make a portrait. I took the picture from ground level to create an out-of-focus foreground and to include a lot of sky (openness, airiness, freedom and so on). This was a carefully controlled picture. The only person who is looking at the camera (me) is Chris, with whom I have the closest long-standing relationship, both professional and social. Note the empty chair, from which I have risen to take the

photograph – I am in the circle and observing it at the same time. For all that it is a memento of good friends and a delightful weekend, there is a narrative here – a frisson, perhaps.

composition

For a few years I conducted workshops at Inversnaid Photography Centre on the west coast of Scotland. The picture opposite is of a small group of participants, including myself (kneeling). Let's look at this group in terms of its picture construction. This is the back door to the house and there is another door to the left with the top half glazed, through which I've placed a flash head connected to the camera with two extension synch leads (I wish I'd had a radio-controlled unit then). This creates the light effect on the wall and provides a little lighting contrast for an otherwise flat scene. A frame has

been carefully constructed: note the precise verticals and horizontals, which are the result of some considerable care taken in setting the camera position. The gentleman in the doorway has been given status (as befits his mature years) by being the person highest in the composition and framed by the dark doorway. The woman at right (my friend Jean Welstead) has been asked to lean into the picture. It's a picture that conforms to ancient compositional principles.

● **At Chris and Jean's Cottage, 1990**
A personal portrait of friends away for the weekend together. There is no reason why such a picture shouldn't transcend the casual snap and become something more significant. This picture was as carefully controlled as if it had been a commission. The low viewpoint provides an out-of-focus foreground that maintains attention on the subjects.
HASSELBLAD; 80MM LENS; BRIGHT SUNSHINE

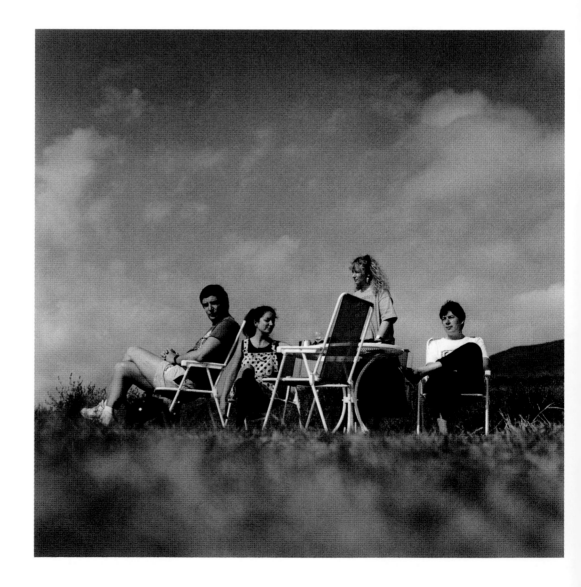

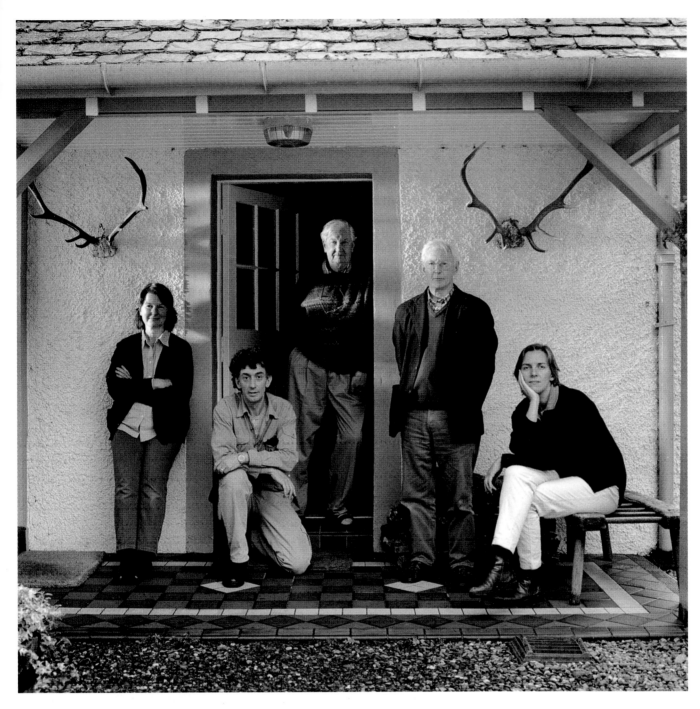

Diagram of Inversnaid Group, 1999
This diagram reduces the photograph to its compositional essentials. I think you get a better idea here of how the distribution of shapes works – especially the heads, which are all at different heights and flow in a sort of wave pattern.

⬆ **Inversnaid Group, 1999**
Made during a five-day workshop, it required very precise positioning of the camera to keep horizontals and verticals aligned in this image. Similarly, each person is carefully posed, though the grouping aims to look natural and relaxed.
HASSELBLAD; 80MM LENS; ONE FLASH HEAD TO THE LEFT AND DAYLIGHT

Hospitalfield, 1991

Isn't it strange how so many photographs seem to gain significance with the passage of time? Sometimes one is vaguely aware when a picture is made that it is important, although perhaps only for the immediate participants, and even many of them don't appreciate this at the time. This picture is a remembrance and a celebration of an occasion, of a group, and of individuals. In a way it's also a self-portrait – besides the fact that I appear in the picture.

This photograph was made on a retreat with second-year students from the photography degree course at Napier University in Edinburgh where I teach. Hospitalfield is a magnificent old house north of Edinburgh and in those days we took students there every year. It was a rich and challenging experience for both staff and students and, to mark each event, I would make a group photograph. Teaching is a privilege, and this group was particularly stimulating. An astonishing five of them completed their degree with first-class honours.

The lecturing staff are at the back, reflected in the mirror: John Charity, myself and Leo Allen. Some of the students, such as Susanne Ramsenthaler and Margaret Mitchell, are themselves now teaching; some are film-makers, such as Nigel Smith and Lachlan Mackinnon; and some are successful professional photographers. A few, such as Hannah Starkey, have gained considerable reputations as exhibiting artists.

Unusually I lit this with tungsten lights rather than flash, I think because I didn't have enough powerful flash heads with me. Sometimes I like the discipline of making portraits with long exposures because it creates an added formality – a gravitas even – when everybody is told that they have to stand very still for one second. There are three lights here: one to the right at the back, lighting the backs of the people on the landing; one high to the left of the camera lighting their faces; and one at the bottom of the stairs lighting the people on the stairs from below.

You can see that the camera in the mirror below me has been shaded from the light, simultaneously hiding it and preventing flare from the back light. You should be able just to make out the tripod legs. I used a large piece of black card clamped to a lighting stand about two metres (six and a half feet) diagonally to the right as a 'flag' or shade.

Everybody received a print at the time. I hope they still have it – and that it continues to provide a memory prompt for them in future decades, as it does for me.

Hasselblad; 80mm lens; tungsten redheads; Ilford FP4

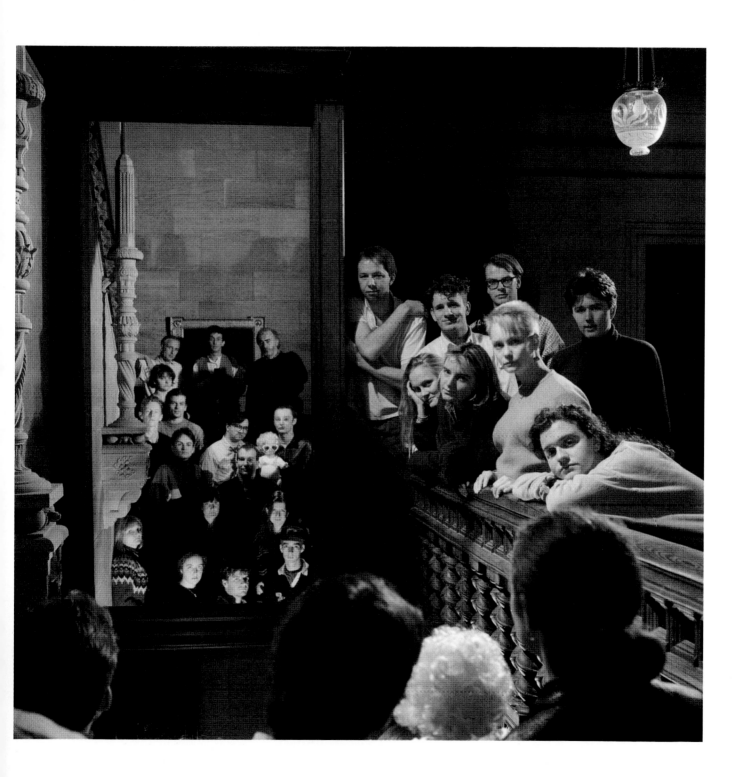

holiday pictures

It would be sad if we didn't use the camera to do what it is best at: that is, to record an occasion, as a prompt for memory and a celebration of friends. The photographs will probably have little relevance other than to yourself and the immediate participants – they will be your audience.

Holidays are a good time to do this: you are away from the pressures of life and you can have quality time with friends or family. Holidays often involve merely eating, sunbathing and drinking, but are also an opportunity for close conversation and, as a photographer, practising your art. The great advantage here is that you will have mental space – nothing need be rushed and you have plenty of time to plan. You also have 'captive' subjects who similarly have nothing more urgent to do. So you're not only going to take snaps, but to make portraits – in particular, group portraits, which may be planned as meticulously as if they were valuable commissions.

recording individuals and relationships

For a few years in the 1990s some friends and I went to stay in an old palazzo in eastern Italy for a

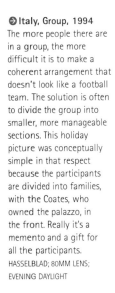

⊙Italy, Group, 1994
The more people there are in a group, the more difficult it is to make a coherent arrangement that doesn't look like a football team. The solution is often to divide the group into smaller, more manageable sections. This holiday picture was conceptually simple in that respect because the participants are divided into families, with the Coates, who owned the palazzo, in the front. Really it's a memento and a gift for all the participants.
HASSELBLAD; 80MM LENS; EVENING DAYLIGHT

fortnight of relaxation, and each year I would make a group portrait and some individual portraits (some of which are shown on these pages) for all those reasons listed above. It's always appreciated when you are able to make prints and send them to everybody after the holiday as a 'thank you' for their friendship. Each of these groups was carefully planned and constructed, in terms of the placement of individuals within family groupings or to take account of particular affinities: they have an element of social analysis, occasionally even subversively so.

I do wonder to what extent the subjects notice this when I make the picture or when they receive a print – 'Oh, I wonder why I have been placed beside him?' or 'Why is he standing by himself?'

Adjacent to the palazzo was an old olive barn, which was in the process of being converted to basic living accommodation. It had low ceilings and several small windows, and one year we spent some time painting walls and ceilings white. Basically it was a large white space, with plenty of room to manoeuvre and a lovely natural light that made it ideal for

David Williams, 1991
The normal convention with portraiture is to put more light on the subject than the surroundings. Occasionally I like to reverse that, as I have here. The palazzo used to belong to an Italian general and the tattered flag seems to suggest a military association. David Coates, who owned the house, was asked to lean out of the window top left.
HASSELBLAD; 80MM LENS; NATURAL LIGHT

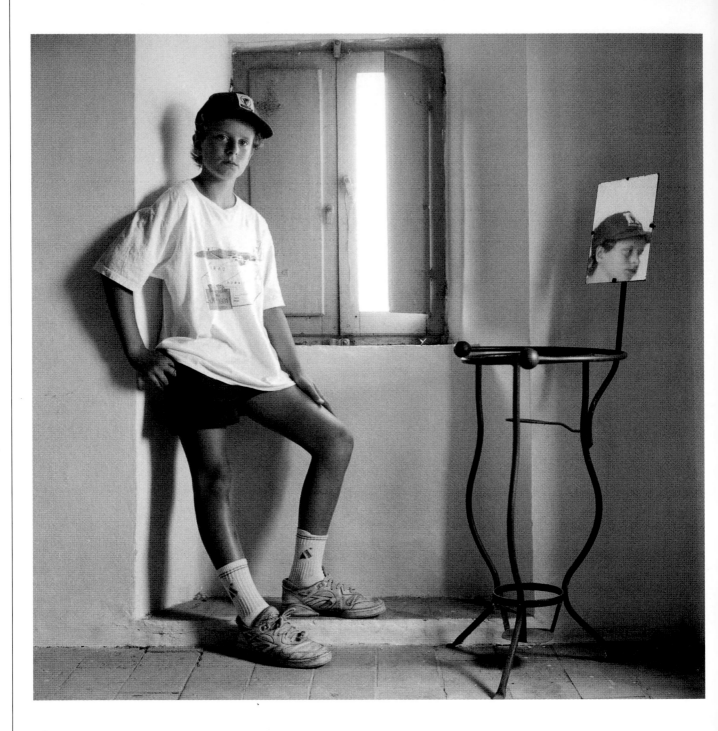

⊕ Bertie, 1991
Another of the series of portraits I made that year. The light in the room could be easily controlled using the shutters to vary the contrast. I doubt if I could have lit it so beautifully with artificial light.
HASSELBLAD; 80MM LENS; DAYLIGHT

portraiture. I used minimal equipment because that was all I had with me – only a standard lens and not even a reflector. Instead of being restrictive, this turned out to be an advantage – it was a real release from making technical and craft decisions. Over a period of days, I made several formal and carefully constructed portraits of the people staying at the palazzo, individually and in small groups. With the passing of time and in a small way, these portraits become increasingly valuable documents of friends at that time, and in that place.

The Tenerife Portrait (see page 67) is a memento of another holiday with a different group, and is another carefully prepared and consciously constructed portrait. Everybody was told that they had to be on the patio before dinner at 8pm when the sun was setting. The light was perfect: slightly hazy, low, direct sunlight – note the shadows. The stage was the gable end of the kitchen of the large house where we were staying, with Tenerife's volcano, El Teide, in the distance, gratifyingly echoing the shape of the roof (I didn't plan that).

⊘ Hannah and Beth, 1994
One of a series of pictures
I made in an old olive barn
with beautiful natural light.
A plant has been moved into
bottom left and a table just
into shot at the bottom to
darken areas of the floor.
As a small visual conceit I've
swung the basket hanging
from the ceiling. Their heads
are turned towards the main
light source at left to
produce more attractive
modelling on their faces.
HASSELBLAD; 80MM LENS; DAYLIGHT

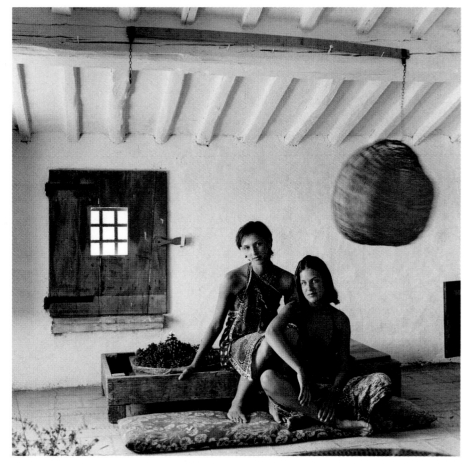

⊙ Marjory Wilson, 1994
Another part of the same
olive barn interior. This was
my partner (now my wife)
looking businesslike in
dungarees. Aesthetically I
was interested in the muslin
draped across the door,
hinting at the interior
beyond and the door to
the barn.
HASSELBLAD; 80MM LENS;
DAYLIGHT

⊙ David Williams, 1994
This is my friend Dave
again in the same olive
barn, where he was
sleeping. Notice the hat,
the headphones and the
sandals, each being
recognizably of him.
HASSELBLAD; 80MM LENS;
DAYLIGHT

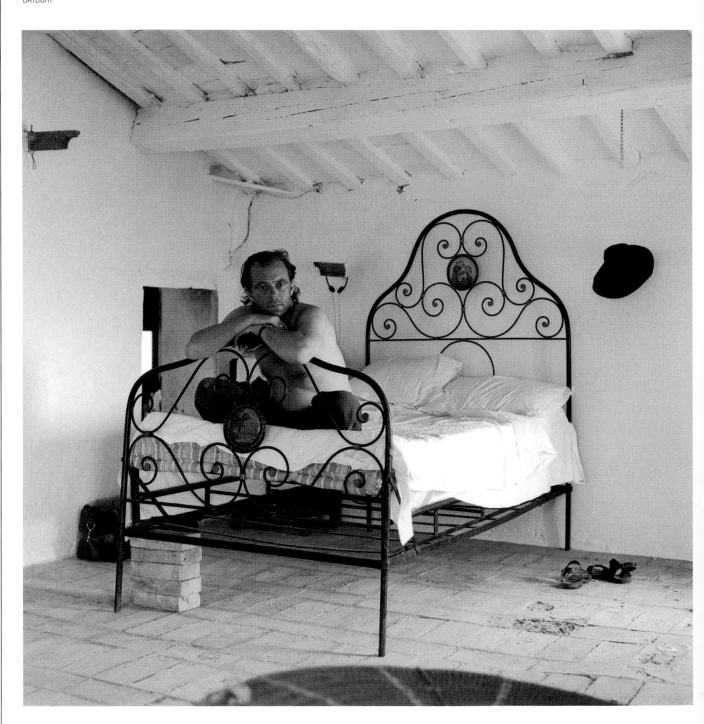

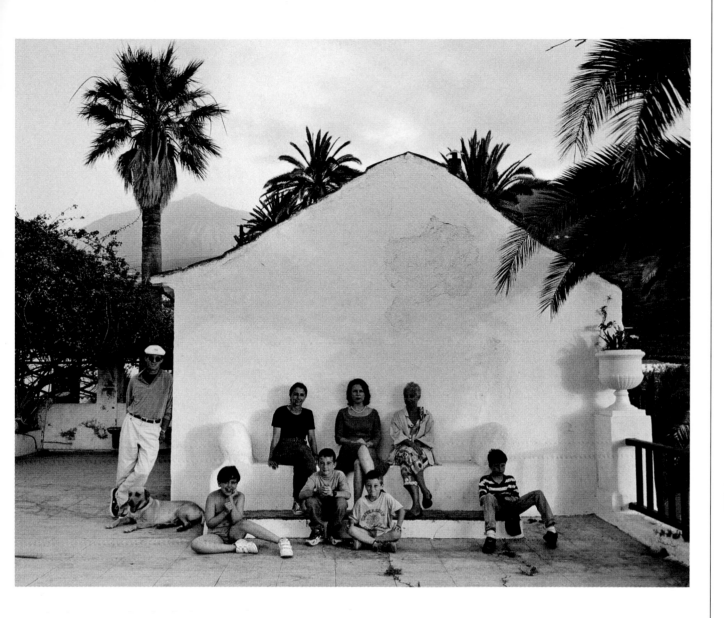

The portrait above is partly an exercise in social dynamics – everybody is carefully positioned. Central to the composition are three wonderful women: my partner Marjory in the middle (and dead centre of the whole picture) and her close friends Alicia (right) and Pino (left). Pino's sons are together in front of her with Marjory's son Roberto to the left. Pino's husband Dougie is standing, looking cool in sunglasses, with his dog obediently at his feet, breaking the line of the corner of the building and connecting Dougie to Roberto.

There may not be total harmony all the time, however, amongst any group of people living together for a while, especially if there are children. Look at Pablo, who was visiting on an exchange, sitting by himself on the right. He wasn't having such a good time that day and didn't really feel like participating in this picture. Can you read his body language...?

We think of holiday pictures as always presenting a happy face to the camera. Whatever familial conflicts are raging either side of the instant the snap is taken, there is always a smile for the photographer. It's like a Pavlovian response and sometimes you have to work hard to stop people putting on a daft grin when you point a camera at them. It's the first give-away that a picture has been made quickly – the longer the portrait takes and the more formal the process, the more that irritating, sometimes self-conscious, smile will fade.

As serious photographers, perhaps we should attempt something more truthful and analytical than is the norm when we are on holiday. Artists are never really on holiday.

⬆ **Tenerife Portrait, 1996**
Part celebration, part memento, partly a study in social dynamics, this was carefully orchestrated. Dougie (on the left), who is a keen amateur photographer, lent me a medium-format camera to do this picture, since I had only 35mm with me. The light was perfect – never attempt something like this other than in the early morning or evening unless you have banks of reflectors or you are photographing in the shade.
MAMIYA 67; 90MM LENS; EVENING DAYLIGHT

Tim Maguire, PR and advertising consultant, 2003

Every planned portrait is an exercise in creative problem-solving. Tim's job is to come up with ideas for advertising and public relations. So the problem here was how to make a picture of a media person, beyond the obvious inclusion of computers and drawing boards? The creative person learns to think laterally.

I have occasionally considered making portraits of people by simply photographing their living spaces – which are often as much an analysis of their characters as a record of their faces (see also page 12). Tim lives in a very modern, minimal and designed flat that has featured in architecture and style magazines. So in some ways his living space is a portrait of him.

When I visited him to discuss the picture, I knew that it had to be made in his sitting room, but I wanted something rather more unusual than I would normally do. As often happens, conversation with the subject provided the trigger for an idea, and Tim mentioned in the course of a discussion why he has no pictures on his walls and that he has often considered the idea of projecting pictures on the wall above his fireplace. So this initiated a train of thought that led to the idea of making a picture of him on 35mm transparency in his sitting room and then returning on another occasion, projecting the slide and making the picture. I had intended to have an empty room with just the projected slide, but at the last moment decided to include Tim, but just his legs, so that there is a 'real' presence as well as a 'virtual' presence.

The picture was taken at dusk, when there was just enough light to illuminate the room, while allowing the projected image to record. It was shot on tungsten-balanced colour negative film. This meant that the weak daylight would be very blue in colour, while the projected transparency (being tungsten) would record as neutral or slightly warm. The colour is not a distortion here because his floor and ceiling spotlights are filtered in any case, to provide a blue light. In fact there are four balanced light sources here: daylight, tungsten light, the projector and the fire.

The picture is about image, style, representation, ego, and projecting an image (metaphorically as well as literally). With the implication that the image could change at the press of a button.
Nikon; 85mm lens; Fujichrome Astia; one studio flash and daylight
Hasselblad; 80mm lens; available light; Fujicolour NPL

the tools

equipment and perspective

It is perhaps sad that, with the exception of film and video, photography is the art that is most dependent on technology. This has always been its Achilles heel and has led to a considerable amount of confusion over its status throughout the last 160 years, since this technology has so many functions – scientific, social and so on – besides its artistic application. Envy the writer who needs just a pencil, or the painter who needs only a paintbrush. This fact can also lead to an unwholesome fascination with the hardware and some of the more macho aspects of the medium. Why is it that most photographers are still men? Why is it that so much of the language of photography is macho? We talk about 'shooting'; 'firing' the shutter; tungsten lights are described as 'blondes' and 'redheads'.

Equipment obsession often goes in phases. At the outset of a photographic career there will be a major concern for what is the right camera, and the temptation to spend a lot of money, in the mistaken belief that this will produce better pictures. This is often followed by a period of ignoring equipment entirely, occasionally even taking a perverse enjoyment in disregarding its importance altogether. Sometimes there is a third phase, though, when interest is restored, based on experience and an understanding that a particular piece of equipment can suggest new possibilities of picture-making.

⬅ George Bruce (with his son, David), Poet, on the Occasion of his 92nd Birthday, 2001
A classic constructed location portrait. Here I used principally available light, but with a silver cloth reflector on an adjustable stand to direct light into the shadow side of George's face. As usual I have used a fairly wide aperture to subdue the background. There is another picture from the same session on page 21.
HASSELBLAD; 80MM LENS; DAYLIGHT; ILFORD FP4

cameras

As the basis for picture-making, choice of camera is clearly the most important decision to make. Probably all photographers have a 35mm camera, and the SLR is the most versatile, with its wide range of interchangeable lenses and the fact that what you see in the viewfinder is what will be recorded on the film. Remember, though, that you are viewing and focusing at full aperture – when the shutter is pressed, the lens stops down to the taking aperture, so that objects that you may think are out of focus will be sharper (watch that lamp-post growing out of someone's head). As has been discussed on page 50, the compact camera has its place for its portability and ease of use.

I have an antipathy towards overly complicated cameras, preferring a simple, no-frills tool that is reliable, with a good lens and an accurate, perhaps centre-weighted, meter. The more choices you have in terms of camera settings, the more you will be thinking about that instead of what's in front of the camera. It's a sad fact that, in general, technology has not improved the quality of art. It has allowed a basic technical standard to be accessible by many, but can we really say that it has provided us with more portrait artists of the standard of Bill Brandt and Irving Penn in the 20th century or Julia Margaret Cameron in the 19th?

35mm

The 35mm camera is the ideal tool for spontaneous and intuitive picture-making. It is relatively small and unobtrusive and its ubiquity means that it appears to be non-threatening – you may not look like a serious professional, unless you are festooned with two or three cameras plus a flash gun, or own one of those big vulgar SLRs with built-in motors and enormous autofocus zooms that cost a fortune. Working on 35mm you will probably use a lot of film, 'shooting' round the subject and leaving a great deal of the creative decision-making until you start editing your contact sheets. Of course you can employ a more studied approach with 35mm, but its speed and ease

David Williams,
Photographic Artist and
Teacher, 1992
This 'snap' was taken while Dave was working on a major body of work using SX70 Polaroid. It is mildly astonishing that, given the contrast created by photographing towards the sun, the film has maintained detail in both sky and shadows with no reflector.
NIKON F2; 50MM LENS; DAYLIGHT; ILFORD FP4

⊙ **Seonaidh Charity, 1992**
This is my friend John
Charity's son, taken in
Ullapool in the far north
west of Scotland. 35mm is
the ideal tool for making
spontaneous photographs
of kids. It's fast and non-
threatening, especially if
used without a tripod or
additional lighting. With
careful exposure and
processing, it's capable
of remarkable quality.
NIKON; 50MM LENS; DAYLIGHT;
ILFORD FP4

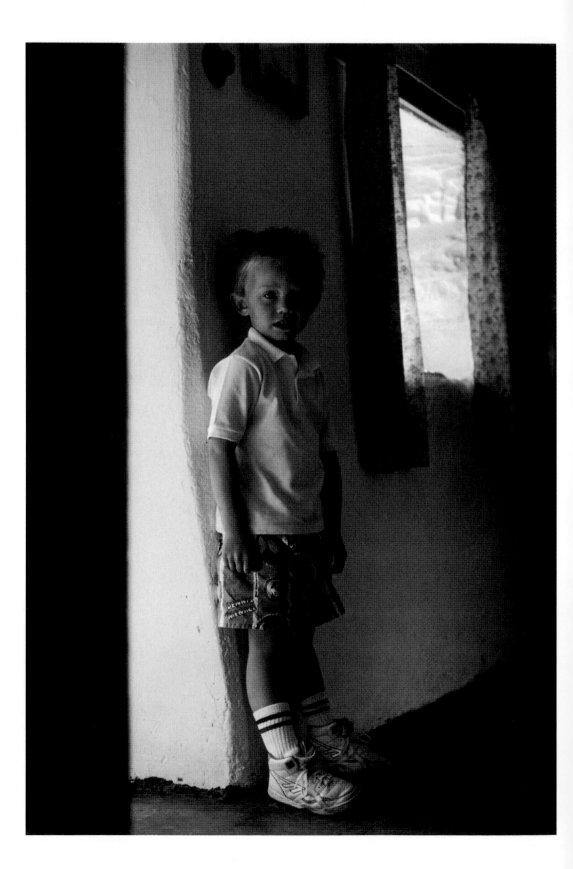

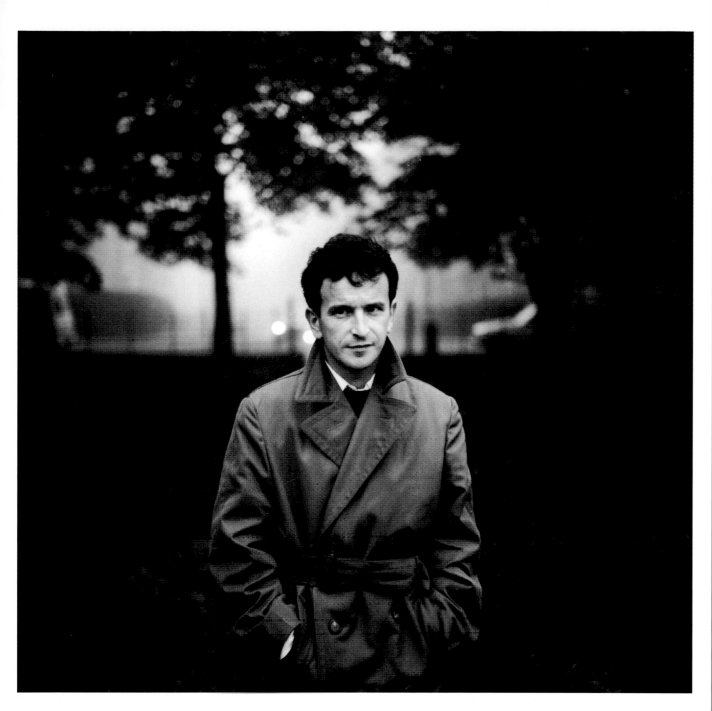

⬆ Brian McCabe,
Writer, 1992
As a personal preference, I
use a square-format camera
and rarely crop from the full
negative. I like the shape and
don't need to make the
decision at the taking stage
whether I should hold the
camera for a vertical or
horizontal picture.
HASSELBLAD; 80MM LENS;
DAYLIGHT; ILFORD FP4

of use almost seems to militate against a more thoughtful approach at the picture-taking stage.

medium format

Bigger negative, bigger prints, better quality. This is true not just in terms of sharpness, but tonality – that is, the ability of the negative to render a long range of tones in the print. So, if you intend to make prints bigger than A4, you will really see a difference if you use medium format. There is more to it than this, though. The larger format will slow you down and make you think about the picture more. The camera will probably be on a tripod, since not many of them are easy to hand hold.

There is a variety of formats available on 120 film, ranging from 6 x 4.5cm, producing 15 exposures, through to 6 x 9cm, producing 8 exposures. The choice is yours – the larger the negative, generally the bigger the camera and the less easy it will be to hand hold it. Personally, I use a 6 x 6cm camera. I like the square format, and the camera is always the same way up so that I don't have to decide at the taking stage whether it's a horizontal or a vertical picture. A variety of

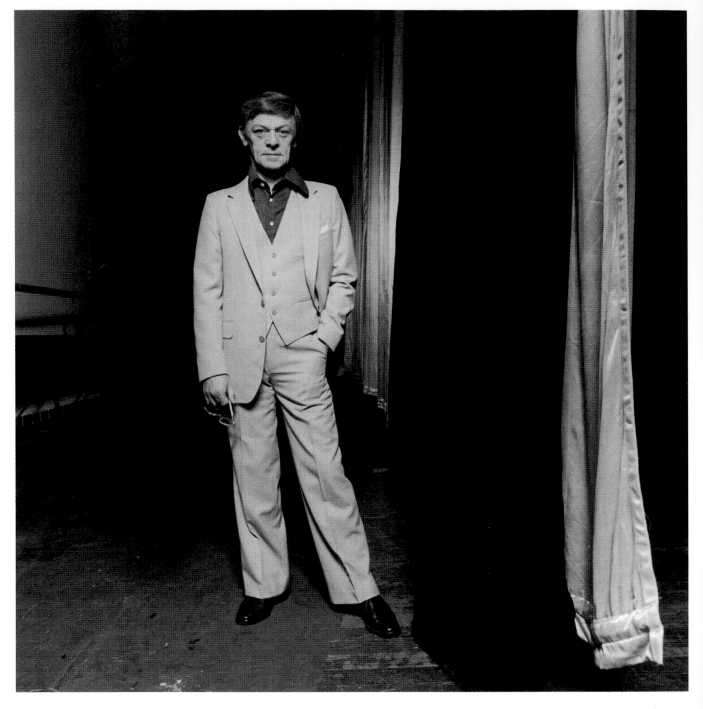

⬆ **Russell Hunter, Actor, 1976**
This was one of my earliest constructed formal portraits. I used one studio flash head with an umbrella, mixed with a little ambient light. Again, this was composed very much within a square format. Although I have upgraded lenses and the focusing screen, I'm still using the same camera body.
HASSELBLAD; 50MM LENS; ONE 800J FLASH HEAD; ILFORD HP5

viewfinders is available for most 120 cameras. I use a non-prism magnifying hood with eyepiece correction adjustment because my eyesight is failing with age. I find it easier to compose the picture directly on a ground-glass screen, despite the fact that the image is reversed, rather than use a prism where you can view 'straight through'. It's a matter of personal preference.

I think if I were starting photography over again on a budget, the camera I would buy first would be a secondhand Rolleiflex twin-lens reflex. It has a fixed lens and there is a slight discrepancy between what the viewing lens sees and what the taking lens sees (parallax). But it is a beautiful camera of the highest quality, and very simple. You will not be distracted by having to make a decision about lens choice – because there is no choice. Many photographers like to simplify their equipment and restrict their options, providing a purity of vision that allows them to concentrate on the subject.

One major advantage of 120 cameras over 35mm is that most of them (though not the Rolleiflex) will

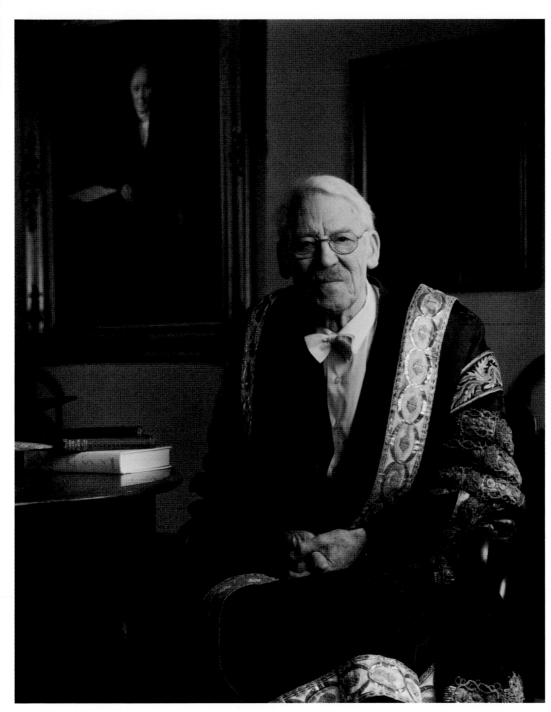

◀ **Sir Kenneth Dover,
Chancellor, University of
St Andrews, 2001**
This was a commission,
intended to have its final
realization as a large framed
print to be hung in the
University. The quality and
formality of large format
seemed appropriate for this
very traditional portrait. I
asked Sir Kenneth to choose
some texts to be placed on
the table beside him, and one
of them is an early edition of
Winnie the Pooh.
TOYO 5 X 4IN; 210MM LENS; ONE
800J FLASH HEAD WITH SNOOT IN
BACKGROUND, ONE 1,500J FLASH
HEAD WITH SOFTBOX; ILFORD FP4

take a Polaroid back. In my opinion, this is the one
technological advance made over the last 40 years
that has really helped the creative process in
photography. The fact that one can test lighting and
exposure, and have an instant hard copy to check
composition, is an immense release for a medium
where there was previously a relatively long time gap
between clicking the shutter and seeing the results.
Polaroid has allowed for more experimentation and
considerably less stress, as you can be fairly sure that
you will get a result.

large format

Why on earth would one want to use a 5 x 4in or
even a 10 x 8in for portraiture? They are large,
cumbersome, expensive to buy and to run, the
image is dark and upside down (unless you buy a
reflex hood), and you cannot see the screen as you
take the picture. Everything I've previously said
while comparing 35mm with medium format is
even more true when comparing 120 with 5 x 4in.
It goes without saying that the quality is superb
and enables extreme enlargements. It most

certainly slows down the picture-making, so that each exposure is highly considered. Having said that, my friend and former colleague, Pradip Malde, a wonderful photographer who now lives in Tennessee and works on 10 x 8in, uses it as most people would a 35mm camera – totally spontaneously, and at an astonishing speed. You'll find some portraits of him in this book.

One of the special by-products of large format is that depth of field is restricted, so that even with a standard lens and a full-length figure it is possible to have the background well out of focus if you wish.

With swing and tilt movements (a full explanation of which is outside this book's remit – see Further Reading, pages 140–41) it is possible to change the plane of focus so that, for example, with a standing figure you can have the head sharp and the feet out of focus. A bit gimmicky, perhaps, but it can have its uses if employed with discretion.

A portrait session made on large format becomes an event in a way that it is not on 35mm or even 120. There is a formality and gravitas in the process, and you will probably find that you take very different pictures as a result. The process requires much more discipline

➔ **Dominic Cooper, Writer, 1987**
This portrait was made on the Ardnamurchan peninsula where Dominic lives. I was interested in making a formal and disciplined portrait at a time when I was considering using 5 x 4in much more, in order to slow me down and allow me to think about the image more carefully before I made an exposure. I used a Polaroid film, which provides a negative as well as a print – handy when you are on location for any length of time.
TOYO 5 X 4IN; 210 LENS; DAYLIGHT; POLAROID 55

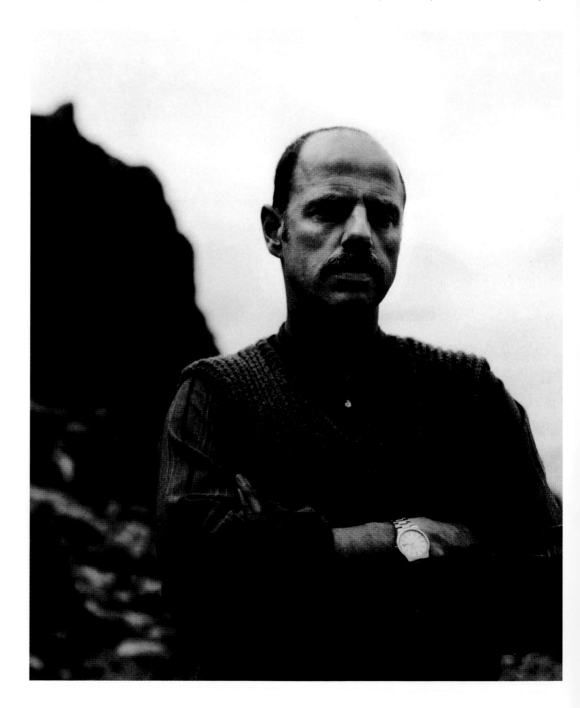

from both photographer and sitter, and the photographs will probably be highly orchestrated, posed and serious.

digital

As pixel numbers increase constantly, so the quality of digital cameras relentlessly improves; at the time of writing there are cameras with chips that will cover a full frame 35mm. Probably by the time you are reading this, discussions about relative quality of 35mm film and 35mm digital will be academic. At the same time the price is coming down, although a top-of-the-range digital camera with a laptop and software will cost the same as an extensive Hasselblad outfit.

Digital 35mm cameras are now the industry standard for newspaper photojournalists, partly because of the speed with which images can be downloaded and sent from anywhere in the world to picture desks; partly because of ease of use; and partly because of low running costs. Having said that, while there are no film costs, the technology is such that equipment needs to be constantly upgraded – digital is a black hole that sucks up money. I use a Hasselblad that is 20 years old and I know that it will not become obsolete unless manufacturers cease to produce film. With digital you constantly need to upgrade hardware and software (although I have a feeling that this will bottom out in a few years' time as digital cameras become capable of surpassing the resolution of the lens – at least in 35mm). In the design and advertising sector, art directors still prefer transparency film, although this is changing, with a move towards colour negative and the recognition that digital can considerably reduce their costs in scanning images for print.

Digital backs for 120 cameras and large format are still prohibitively expensive, except for professional studios with a large throughput of work. For further discussion of the wider issues surrounding digital outputting, see page 136.

⬆ **Elizabeth Woodcock, Writer, 2003**
Digital really comes into its own when you need a picture quickly. This is a PR picture for a friend. She arrived at the flat, we did the pictures, downloaded them, made a few adjustments and she walked out with a CD, all within one hour. End of job – no processing, no waiting, no stress, and no cost.
NIKON D100; 85MM LENS; THREE FLASH HEADS AND A REFLECTOR

George Hughes, Celebrity, 1995

There are very few famous people in this book. Some portrait photographers collect pictures of celebrities, which are of interest to a wide audience and clearly marketable. Sadly, but understandably, an indifferent picture of a celebrity is more sought-after than a good picture of an ordinary person.

The BBC had contacted me with a view to including me in a television series about Scottish art, involving a variety of different artists working in different media, and targeted at schools. As part of the programme they wanted me to select a personality and make a photograph. We talked about who the subject might be, and I began to think about the nature of fame. It occurred to me that if you are 10 or 11 years old, the famous people in your life are probably not the same as for grown-ups. So I thought of the crossing patrol man at my son's school (the 'lollipop man'). To the children, parents and staff at the school he is famous – and rightly so. He's everybody's friend, takes his duties seriously, takes the time to listen and knows the names of almost all the kids. A special person. And famous to the children.

The obvious approach would be to put George in the context of his job – with the children outside the school – but this wouldn't tell us anything we didn't know. I decided to show a more private side of him, at home relaxing with a cup of tea between shifts, as a means of providing more information about him.

This is a highly constructed portrait. Virtually everything has been placed, with George at the centre. The teddy bear and the person in the child's picture (signed Robyn) are both looking at him and, with the framed snap top right, create a diagonal composition and imply that he is a grandfather. There is a model of a lollipop person on the fridge. The blinds have been partially lowered to prevent too much white at the top of the picture, and the flowers have been included, suggesting – along with the view of the roof garden – that he's a keen gardener.

Lighting was with two flash heads. One was bounced off the wall on the right, and the other from the rear as an accent light on the back of his head, suggesting the light from the door. The lighting and George's central placement connote somebody of status. The way he is leaning towards the camera, head tilted slightly to one side with his mouth slightly open, suggests he is engaged in friendly empathetic conversation.

This is a picture *of* a lollipop man, but it's *about* humanity.

Hasselblad; 80mm lens; two studio flash heads and daylight; Ilford FP4

lenses

You will probably read in some manuals that there is such a thing as a 'portrait lens'. Usually it is considered to be about one and a half times or twice the focal length of a standard lens. Clearly this is nonsense. Any lens can be a portrait lens – if you make a portrait with it, it's a portrait lens. Having said that, if you are doing a head and shoulders, you will find that the perspective will appear to be distorted if you use a lens that is too short or too long. Too short, and the nose will appear to be too big compared to the ears; too long, and the face will appear to be flattened. This only really matters if your intention is to make pictures that are 'realistic' and/or flattering. This may not be the case.

distance from your subject

What is more important is the effect that the focal length has on your proximity to the subject. Let's say that you are making a half-length portrait. You may commence with a so-called portrait lens, allowing you to work at a distance of say, three metres (ten feet). This is comfortable for your subject, who won't feel threatened by the camera, but it lacks intimacy. The resultant picture *looks* remote from the viewer and suggests that the portrait was made without any close communication. If you are working close to

your subject – perhaps two metres (six and a half feet) or closer – with a standard lens, there will be a feeling of intimacy: you are within whispering distance, and that intimacy will be apparent in the final image due to the increased perspective.

Recently I bought a new lens for my Hasselblad. I had previously owned only a 50mm (medium wide angle), an 80mm (standard) and a 150mm (medium telephoto). Most of my portraits are made using a standard lens with the occasional use of a 150mm for head and shoulders. For a long time I wondered about buying a 250mm, but couldn't really justify it in terms of usage. These are after all, expensive pieces of glass. The purchase was precipitated by a particular project (not a portrait) that I wanted to do that required the perspective of a relatively long telephoto. It occurred to me that it might be interesting to use it for some portraits – it might provide a new perspective (so to speak) – a new way of seeing. So I used it on the portrait of Steve Earle, the American rock and country musician (opposite). While I am relatively pleased with the picture, the experience was not very fulfilling. With this lens, I was about eight metres (26 feet) away from him – not conducive to any sort of normal conversation – and directions were confined to semaphore and shouted instructions.

⊙ **'Portrait' Lens Comparison**
You can instantly see the effects of different focal length lenses in this comparison. These are full-frame prints from 35mm negatives. See how the perspective changes, causing the face to become progressively broader.
1. Taken with a 35mm medium wide-angle lens.
2. Taken with a zoom at 70mm.
3. Taken with a 200mm telephoto lens.

⬆ **Steve Earle, Musician and Songwriter, 2003**
Steve Earle was giving a concert in Edinburgh and I suddenly decided to attempt to do his portrait. I'm a fan. I hung around the stage door until he appeared and he agreed to be photographed. I've never done that before and I don't think I'll do it again – I prefer to be more in control. The session lasted six minutes. Note the compressed perspective of the 250mm lens.
HASSELBLAD; 250MM LENS; DAYLIGHT; FUJI REALA

film

As may be apparent by now, I believe in keeping technical elements as simple as possible. So it is with film stock. My personal work is mainly in black and white. This is another area where one cannot separate theory from practice. What is your picture about? Time, place, memory, affection, physical characteristics, facial expression, body language, analysis of a personality? Only rarely is colour of relevance. Usually it's a distraction. Now I realize this is reactionary because most photographers would say that colour is what we expect; it's natural and realistic. However, I would maintain that you should make the positive decision to use colour only if you can consciously utilize its psychological, emotional or aesthetic qualities, or if a client demands it. If not, it has to be black and white. Whichever, you should be able to justify your decision, if only to yourself.

types of film
I don't really want to get into any sort of discussion about which is the best film – either black and white or colour. For what it's worth, I've had a rich and fulfilling life as a photographer always using the same film and developer for black and white – Ilford FP4 and D76 diluted 1:1. Rate it at 80 ASA and develop it for ten minutes. Find a film and developer combination that works for you and stick to it, unless somebody can really persuade you that there are significant benefits to be had from changing to something else.

For colour films, the technology changes so quickly that I have to keep asking professional friends about what the best films are. Don't lose any sleep over it. A decision does have to be made about whether you work in colour transparency or negative. If the final realization will be as a colour print, then almost certainly the obvious choice will be negative, although if it is to be a digital print, some people prefer to scan from transparencies. For publication, transparency is still the industry standard for the best quality, despite recent inroads being made by colour print and digital originals. Transparency stock though, is much less forgiving in terms of colour balance, mixed lighting and exposure latitude.

Polaroid
As I said earlier, Polaroid has been significant in the technical development of photography. It's used mainly as a test for exposure, lighting and so on, but it can be an important medium in its own right. It is wonderfully releasing – none of that agonizing over exposure assessment or processing problems. You can really concentrate on what's in front of the camera without all that technical baggage. And, unlike digital, you get the final result – the hard copy – immediately. The digital image still has to be printed – with all that attendant uncertainty and anxiety.

Polaroid SX70 would be the medium of choice, and current technology is such that it is relatively easy to scan and print digitally to whatever size you like. Tragically, Polaroid discontinued their flagship SX70 camera some years ago in favour of their cheap automatic amateur models. The original SX70 was an

⊕ Professor Paul
Willemen, Film
Theorist, 2001
A friend and colleague at
Napier University. This was
taken during one of my
annual parties for students,
using a Polaroid SX70,
which is capable of very
long automatic exposures.
During a (hand-held)
exposure of several
seconds, throughout which
I waved the camera about
a bit, I manually fired a
flash. Paradoxically,
considering the control
I normally like to have, I
enjoy the unpredictability
of it.
POLAROID SX70; AMBIENT LIGHT
(CANDLES), METZ FLASH GUN

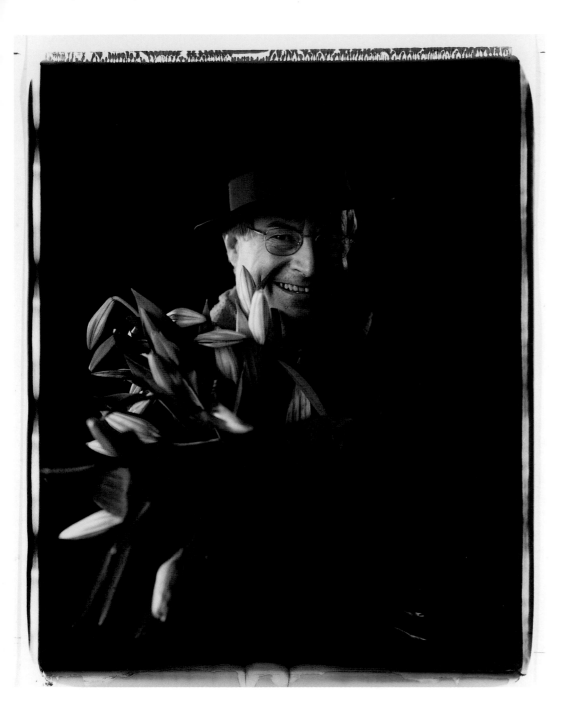

← Robin Harper, Green
Party Member of Scottish
Parliament, 2001
It was a delight to photograph
Robin in the foyer of the
Scottish National Portrait
Gallery in Edinburgh using the
amazing 20 x 24in Polaroid
camera. It's a very simple
picture – how else to portray
him but with his trademark
floppy hat, a broad smile and
a bunch of flowers?
POLAROID 20 X 24IN; ONE 6,000J
FLASH WITH SOFTBOX, ONE 3,000J
FLASH WITH SNOOT FROM REAR

eccentric-looking folding camera that was autofocus (overrideable) and could make exposures of up to 20 seconds. Some photographers use it almost exclusively for gallery-led work. Luckily there are still plenty of them around secondhand and cheap. The major downside is the expense of the film and now, sadly, Polaroid's uncertain future because of the inroads of digital capture.

Some years ago Polaroid commissioned several giant cameras. These are astonishing machines that make Polaroid pictures measuring 20 x 24in. They can be hired by photographers for a fee or used by the invitation of Polaroid. Recently I was one of a few photographers who were invited to use one for a morning, and it was a wonderful experience. Imagine looking at an image on a 20 x 24in ground glass, making an exposure and peeling off the backing to see an image of staggering quality two minutes later.

In recent years, Polaroid has been marketing various alternative processes like 'emulsion lift' and 'image transfer', where you basically transfer the Polaroid image on to watercolour or other types of paper: interesting for some applications, but a bit too gimmicky for my taste.

lighting

⊙ Louisa Burnett-Hall, 1988
This was a studio portrait,
intended to be as flattering
as possible, but with simple
lighting: a flash head with
softbox above the camera,
with a white reflector angled
up from below, plus one
other flash head with a
snoot, adding some light to
the drape on the right. The
print has been diffused
slightly with black stocking
material over the enlarger
lens. There's a very different
portrait of Louisa on page 10.
HASSELBLAD; 150MM LENS; STUDIO
FLASH; ILFORD FP4

In the studio, photographers use electronic flash almost exclusively, and especially for portraiture. Here I am referring to studio flash units, not hand-held flash. Electronic flash is colour balanced for daylight (5,500 degrees Kelvin) and consistently so, unlike tungsten lighting, which can change colour temperature with age. Because the flash duration is relatively short, you can hand-hold the camera if you wish. In addition, unlike tungsten lighting, you can adjust the output of the flash units, often over 2 or 3 stops, without altering the colour balance. On the minus side, what you see with the modelling light (that is, the built-in, low-powered, tungsten lamp that gives you a visual impression of

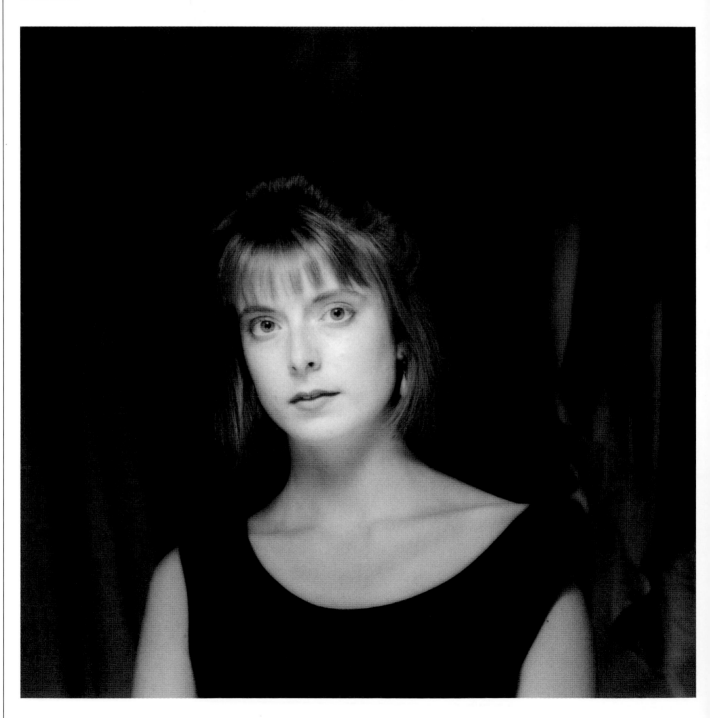

⊙ Louisa Burnett-Hall, 1988
This was a studio portrait, intended to be as flattering as possible, but with simple lighting: a flash head with softbox above the camera, with a white reflector angled up from below, plus one other flash head with a snoot, adding some light to the drape on the right. The print has been diffused slightly with black stocking material over the enlarger lens. There's a very different portrait of Louisa on page 10.
HASSELBLAD; 150MM LENS; STUDIO FLASH; ILFORD FP4

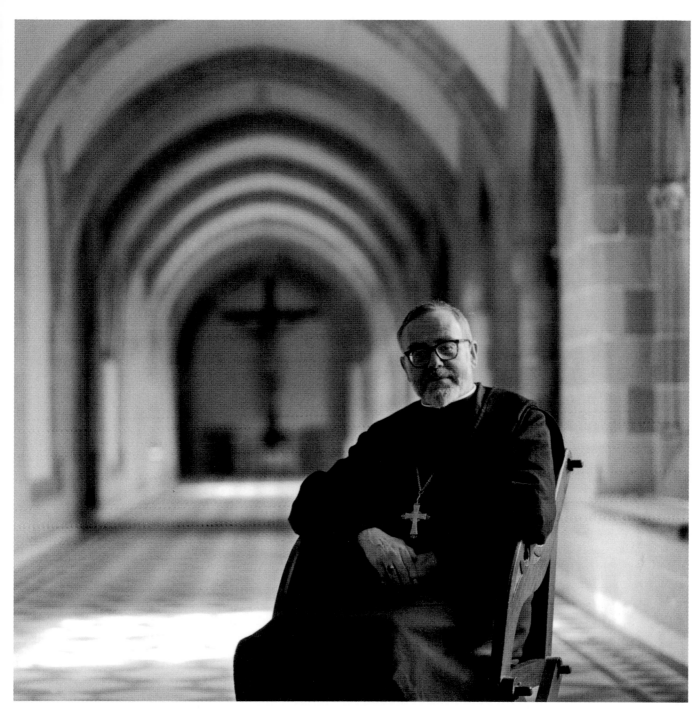

what the light from the flash will look like) is not exactly what the flash will give you, especially if you are using snoots, which are cone-shaped attachments on the front of each flash head that provide a narrow circle of light, rather like a spotlight. There will be no apparent difference between what the modelling light shows and what the flash actually provides if you have softboxes attached, which give even, soft light. Flash heads are more expensive than tungsten, but there is a good secondhand market and I'm still using flash

equipment that is 15 years old. On balance, in my opinion, there is little contest between flash and tungsten for most purposes, although a few photographers swear by tungsten for the edge it has on control of the light.

For some years I worked with only two lights, which I used for both studio and location work. In the studio I would use one head for the subject and the other one for the background. It is still the case that most studio portraits can be made with just two heads, or even only one, although if you are getting

⬆ **Fr Mark Dilworth, Abbot, Fort Augustus Abbey, 1994** When travelling some distance for a commissioned portrait, it's important to be prepared for all lighting eventualities – so the car was loaded with almost the whole studio. In the event, I used all natural light. I'm afraid only experience can tell you when to use additional light and when to recognize the qualities in the existing light.
HASSELBLAD; 150MM LENS (WIDE OPEN); AVAILABLE LIGHT; ILFORD FP4

⊙ **Martin Kennedy, Photographer, with his Scooter, 1990**

A rare example (for me) of highly complex lighting involving four flash heads. The patch of light on the background has been carefully placed to define the dark shape of Martin's head and shoulder. But sophisticated lighting can be achieved with far fewer lights, and with complex lighting there is the danger that it's all you see.
HASSELBLAD; 80MM LENS; STUDIO FLASH; ILFORD FP4

into more sophisticated lighting set-ups with complex backgrounds, you will need more.

If you are a beginner in the studio, my advice would be to keep it simple – one light plus reflectors. However many heads you use, it is important that all the flash heads used in the studio for portraiture are the same power, with the appropriate modelling lights also of the same power. As you alter the power of each flash, so the modelling light varies in proportion. This way you will have a reasonably accurate visual impression of the balance of your

lighting. Flash heads for portraiture need not generally be very powerful – 800 joules are adequate for most purposes.

lighting stands

In addition to the heads themselves, you will need stands. It's best to buy lightweight ones that will do for both studio and location, and a range of reflectors, barn doors and softboxes. As I've mentioned, I have an almost perverse tendency towards using minimal equipment and an antipathy

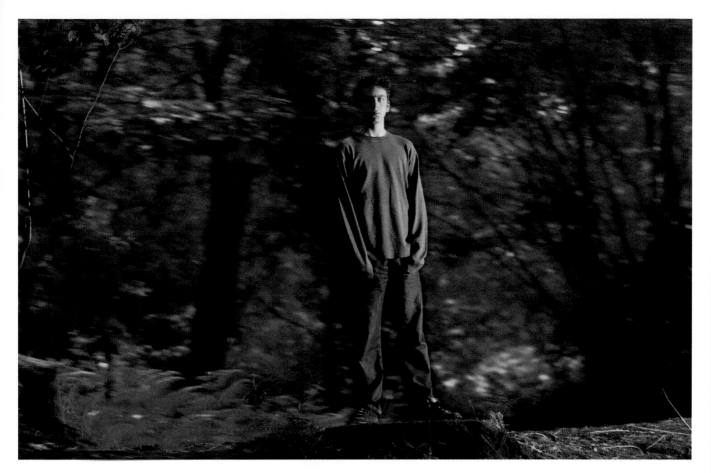

to gadgets, but I did recently buy a very useful accessory – it's a stand that is designed to hold collapsible reflectors in almost any position. Goodness knows why I've denied myself this small luxury all these years. Besides that, if you are working in the studio, you should try to purchase spare stands for attaching additional reflectors, drapes and so on. You can't have too many. A boom stand is useful for positioning a light directly over the subject.

The same lights can be used for location work, although you will need a carrying case. I have an additional small kit of three low-power flash heads (about 400 joules), with stands, barn doors and a small umbrella reflector. This fits into a case about 60 x 25 x 45 centimetres (24 x 10 x 18 inches). It also has the very useful facility of plugging into a car battery.

hand flash

I very rarely use a hand flash. For most quality work it is important to see what the light is doing, and this is impossible without a modelling light. Hand flash is necessary outdoors, however, unless you have units that will plug into a car battery, or you use a

generator. On the occasions when I have used hand flash, I've put it on a stand and connected it to the camera with a long extension cable. Unless you use Polaroid, it takes experience to judge what the light is doing. I have recently acquired a radio flash trigger, enabling a flash to be fired at great distances or behind walls. It's not cheap, but it's a good example of new equipment providing fresh picture-making possibilities. Flash on-camera rarely produces satisfactory results unless mixed with ambient light.

other things

You will definitely need an exposure meter that reads both flash and ambient light, with reflected and incident light modes. There are some excellent, reasonably cheap digital meters on the market. And don't forget the essential kit bag of clips, clamps, tape, and a white sheet to lay on the floor or pin to the walls as a reflector. In addition, no self-respecting location photographer would be without a large sheet of black velvet in their car for hanging on walls as a 'minus' reflector, covering windows and myriad other uses.

⬆ **Roberto Wilson, 2003**
A picture of my son practising to be a rock star. One flash gun has been positioned far to the right of the picture and about 20 metres (65 feet) from the camera, triggered by a radio-controlled slave. The ambient light has been underexposed by about 1 stop (see page 107) and the camera deliberately shaken during the exposure of about 1/15 second. You can see that the shadow side of Roberto's face is blurred, while the light side is sharp due to the short flash duration.
NIKON F3; 80–200 ZOOM (AT 200MM); METZ FLASH GUN MIXED WITH DAYLIGHT; FUJI REALA

Pradip Malde,
Photographer and Teacher, 1994

There are some people that I have photographed many times over the years – close friends I have ready access to and want to celebrate. There are a few pictures of Prad in this book made over a period of a decade, principally when we taught together at Napier, although this portrait was made in Tennessee some time after he moved to the States to teach. He was an immense influence on me and the students who were lucky enough to have been taught by him. He is one of the most innately creative people I know.

You know how it is: you are with a close friend, the atmosphere is conducive, and you have time on your hands. You are receptive. You then identify the possibilities of the location, in this case Prad's house, where there was good natural light. Prad works on 10 x 8in and makes exquisite platinum prints – expensive and complex. Somehow it seemed absolutely appropriate and conceptually neat to do his portrait using his own camera, just as Imogen Cunningham did with Alfred Stieglitz in 1934. (Interestingly and coincidentally, Prad had just completed a monograph on Cunningham illustrated with his platinum prints from her original negatives.)

When options are reduced and you have to make do with what is available, you should make it work for you. If I had used a battery of studio lights, I could not have effectively reproduced this wonderful light. In the event I didn't even use a reflector.

There was a large window on the left side, creating soft side light. This was 'filled in' by a window far off to the right, with a little bit of light from an open door behind the camera filling in the front of his face. Then there was the curious small window in shot in the background that's providing an accent highlight on his head. Perfect. The light source in shot is a device that you may notice several times in this book. It provides a reference pure white, allowing the tones throughout the rest of the image to be printed as dark as you like without the whole print appearing muddy.

I made two exposures. With large format most people take a different sort of picture – highly formal and constructed. I felt constrained by the fact that it was Prad's film I was using and 10 x 8in is expensive, so I had to get it right. I love that discipline (although I would be terrified if I could only make two exposures, with no Polaroid, for a commercial assignment).

This portrait is about gazing, making, light… and teapots.

Deardorff 10 x 8in; 300mm lens; available light; Kodak T Max 400

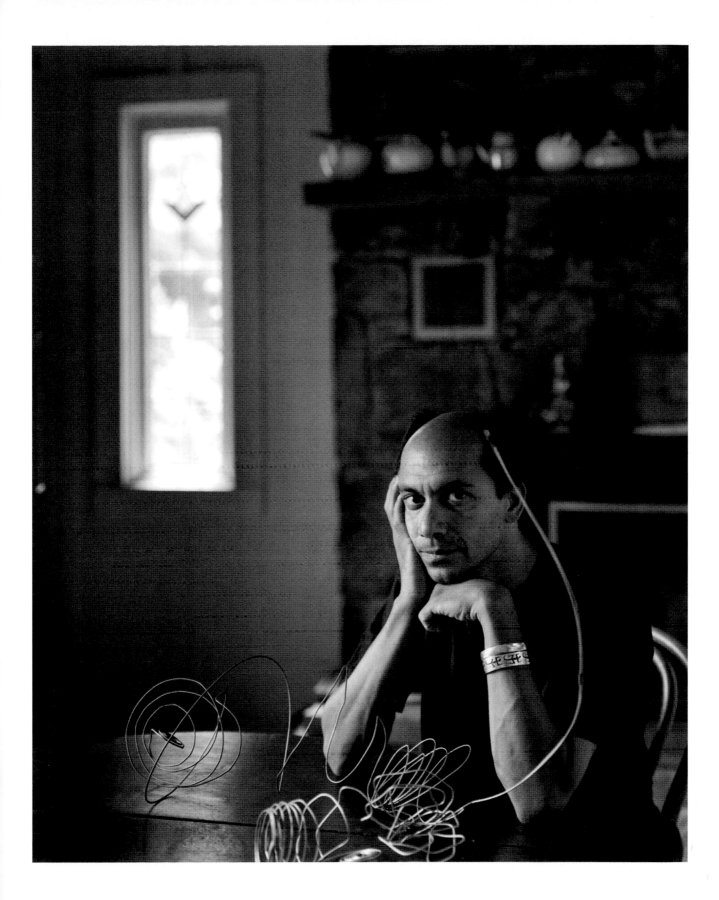

the importance of light

A photographer's major creative tool is light. No, not Photoshop, not filters, and certainly not cameras, although on occasions all of these can be helpful. But all photographs, by definition, need light, and it is your ability to use it or manipulate it that is one of the main ingredients of a successful picture. You could argue that such notions are old hat these days, that ancient values of photographic aesthetics, like composition and lighting, were buried with modernist formalism in the 1960s, and that it is the idea, the content, that rules today. There is, and has been for two decades, an anti-craft ascendancy pervading a great deal of editorial and gallery-led photography. It is true that sometimes an overly seductive aesthetic – work that is visually slick – can distract attention from the message, but, at the opposite extreme, the ineptly executed and banal image will often be too tedious visually for the viewer to bother attempting to engage with the idea. There is, as usual, a middle way: a marriage of elegant form with eloquent content, each supporting and sustaining the other.

weighing up options

In the previous chapter I said that when it comes to camera equipment you should keep it simple: remove as many options as possible. The problem with lighting on location is that you have a lot of options – so there are decisions that have to be made. In the case of the spontaneous portrait this isn't a problem – you will generally, of necessity, just be using available light. But if you are doing a planned portrait in a given situation, you will have to decide whether to use purely available light or add reflectors (and if so, what type), or use supplementary lighting mixed with ambient light, or light the portrait completely.

Technically, if your lighting contrast is too great (more than 3 stops with colour and 4 stops with black and white), you will need to use reflectors or a fill-in light, or risk losing shadow or highlight detail. Besides that, these are difficult aesthetic decisions to make, and all I can suggest (lamely) is that you use your judgment.

available light

Perhaps the majority of portraits I make, especially 'found' portraits (see Chapter 3), use available light. It is often the case that what prompts me to make a portrait is recognizing a special quality in the light itself. This is a shameful admission – what should always be your primary motivating factor is the wish to photograph the individual, not just the light. The reverse is also the case – however much I want to photograph somebody, I just wouldn't do it if the light weren't right. Knowing when it is right or not is really a matter of experience coupled with training your eyes. As a photographer you will know

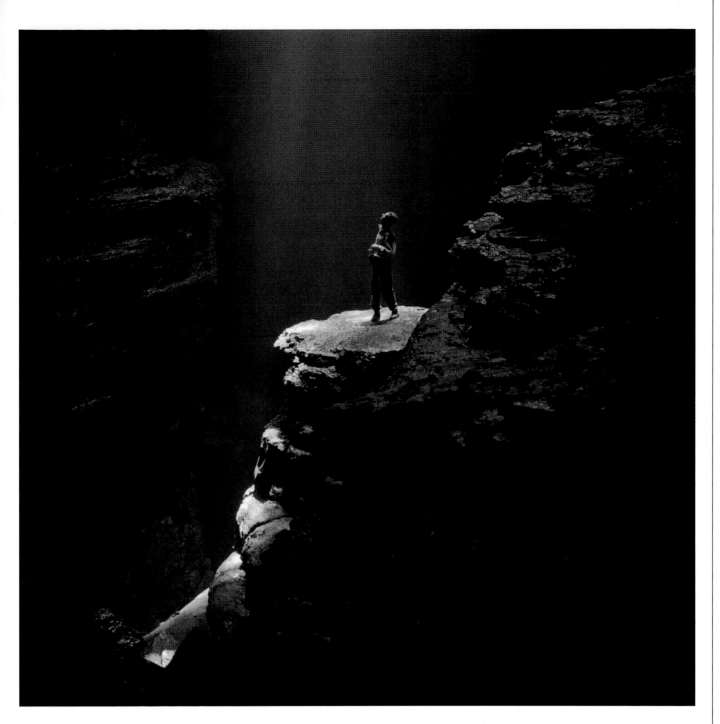

the importance of looking in a much more intense way than is usual. One of the things you should be looking at is light.

I don't do it so much now, but I remember that as a young and totally obsessed photographer, I would sit in bars or cafés with friends and totally lose concentration on what they were saying because I was analyzing the light on their faces: the effect of the sunlight coming through the window coupled with light bouncing off a mirror, for example, or where that catchlight in their eyes was coming from.

exterior shots

As I keep saying, there are no rules, but if you are working outdoors there are some guidelines to consider. You will generally want to stay away from midday sunlight, unless it is shaded. It's contrasty and too high, resulting in deep shadows in the eyes and a long nose shadow. You can take your subject into a shaded area, but there the light may be too flat, especially if you are working in black and white, which generally likes a bit of contrast. So try late afternoon or early morning for the most interesting light.

⬆ Pradip Malde, 1994
This dramatic cave is in Alabama. Sometimes you have to take a picture just because of the light. I don't think this says much about the subject – other than that he was brave enough to climb down to that promontory so that I could take this picture. Lighting contrast was very high and it was a difficult print to make. See also the portraits of him on pages 89 and 115.
HASSELBLAD; 80MM LENS; DAYLIGHT

◉ Bjorn and Jens Linus
Sterri, 1995
Soft side lighting from
an overcast sky produced
some nice modelling for
this portrait. The aperture
was deliberately kept wide
open to focus attention on
the child.
HASSELBLAD; 150MM LENS;
DAYLIGHT

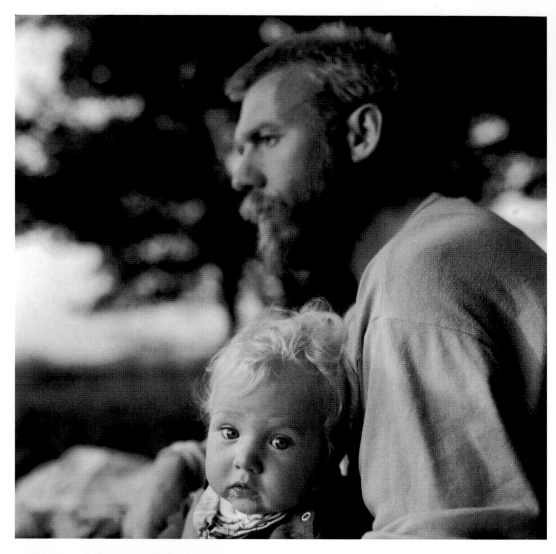

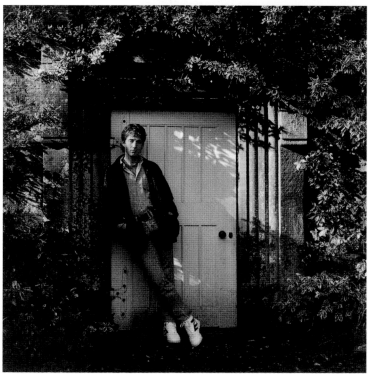

◉ Kane Rutherford,1987
Late afternoon October sun
created interesting light.
The contrast on Kane's face
has been reduced by
natural light bouncing off
the white door and the
light-coloured stonework.
HASSELBLAD; 80MM LENS;
DAYLIGHT

interior shots

The light from a large window on a dull day is hard to beat, and very difficult to reproduce with studio lighting. This is why portrait photographers like Irving Penn and Snowdon have used it extensively in their daylight studios. It's about simplifying things again, so that you are concentrating on the subject and not on nuances of light. Probably you will not be using available light in the studio, however, and you may not have large windows in your chosen location. If you are working purely with daylight, the best light is often with the subject slightly side-on to the window. Photographing towards the window is often good, but means you will need some fill-in from reflectors or flash. With the window behind you the lighting will be flat, with the light in the room falling off to darkness. Remember that the closer your subject is to the window the softer the light will be.

Available light indoors will often necessitate working in low light conditions. For some reason, a lot of photographers are frightened of this, thinking that you need a shutter speed of a minimum of

⊙ **Graham MacIndoe, 1988**
Here I've used natural window light with no reflector to maintain quite high contrast. I love that highlit curl of hair – it's the one thing that raises this out of the ordinary.
HASSELBLAD; 80MM LENS; DAYLIGHT

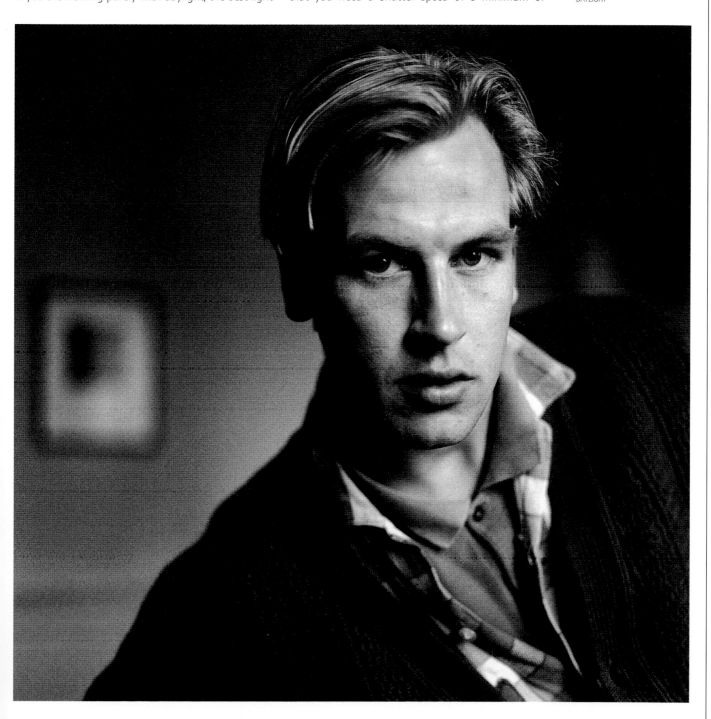

Calum Colvin,
Photographic Artist,
1993
Low light, hand-held, wide
open – it's not really sharp,
but sharp enough. The
light on his face and the
highlights in the
background accentuate
his profile and there's a
scintillating glint in his eye.
See also the more formal
portrait of Calum on
page 100.
HASSELBLAD; 80MM LENS;
AMBIENT LIGHT

1/30 second to guard against subject movement and camera shake, and an aperture of at least f/4 (on 35mm) to be sure of a reasonably sharp image. Be adventurous here: allow yourself to live dangerously. I have made portraits hand-held at 1 second and at full aperture that are acceptably sharp (OK, what is acceptable to me may not be to you). I don't think Robert Frank ever took a really sharp image and in his case it certainly doesn't matter. Naturally, you have to be sure to focus carefully and to rest the camera on a shelf or table if you are not using a tripod. One small tip: if you are hand-holding a 35mm camera, wear the camera across your chest like a bandolier instead of over your shoulder; then, when you bring the camera up to your eye, providing that the strap's length is adjusted properly, the strap will be tensioned across your back and the strap just long enough to allow you to get the viewfinder to your eye. In this way you are bracing the camera, not just with your hands, but with the strap too. Not very sexy, but it really does help you to hand-hold at a slower shutter speed.

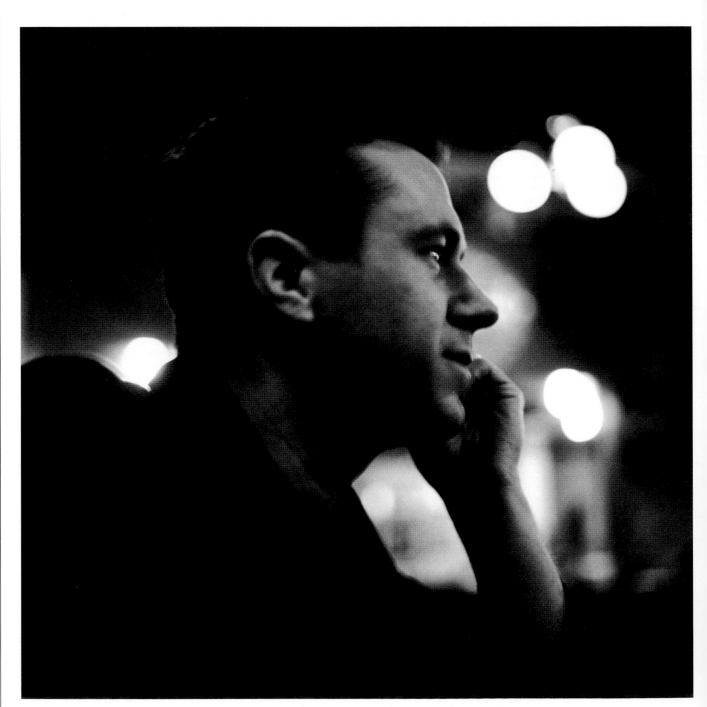

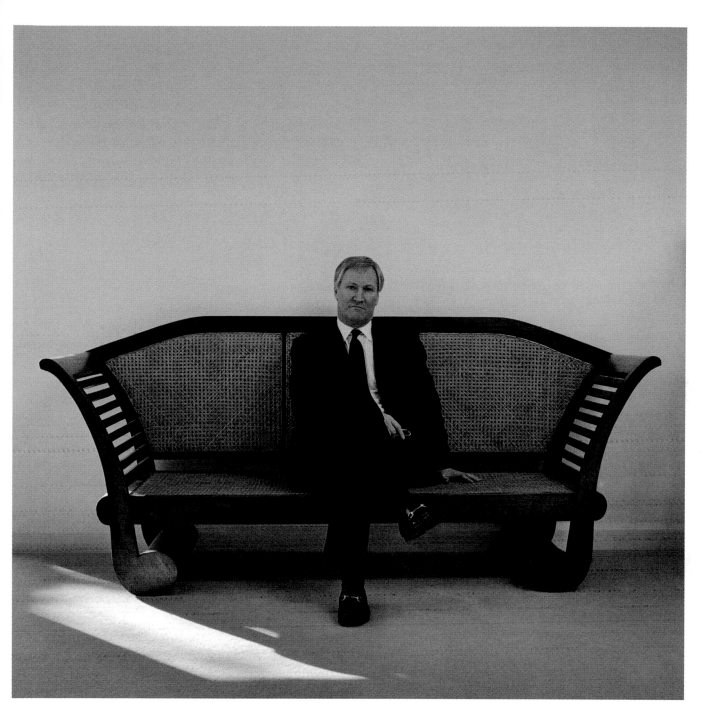

⬆ **Dr Brian Lang,
Principal, University of
St Andrews, 2001**
A minimal treatment for a
modern university principal.
He had just moved into his
house and it was almost
empty – a photographer's
dream. Plenty of space, no
clutter and beautiful light.
In cases like this, resist the
temptation to use
supplementary lighting,
providing that the contrast
is not too great.
HASSELBLAD; 80MM LENS;
DAYLIGHT

Michael Clark, Dancer, 1988

Michael Clark is well known in the UK as the *enfant terrible* of contemporary dance. This portrait, commissioned by the Scottish National Portrait Gallery, was made while he was in Edinburgh with his group performing one of his productions, entitled *I Am Curious, Orange.*

I managed to persuade a local ballet school to let me use their main studio for the picture and did some test shots a few days before the actual session. The studio had wonderful natural daylight – a gift, if soft, even light was required, but in this case it wasn't. I wanted a much harsher light, so I constructed two walls of black velvet attached to lighting stands at one end of the studio in order to create a shadowed area in which the subject would sit. Directional lighting was provided by a single flash head with a small softbox placed directly above the camera. It's the sort of lighting one might use for a fashion picture – the face becomes sculpted with the cheekbones accentuated. The lighting for most of my location portraits is constructed to look natural – gentle fill-ins usually. In this case, I wanted something more theatrical. In the event there were other fortuitous unpredicted effects: the eyes are partially shadowed with barely a catchlight, and the earring is highlighted. There is a glinting reflection on his slightly petulant lips.

The plan was that I would meet him for an hour before the session for a cup of tea and a chat, then stroll round to the studio and do the picture. I find it difficult to make a portrait cold of somebody I've never met. His schedule turned out to be too tight for that, so we were to meet at the studio. He was late and I had just 15 minutes to make the picture before he had to leave for his evening performance.

I was lucky that it was a dull day. It enabled a long (1/8 second, I think) shutter speed with the flash set to minimum power for a wide aperture to throw the background out of focus. The hanging ceiling lights become flying saucers flying out of his ears. I hand-held the camera to create a slight blur outlining his body while the instantaneous flash has rendered the centre sharp.

This has never been a picture with which I've had much empathy – obviously, partly because I never got to know him. He was just somebody in front of the camera, like a fashion model. In retrospect, paradoxically, that lack of communication probably produced a more meaningful picture. As the social psychologist Halla Beloff once said of this picture, '*Isn't* he a naughty boy?' Hasselblad; 80mm lens; studio flash mixed with available light; Ilford FP4

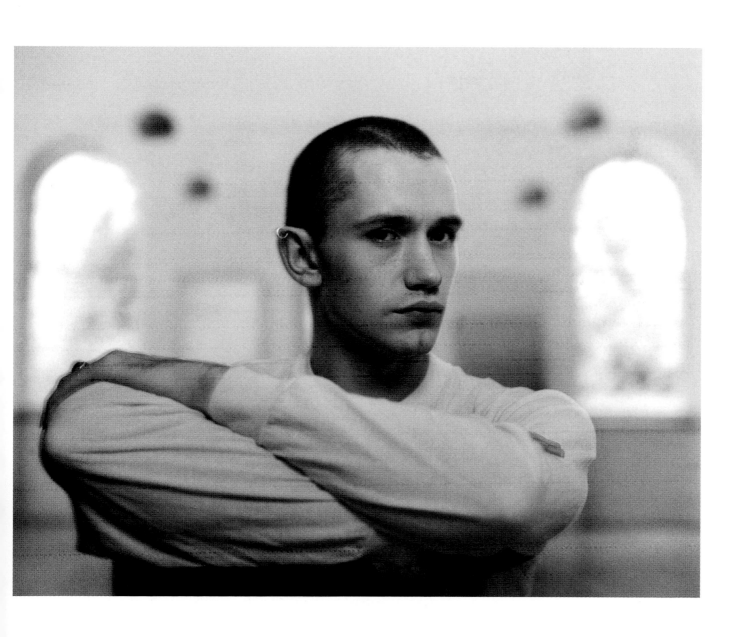

adding reflectors

Occasionally, available light needs a helping hand, and the simplest way to do this is through the use of reflectors. Here I'm going to deal with reflectors on location; reflectors in the studio will be dealt with on page 114. The problem on location is that you either need a stand of some kind to hold a reflector, or an assistant. Outside, it will usually need to be the latter – a one-metre (three-foot) diameter reflector can fly a long way if it's caught by the wind. There is a custom-made stand on the market that will hold circular, collapsible reflectors – it's very useful and portable and I generally pack it in the same case as my lights. There are two reasons why you may want to use reflectors: first, because the lighting contrast is too great; and second, to provide emphasis for a particular area of a picture.

reducing contrast

If the difference in exposure between an incident light exposure reading taken in bright areas and one taken in the shadows is more than 4 stops in black and white or 3 stops in colour, you may lose shadow or highlight detail. You nearly always want highlight detail, unless it is just small areas, because the eye cannot happily cope with large 'burnt out' areas. You may well be happier with large areas of darkness with no detail. With experience you will be able to tell when you need a reflector and how close it should be

➔ **Carlo Menotti, Composer, 1984**
In this commission for a magazine, I used natural daylight from large windows in Yester House, near Edinburgh, where the photograph was taken, but switched on the table light to provide an element of warmth. There is a limited colour palette here, with a focal point provided by Carlo's red jumper.
HASSELBLAD; 80MM LENS; AMBIENT LIGHT

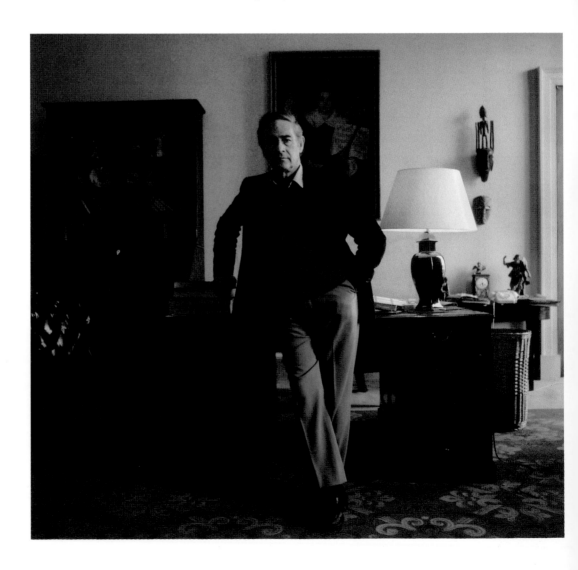

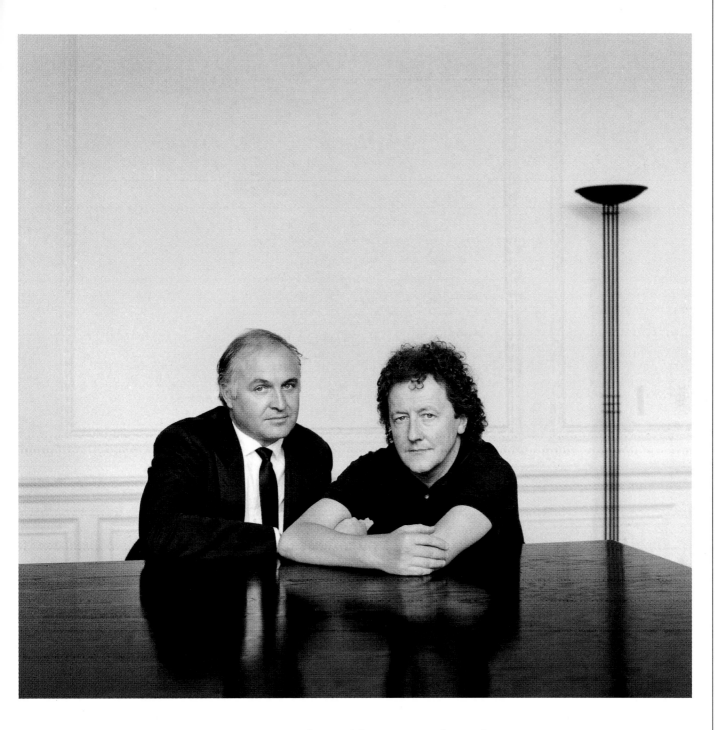

to the subject (obviously the closer it is, the more light is reflected into the shadow). If you are nervous, you could take exposure readings to ensure you have a balance of light that the film can cope with. The larger the reflector, the greater and more even the fill-in will be, so that the reflector will not announce its presence so obviously – it will just be a soft, even fill. I often put a couple of large white sheets in my bag, together with pins and clips to hang them, if I am working in a location where the walls are dark or strongly coloured.

changing emphasis

Reflectors used to provide emphasis will probably be silver: either custom-made silver cloth, or shiny silver board, or even a mirror, in that order of reflectivity. If you can't lay your hands on silver board or mirror board, silver foil crumpled and glued on to mounting board works well. These reflectors are more difficult to work with because the light they reflect is directional and can be harsh, depending on the quality of the light they are reflecting. Be very careful if you are using them to lighten a face.

⬆ **David Coates and Ian McIlroy, 1989**
Flat, soft, natural lighting contributes to the minimal composition. David and Ian are long-term friends and business partners in a design consultancy. David is the 'suit' and Ian is the 'creative'. Notice the careful positioning of the lamp with the corner of the table.
HASSELBLAD; 80MM LENS; DAYLIGHT

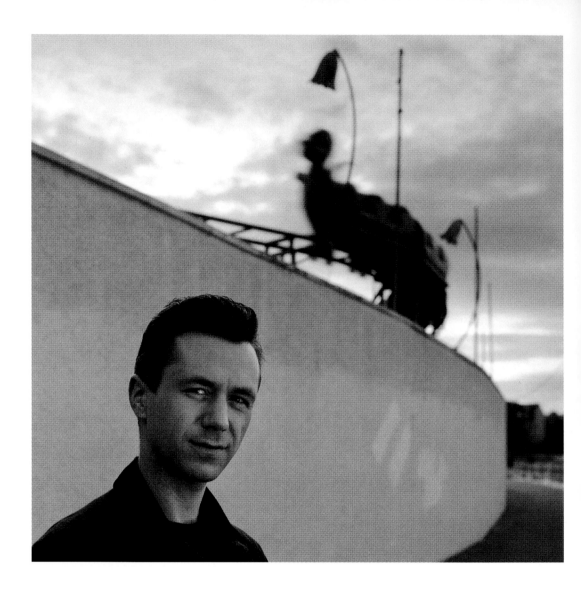

➲ **Calum Colvin, Photographic Artist, 1993**
A commission from *Portfolio* magazine. Usually I carefully calculate the direction of the light for a portrait. Here the hazy sun was in the wrong place, necessitating a reflector at the front to bounce light back into Calum's face. This was taken in Portobello, a fading seaside resort near Edinburgh. That's a funfair behind the wall. I paid the operator of the ride to keep sending it round the track, so I could only make one exposure every three or four minutes.
HASSELBLAD; 80MM LENS; HAZY SUNLIGHT AND ONE MIRROR REFLECTOR

choosing the best reflector to use

Whether you are inside or outside, the type of reflector you use will be determined by the effect you want and/or whether the light is harsh and contrasty, or soft as on a dull day. On a sunny day, a white reflector will be fine for punching light into shadows, but on a dull day you may need to use silver. In my portrait of Calum Colvin (above), I had a friend hold a mirror, about 30 x 50 centimetres (12 x 20 inches), just out of shot below camera level to reflect the overcast daylight behind him. This was a case of making the best of a situation where the sun was in the wrong place. You can see the catchlights in his eyes made by the reflected light from the mirror.

Occasionally you may wish to use a minus, or black, reflector – perhaps if you are working in a situation where there is too much light reflected off walls into the shadow side of a face, or where you want to increase lighting contrast, or even remove shadow detail altogether. Besides white sheets, I usually have some black velvet in my car for such a purpose (it's also handy for covering equipment if you are leaving it in the car).

Reflectors need not be black or white. If you are working in colour, shiny coloured card can be used to reflect coloured light into parts of the picture. You can also buy a gold-coloured collapsible reflector – great for giving a healthy glow to pallid northern skins, but use it with discretion.

mixing flash with
ambient light

The next stage in manipulating the existing, ambient light is to introduce additional light sources in situations where reflectors cannot provide enough controllable light: if there is only one lighting technique that you learn from this book it should be this. It really expands your lighting possibilities.

shutter speed and aperture

While the technique of mixing flash with ambient light is not complex, I've found that students sometimes find it difficult to grasp to begin with. It hinges on the fact that the exposure to film in

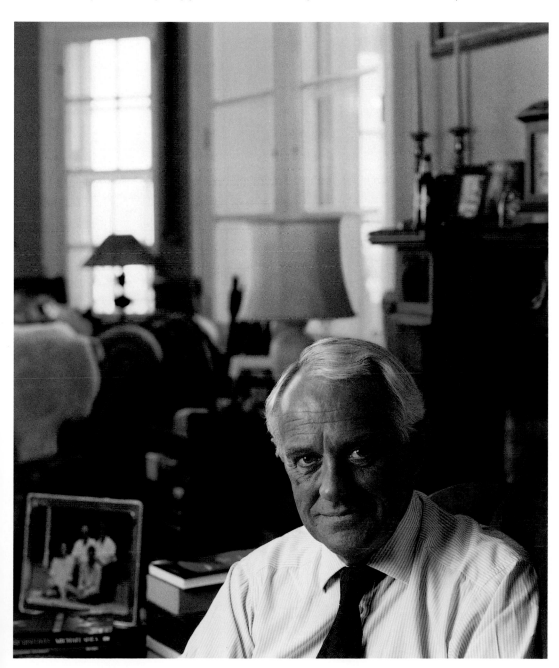

◀ Dr Michael Shea, Author, Former Diplomat, 2003
Here I used a main light on the face with one large softbox and a reflector on the right, plus a flash head bounced off the ceiling in the background, exposed at 1 stop less than the main light. The use of 5 x 4in enabled me to take a high viewpoint in order to see the room in the background while still maintaining parallel verticals.
TOYO 5 X 4IN; 210MM LENS; TWO 800J FLASH HEADS, WHITE REFLECTOR, DAYLIGHT

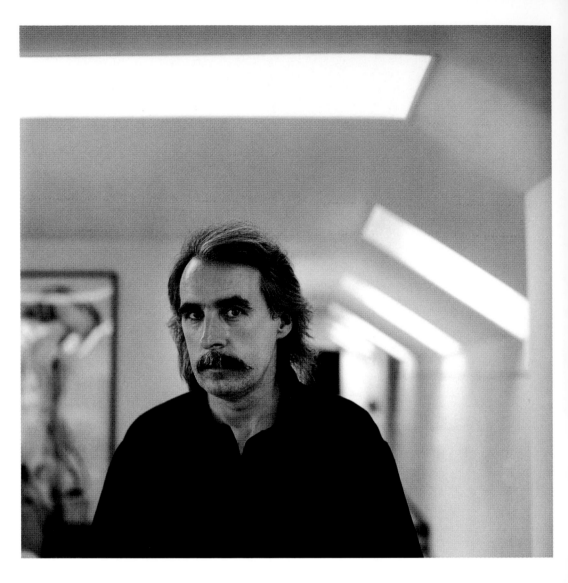

continuous light (daylight, tungsten and so on) is controlled by both shutter speed (duration of exposure) and aperture (intensity of exposure). With flash, the duration of the exposure is the duration of the flash itself. We don't know how long it is and we don't really need to know for most applications – it will be somewhere between 1/250 second and 1/10,000 second. This means that the exposure for the flash is controlled only by the f-stop set on the camera. The shutter speed will not have an effect on the flash exposure.

Of course, if you are using 35mm with a focal plane shutter you need to know what the flash synchronization speed is and be careful not to set a speed faster than that. This speed (usually between 1/60 second and 1/125 second) is normally marked on the shutter speed dial. If you are using a camera with a between-the-lens shutter (most 120 cameras

and all large-format cameras), you may use any shutter speed. There is another proviso here, and that is that with some very powerful studio flash units, the flash duration may be as low as 1/250 second when set to full power. Clearly, if that were the case, it would be inadvisable to use a shutter speed faster than the flash duration because there would be the possibility that the film would not receive the whole of the flash exposure.

controlling light in different areas

We have established that shutter speed and aperture together control ambient light exposure and that the aperture alone controls flash exposure (the above provisos notwithstanding). Let's look at the portrait of Sir Robin Philipson (opposite). He is sitting in a relatively shaded area created by closing

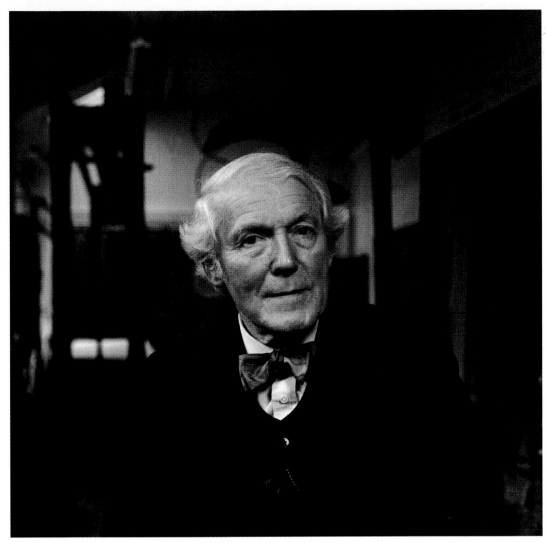

◀ Sir Robin Philipson,
Artist, 1988
The subject was placed in an
intentionally shaded area of
the studio in order that he
could be lit with flash
independently of the
daylight. He has been made
to stand out from the dark
background partly due to the
lighting and partly because I
selected a wide aperture for
limited depth of field. See
also lighting diagram below.
HASSELBLAD; 150MM LENS; ONE·
800J FLASH WITH DAYLIGHT

the curtains over the window nearest to him so that
I can control the light on his face with studio flash.
He is lit with one 800 joule flash unit with a white
umbrella, giving a fairly soft, even light. The
exposure for the flash would be about f/5.6. The
background is daylight coming through a window
and skylight at the rear.

After the flash exposure reading is taken for the
subject – to determine the f-stop to be set on the
camera – an ambient light reading is taken for the
background to determine the shutter speed that
goes with that aperture (f/5.6). Let us say it was
1/15 second. So we now have an f-stop setting that
controls the flash and a shutter speed that,
combined with that f-stop, controls the ambient
light in the background. The beauty of this is that by
simply changing the shutter speed we can control
the exposure to the background (making it lighter or

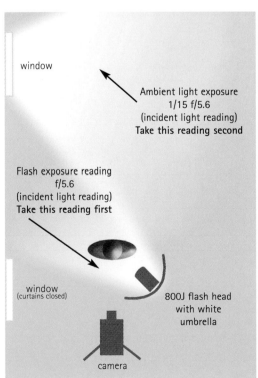

window

Ambient light exposure
1/15 f/5.6
(incident light reading)
Take this reading second

Flash exposure reading
f/5.6
(incident light reading)
Take this reading first

window
(curtains closed)

800J flash head
with white
umbrella

camera

Andy Howitt, Dancer, 2001

Throughout this book I've tended to preach simplicity of technique as a means of maintaining attention on the subject itself and the *content*, rather than 'show-off' clever lighting and visual tricks. In this case I was keen to produce something theatrical and sculptural as a counterpoint to the popular culture that the picture represents.

Let me explain: in 1978 a famous goal was scored in the football World Cup in Argentina by the Scot, Archie Gemmill, against Holland. In 2001 a friend of mine, Alec Finlay, had the idea of writing the 'score' for this remarkable goal in a dance notation (rather like music) called Labanotation. This was duly written and Andy was commissioned to 'dance' this goal, which he did in various performances. I made a sequence of 24 studio photographs of Andy as part of an installation depicting various stages of the scoring of the goal. Football meets ballet meets photography. It seemed appropriate to make the pictures balletic and theatrical. Football is often referred to as 'the beautiful game' and I wanted to make these pictures as classically beautiful as possible.

Dark grey background paper was laid on the floor of the studio and black paper attached to the wall, carefully taped together to make a neat horizon line. One flash head with a 30-centimetre (12-inch) reflector and barn doors was placed on each side, low down and to the rear, to provide back light, and a large softbox on a boom was placed to the front, very high up, as a fill-in light. The back lights had to be carefully flagged (shaded) to prevent light spilling into the lens (creating flare) and overlighting the floor. Exposure was calculated for the back lights, and the fill-in front light was underexposed by about 1 1/2 stops. There was no additional lighting on the background other than light that 'spilled' from the fill-in.

I now have a small studio and I knew it was going to be tight to make full-length pictures, so Andy had to be really disciplined to keep the poses within very strict parameters. I decided to use 35mm for this for its ease of use and to maintain spontaneity. It was a delight to work with somebody so in control of his craft. He was brilliant. We shot the whole sequence twice – half an hour from start to finish.

Strictly speaking, this is a diversion from what I would normally consider a portrait in the sense that it is not an analysis of a personality. Initially the work was made as part of a conceptual art installation. In retrospect, it could also serve as a celebration of Andy Howitt's artistry, craft skills and physique.

Nikon; 50mm lens; studio flash; Ilford FP4

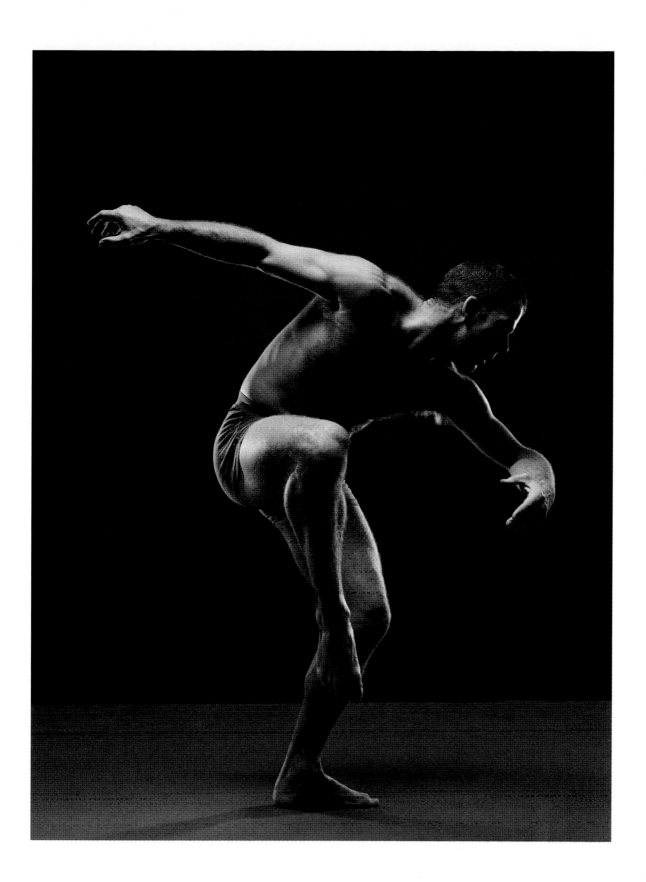

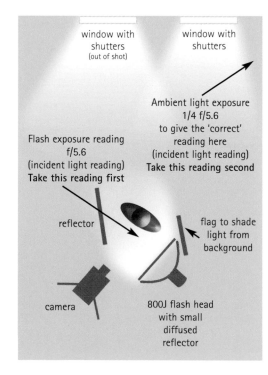

⬆ Ambient Light/Flash Sequence

1. No flash; 1/4 second at f/5.6
2. 1 second at f/5.6
3. 1/4 second at f/5.6 ('correct')
4. 1/15 second at f/5.6
5. 1/60 second at f/5.6
6. 1/250 second at f/5.6

HASSELBLAD; 80MM LENS; ONE 800J FLASH HEAD WITH DAYLIGHT ILFORD HP5; ILFORD MULTIGRADE WARMTONE FILTER 1.5

window with shutters (out of shot)

window with shutters

Ambient light exposure 1/4 f/5.6 to give the 'correct' reading here (incident light reading) **Take this reading second**

Flash exposure reading f/5.6 (incident light reading) **Take this reading first**

reflector

flag to shade light from background

camera

800J flash head with small diffused reflector

darker) *without changing the flash exposure on the sitter* (see the diagram on page 103).

Look at the series of pictures of my son Roberto in my studio (above). The initial exposure reading was taken for the main (flash) light and then an area of the background was selected that I wanted to be 'correctly' exposed with the daylight from the window. In this case I decided that the end of my filing cabinet next to the ladders should be the point from where I would take my incident light reading in order to expose that 'correctly'. Obviously, the closer one moves to the window (a light source), the more overexposed the negative becomes, and the further into the room, the less exposed it is. I flagged (shaded) the flash with a sheet of black card so that as little light as possible spilt on to the wall on the right: as far as possible I wanted it to be lit only with daylight (see diagram left).

I included one exposure with no flash at all as a 'control'. You can see that, with the exception of the longest exposures, I was able to control the exposure on the background with very little difference to the

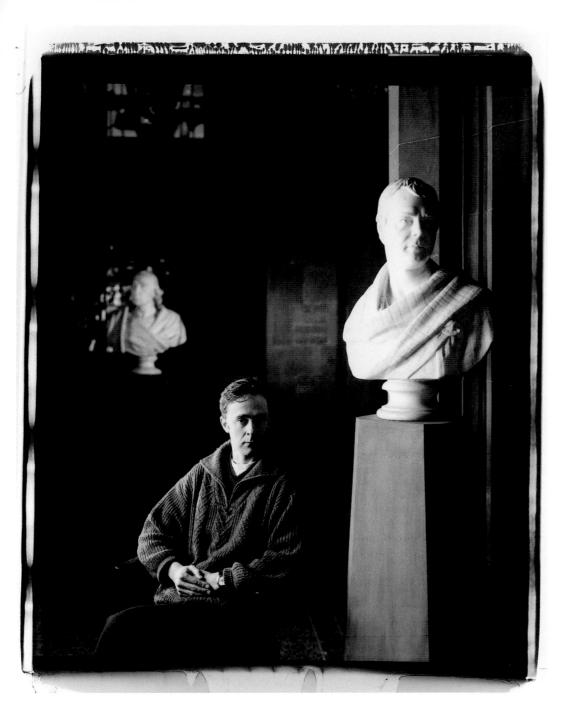

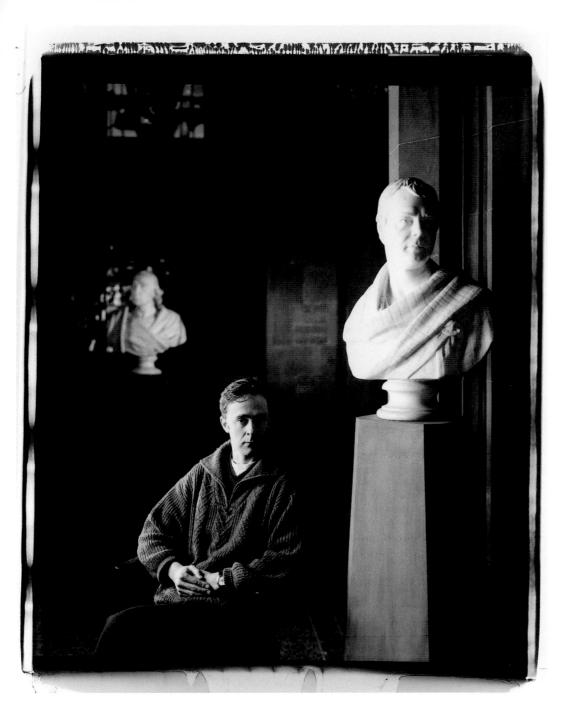 Alec Finlay, Artist and
Writer, 2001
Made during a morning of
using Polaroid's giant camera.
Here I used mainly flash, but
selected a shutter speed long
enough to allow some
daylight to record in the
window. A natural reflector
has been created by the bust
of Sir Walter Scott, which
throws some light back on to
the side of Alec's face.
POLAROID 20 X 24IN; ONE 5,000J
FLASH HEAD WITH LARGE SOFTBOX,
ONE 3,000J FLASH HEAD WITH
SMALL SOFTBOX TO LIGHT THE
BACKGROUND

flash exposure on the subject. Despite enormous temptation, all the prints were made with no burning and dodging whatsoever. I have captioned exposure 3 as 'correct' because that was the one that was calculated to expose correctly for the filing cabinet. It would be a matter of personal taste which one you would choose.

flash outdoors

The technique for using flash outdoors is similar. I rarely use hand flash because it does not afford enough control and, wherever possible, I try to use a meter rather than rely on the automatic exposure facility of the flash.

First take a flash meter reading for the subject; let's say it reads f/8. Then take the available light reading for that aperture, for example, 1/60 second at f/8. Then decide by how much you want to underexpose the daylight; let's say 1 stop. So your final exposure will be 1/125 second at f/8: f/8 to correctly expose the flash and 1/125 second at f/8 to underexpose the daylight by 1 stop (see also next page).

⬆ Louise Heron, 2003
Here, a hand flash was attached to a lighting stand and diffused slightly with tracing paper. This was the 'main light'. The ambient light was underexposed by about 1 1/2 stops by selecting a faster shutter speed than would be 'correct'. This acts as the fill-in for the face.
NIKON F3; 35MM LENS; METZ FLASH GUN AND DAYLIGHT

⬅ David Mach, Sculptor/Artist, The Temple at Tyre Installation, Granton Docks, Edinburgh, 1994
A relatively simple 'construction' (the photograph, not the Temple). I pleaded with the crane operator to move the distracting crane arm, but to no avail. This was a very dull day, necessitating additional light from a flash to provide foreground contrast and allow the subject to stand out from the background. In terms of colour, I was interested in the limited palette, with the matching blues of the hat and the drum contrasting with the orange of David's safety harness.
HASSELBLAD; 50MM LENS; PORTABLE FLASH HEAD RUN FROM CAR BATTERY; WARM GEL OVER SMALL SOFTBOX, MIXED WITH DAYLIGHT

unusual light sources

The doyen of American humanist documentary photographers, Eugene Smith, once famously said, when asked by a student whether he used only available light, 'Yes. I use any light that's available.' Possibly apocryphal, but that really sums up my approach to location portraiture. As I've said, if you have nothing to lose, it can really pay off to be brave. If you are undertaking a commission or you are photographing an important subject and the picture is unrepeatable, you should play safe in the first instance to be sure you get a result. But once you have that, you can allow yourself the indulgence of experimentation with extreme lighting conditions or unusual light sources.

The portrait of the artist Imogen Gardner (see next page) was made with car headlights in a lay-by in the highlands of Scotland. It was a bit of luck that the exposure for the sky was reasonably balanced with the exposure for the headlights, although I was able to adjust the balance to a certain extent by moving the car towards or away from the subject. As it is a black-and-white image, the discrepancy between the colour balance of the headlights and that of the sky doesn't matter.

Albert Watson is arguably one of the world's greatest editorial photographers, whom I was privileged to meet in Edinburgh. In my portrait of him (below) I used available light augmented by a small hand torch held by a photographer friend, who was highly amused at the minimal equipment. Albert didn't comment. I liked the idea of photographing one of the world's most highly paid photographers with a battered old Leica and a cheap torch. I filtered the torch with a blue gel to balance the colour with daylight, otherwise it would have been impossibly warm. In fact, it's not a full conversion from tungsten to daylight since I wanted some warmth in the colour.

⬇ **Albert Watson, 2003**
For this I used a small hand torch with a 1/2 blue conversion filter taped to it (to partially convert the tungsten to daylight), and held high up to the right by a friend. The camera was hand-held at 1/15 second and I took only ten pictures and five minutes. All the equipment would fit into a jacket pocket.
LEICA CL; 40MM LENS; HAND TORCH AND DAYLIGHT

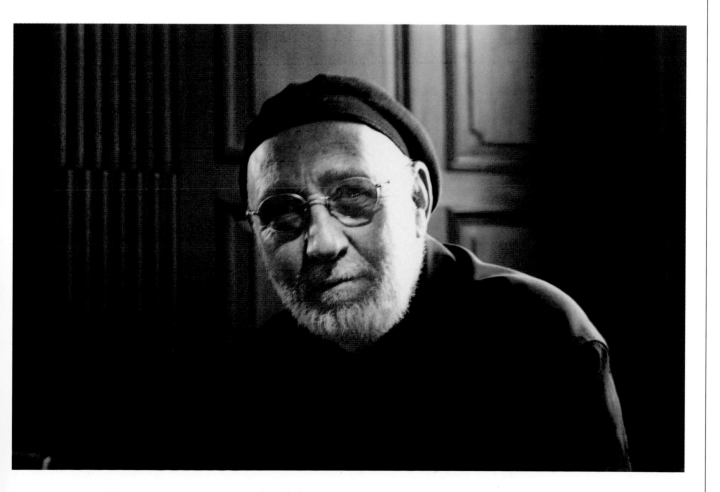

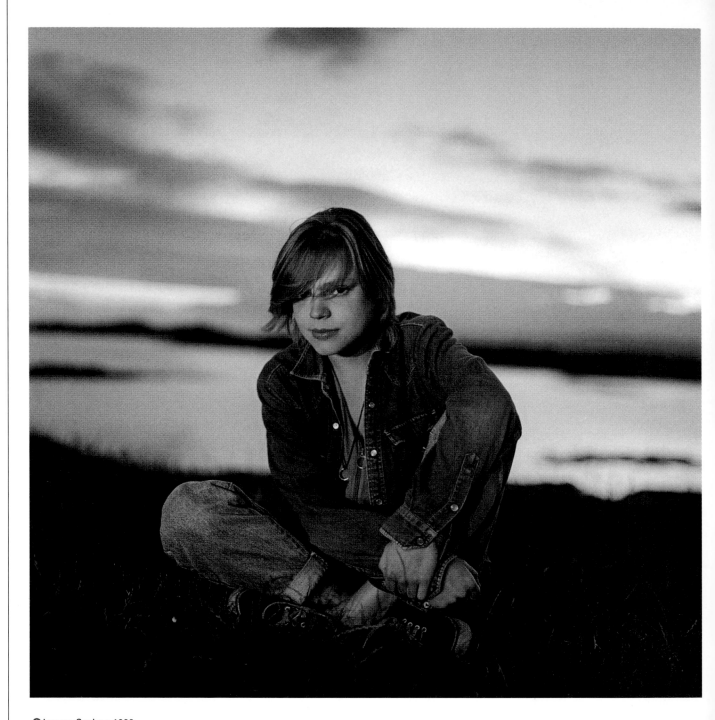

⬆ Imogen Gardner, 1992
Sometimes you need to use
any light that's available. This
was lit with car headlights as
the sun was setting. I was
lucky that the intensity of
the headlights was a good
match in intensity for the
daylight.
HASSELBLAD; 80MM LENS;
DAYLIGHT AND HEADLIGHTS

the studio

This section (like many others) could make a book of its own, so I'm going to make it as simple as possible. Anybody who really needs to learn extensive techniques of advanced studio portraiture should consult the Further Reading section (see pages 140–41). Having said that, I have been consulting some books on lighting recently in the hope that I can recommend them. Many of them are awful – either far too (needlessly) complicated and hard to understand, or just wrong. In one book, I found numerous factual errors, the worst of which was that it claimed that candle light is low in intensity (correct) and soft in quality (wrong). If you don't believe me, the next time you are gazing lovingly at your partner over a candlelit dinner table, look at the shadows the candle casts – they are extremely hard, because a candle is almost a point source of light, like the sun.

The way I learnt studio lighting was by looking at portraits, trying to work out how they were lit, and practising, continually. I still believe that this is the best way, but here are a few pointers to assist that process.

Although in the past, as a full-time commercial photographer, I have used complex and varied lighting techniques, if I am making a portrait in the studio now I keep my lighting as simple as possible. You will have noticed that this is a theme that runs throughout this book: KISS – keep it simple, stupid. There are two reasons for this. One is that overly

◀ **Rachel and Alice Edwards, 1994**
Here the light was very simple – only one flash head with a one-metre (three-foot) square softbox on a boom arm above the camera. The children were placed on white background paper about three metres (ten feet) from the back wall, so that the light fell off to produce a mid grey. The white paper on the floor also acted as a reflector to give a soft, even light.
HASSELBLAD; 150MM LENS; ONE 1,500J STUDIO FLASH WITH SOFTBOX

Neil Millar,
Photographic Assistant, 1989

I consider myself to be part of a photographic tradition of straight portrait photography. I believe in the magic of the process of photography being able, uniquely, to reveal certain truths, in and of itself. I believe in employing a purity of process, without tricks and manifest cleverness, as a means of maintaining an honesty of vision. I enjoy the discipline of working within the constraints of the medium. Sounds like pretty fundamentalist stuff – and as such I know that I expose myself to a great deal of criticism. But this is not to say that I don't appreciate work that involves techniques of image manipulation, montage, or clever lighting, if such special techniques are appropriate to the subject.

This picture of Neil was made when he was working for me and another photographer, Chris Hall. Neil was a wonderful assistant and uniquely eccentric, so I wanted to make a picture that reflected this. With a certain perversity, I've always enjoyed making pictures with minimal equipment – and you can't get more minimal lighting than a torch.

First of all, you must determine the exposure for the torch at a given distance. Let's say at two metres (six and a half feet) the exposure is 1 second at f/8. This means that for each part of the image to be properly exposed it needs to be exposed for that length of time from that distance. Simple. So, in a darkened room, you open the shutter set to T and start painting. Of course it is difficult to ensure that every part of the picture will be exposed for exactly 1 second and at a distance of two metres (six and a half feet), so the result is not entirely predictable. Some areas will be overexposed, and some will be underexposed – and that's great. Sometimes it's a good idea to lay down a 'base' exposure, perhaps with soft, even bounced flash, underexposed by about 2 to 3 stops, in order to provide just a little detail in the shadows that have not been lit with the torch. One of the delights of photography for me (paradoxically, since I expend a lot of effort trying to maintain control of the medium), is that it can be unpredictable and the results can delightfully surprise or frustratingly disappoint.

I've 'painted' Neil's hands, feet, boots, a 5 x 4in camera in the background, a halo round Neil and a lighting stand growing out of his head. The exposure time was about five minutes.

Like my calotype Self-Portrait (see page 131), I like the idea that the photograph is made over a period of minutes, rather than milliseconds, really subverting the notion of the snapshot.
Hasselblad; 50mm lens; one torch; Ilford FP4

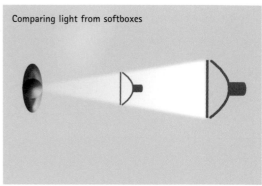
Comparing light from softboxes

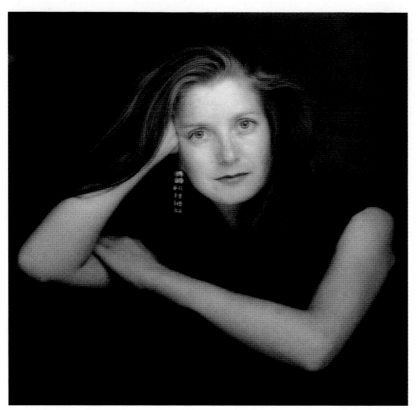

⬆ Fiona Forbes, 1991
Here (unusually) my
intention was to produce a
flattering portrait. I used a
large softbox close to the
subject with a large white
polystyrene reflector as close
as possible on the left, with
another white reflector
below. The technique is
almost to build a white tent
round her. No light was used
on the background; rather it
has been allowed to fall off
to indistinct darkness. The
print has been slightly
diffused under the enlarger
(see page 127).
HASSELBLAD; 150MM LENS; ONE
1,500J STUDIO FLASH WITH SOFTBOX
AND REFLECTORS

clever lighting can get in the way of 'seeing' the subject – you are looking at the *image* instead of the subject. The second is that complex lighting often means that it is difficult to be spontaneous – you will find that you are constantly making adjustments as the subject moves, and this gets in the way of the 'flow' of the session; there is nothing worse than constantly tinkering around with lighting and making exposure readings throughout a session.

I rarely work in the studio now and, for portraiture, I usually prefer to work on location, relating the environment to the subject. But using the studio for 'serious' portraiture can be a very pure process – it becomes just about the relationship between you and your sitter, with no distractions. All there will be is the person, their body language and expression. The studio is like a blank sheet of paper on which you will attempt to create a meaningful image.

the main light

The first decision is: what type of light will mainly light the face? How hard or soft will it be? A basic principle is that the larger the light source, the softer the light, and the closer that source is, the softer it is. A half-metre (one and a half foot) softbox one metre

(three feet) from the subject will give the same *quality* of light as a one-metre (three-foot) softbox (four times the area) at two metres (six feet) – see the diagram above. If you want a harder light, an ordinary reflector on your flash head (which can be diffused with tracing paper or diffusion material if you wish) can be used. Or, for the hardest light, use a spot light that will provide very hard-edged shadows. You can buy flash spot lights that are focusable and with a diaphragm that can reduce the angle of the light, although they tend to be expensive.

fill-in

To control the lighting *contrast*, you will need a reflector. This does not change the quality of light (hardness or softness), which is determined by the light source; it merely determines the density of the shadow side of the subject. Normally you will want this reflector to lighten the shadows, without creating a light effect of its own, so it should be as big as possible. Sheets of thick polystyrene three by two metres (ten by six and a half feet) are ideal,

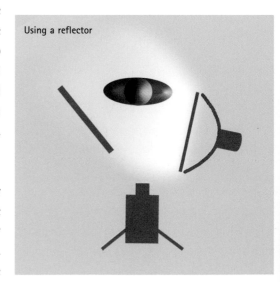
Using a reflector

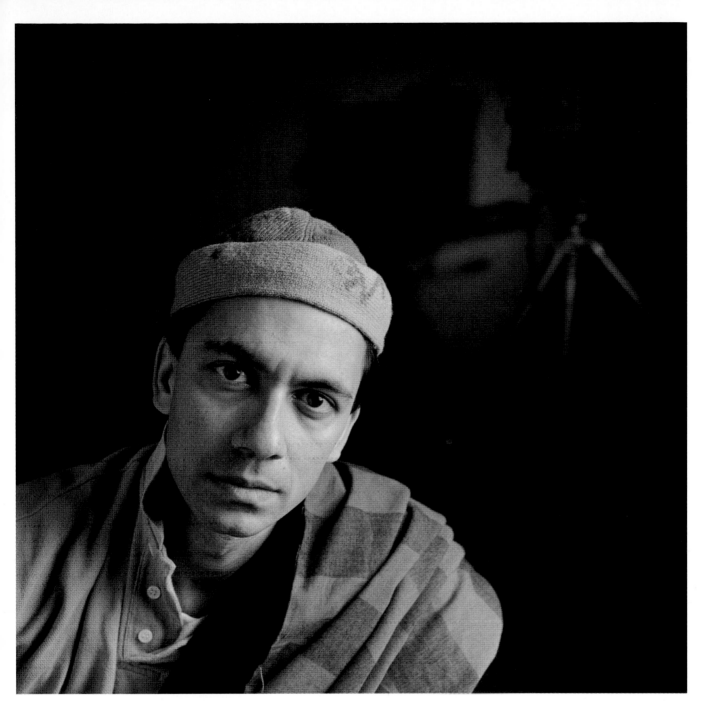

accent light

positioned slightly to the front of the subject and not too far to the side. This will give the most even and natural fill-in. The distance you place the reflector from the subject depends on the desired contrast.

If you are using a spot light, which has a narrow angle of light, and therefore cannot be picked up by the reflector, you need to use a fill-in light instead. This should be a soft light, positioned just above the camera, so that it casts very little shadow of its own, and adjusted to provide an exposure of between 1/2 stop and 3 stops less than the main light exposure, depending on the amount of contrast required.

An accent light is from behind the subject and provides a rim light on either or both sides. It helps to give a three-dimensional feel to the portrait and can add drama. It could be a hard light like a snoot, or a soft light. When I could only afford two lights, I used a long, narrow sheet of silver board attached to a stand behind and to the side of the subject to provide it (see diagram and portrait of Leonard Maguire on page 117). I've never heard of anybody else doing this, although I think it's a technique used in film lighting, and I still sometimes do it today, using a circular cloth

⬆ Pradip Malde, 1988
One flash head with a small softbox was used about one metre (three feet) away on the right, with a large polystyrene reflector on the left and slightly to the front. His 10 x 8in camera in the background was lit with a flash head fitted with a snoot. The exposure measured from the face was f/8 and the exposure for the background was f/5.6. The camera was set to f/8 (the background was underexposed by 1 stop). HASSELBLAD; 150MM LENS; TWO 800J STUDIO FLASH UNITS

⊙ Using Reflectors

1. Here I used a large white polystyrene reflector to the front and about 1.5 metres (five feet) from the subject (see also diagram on page 114).

2. The white reflector has been replaced with a black reflector, which has been moved closer to the subject to reduce any light bounced off the walls of the studio. This increases contrast. Notice how the face appears thinner.

3. Here a small white reflector on a stand has been placed to the rear left to create a slight accent on the side of the face.

4. The white reflector has been replaced with a silver cloth reflector. A bit too dominating perhaps?

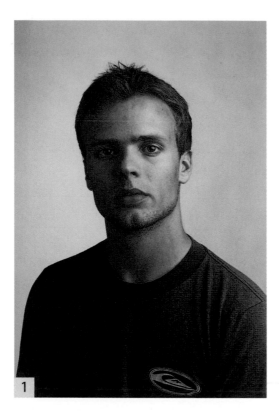

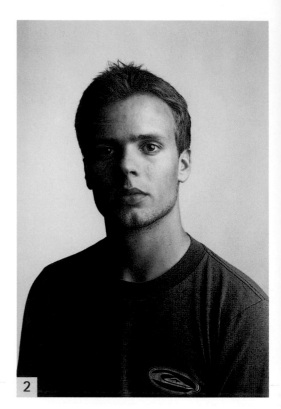

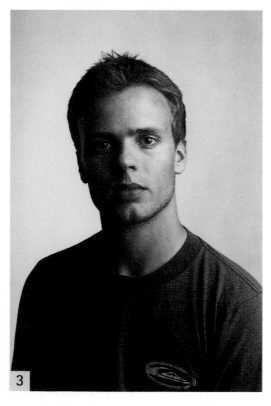

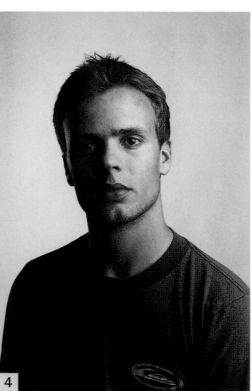

reflector that is white on one side and silver on the other. If you are using a light, its brightness is difficult to judge and can't really be assessed by light measurement, although the power should be less than that of the main light. It is best simply to adjust the power of the flash until it looks right visually. If you are working in colour, subtle coloured gels may be appropriate. Having said all this, accent lights are rather unfashionable these days and aren't really consistent with my continual entreaties to keep things simple. Somehow they seem to make a portrait look overlit and a bit theatrical and unnatural.

the background

I am going to assume that the portrait you are doing is head and shoulders or half length – in other words, that there is no horizon line in the picture. It is useful if you can control the light on the subject and that on the background independently, unless you particularly want the shadow of your sitter on the background. To this end, the subject should be a minimum of three metres (ten feet) from the background. Let's look at my portrait of Leonard Maguire (right). This was lit by a one-metre (three-foot) square soft light close to the subject, a large white polystyrene board some distance away to give just a little fill, and a sheet of silver board to give an accent light as described above. Like many of my studio portraits, the background was white background paper allowed to go much darker because there was very little light on it. I find that the best way to predict the tone of the background is by applying a very simplified form of the Zone System.

the zone system

Now, I implore you, do not get yourself embroiled in the Zone System. I've had a rich and fulfilling life as a photographer without ever applying it in its entirety, but a basic *understanding* can be useful. Let me try to sum it up briefly. There are 10 Zones, from totally black (Zone 0) to pure white (Zone 9), each representing a difference of 1 stop. The most important Zone is Zone 5, because that is middle grey and all light meters are calibrated for middle grey. In other words, whatever the light meter (in reflected light mode) is pointed at, it thinks it is middle grey, no matter what tone it actually is.

Another important Zone is Zone 3, where there will be recorded detail in dark areas, with just the beginnings of tonal separation. If you underexpose middle grey by 2 stops, that is what you'll get. Another one is Zone 8, where there will just be texture and tonal separation in the light areas. If you overexpose middle grey by 3 stops, this is what you'll get. In black and white, therefore, it follows that film can record a range of 5 stops – 3 over and 2 under middle grey – if you want texture and tonal separation. That's the general idea. For a fuller explanation of the Zone System, consult the Further Reading section (pages 140–41).

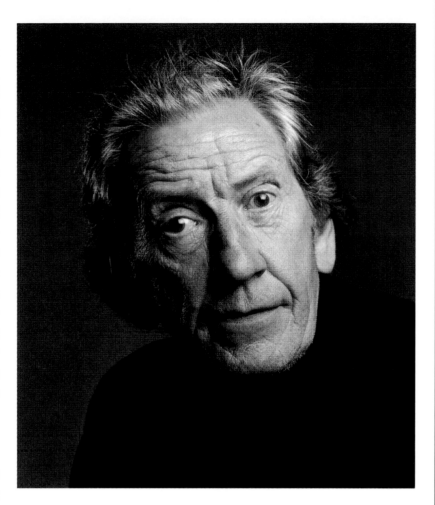

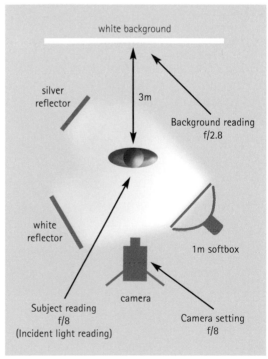

⬆ **Leonard Maguire, Actor, 1985**
Actors are often difficult to photograph because they're always acting, making it difficult to get anything more analytical. Again, simple and minimal equipment was used – just one light plus reflectors, a silver one and a white one.
HASSELBLAD; 150MM LENS; 800J FLASH HEAD

Diagram labels: white background; silver reflector; 3m; Background reading f/2.8; white reflector; 1m softbox; camera; Subject reading f/8 (Incident light reading); Camera setting f/8

applying the zone system

How do you apply this to your background in the studio? Suppose you are using white background paper – the most commonly used. If the exposure for the subject is f/8 (that is what you will set the camera to) and the exposure on the unlit background is f/2.8, both measured with incident light measurement, then the white paper (which we could refer to as Zone 8), would drop 3 zones (or stops) to Zone 5 – middle grey. So you can confidently predict that your white paper will come out middle grey. It helps if you have a mental image of what middle grey looks like – get a Kodak Grey Card as an indicator. (See the portrait of Leonard Maguire on the previous page.)

Similarly, if you are using a middle-grey background paper instead (lets call it Zone 5), it would drop 3 zones to Zone 2 – that is black with *just*

detail and little tonal separation. If you wanted your white or grey background to *be* that tone you would have to put an additional light on it to give the same reading as the subject. It follows then that if you are using a middle grey background and you want it white, you would put 3 stops more light on to the background than is on the subject, to take it from Zone 5 to Zone 8.

It is still quite fashionable to have pure white backgrounds with no detail, like David Bailey's work in the 1960s. For this, you will need two lights with ordinary reflectors, like copy lighting where the lights are at 45 degrees to the background, in order to light the background as evenly as possible. Using white background paper, take an incident light reading there that will indicate an exposure of 1 stop more than the exposure for the subject. This will give you Zone 9 – white with no detail. Take care, though, not

● **Hannah Starkey, Photographic Artist, 1993**
This was a demonstration for students at Napier, when Hannah was a student there. Four lights were used: one softbox on the face, a snooted flash lighting part of the draped background, providing a highlight to define the shape of the shadow side of Hannah's face, another snooted flash lighting the background on the right, and one more lighting the hair from behind as an accent light.
HASSELBLAD; 150MM LENS; FOUR 800J FLASH HEADS

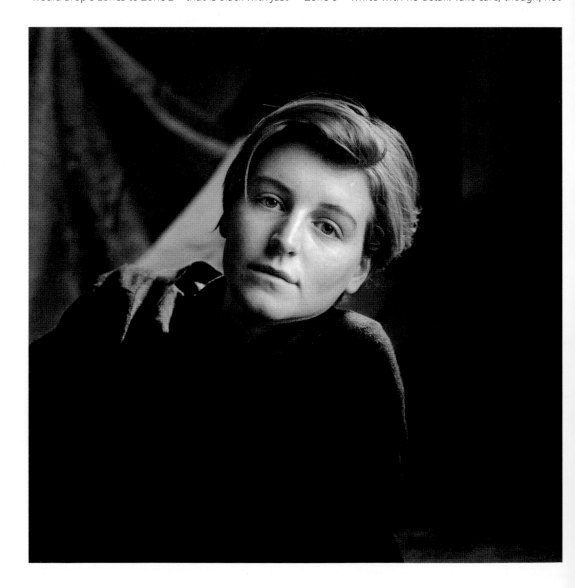

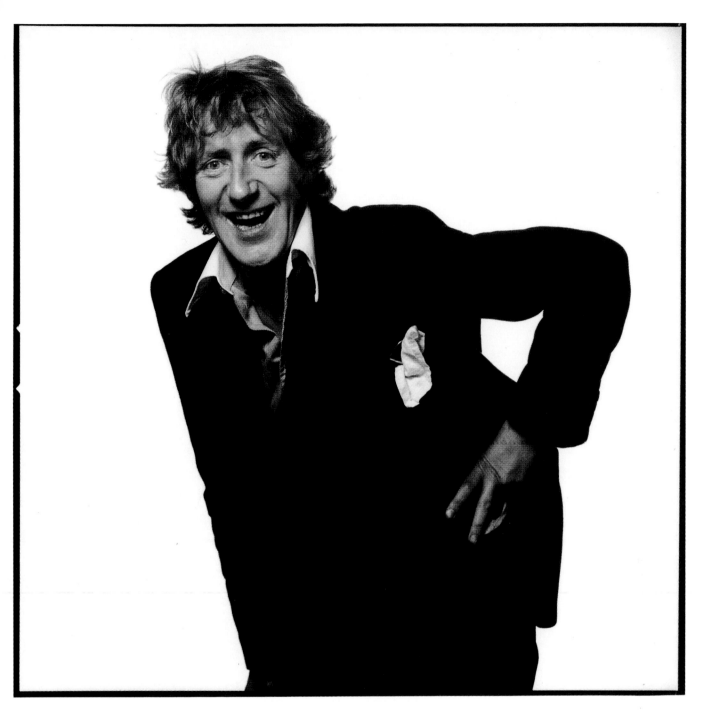

⬆ John Bett, Actor, 1982
An early portrait in a style that is still popular. I used one umbrella flash above the camera and two lights with 30-centimetre (12-inch) reflectors evenly lighting the white background. I gave the background 1 stop more light than the subject to be sure that it would go pure white.
HASSELBLAD; 150MM LENS; THREE 800J FLASH HEADS

to give it more light than that, because there is a danger of flare from the light bounced off the background. And be sure that your lenses are clean, otherwise the possibility of flare is even greater.

Backgrounds can be considerably more inventive than this – but don't try to be too clever. Naturally, if you are producing backgrounds with variable tone by applying splashes of light, or drapes, or whatever, you can apply the same exposure assessment procedure to make a reasonably accurate prediction of the result – with a bit of practice.

Bjorn Sterri, Photographer,1997

I once said to Bjorn, when he was particularly poor, that he should sell his Leica, his Hasselblad and his Linhof and spend the money on Polaroid SX70 film. He has become an expert in that medium, so it seemed that including a Polaroid of Bjorn would be fitting. You can buy an SX70 camera secondhand (tragically, they don't make them any longer) very cheaply, but the film is expensive.

There is something so liberating about SX70, really allowing experimentation – if the first image isn't right when you see it, you take another, and then another. You can alter colour and contrast by developing pictures quickly over a candle flame, or put them in the fridge to develop slowly. You can manipulate the image with controlled pressure on the print as it develops, and you can make use of the camera's automatic long exposure facility to fire one or more flashes during exposure in low light. The major problem with traditional photography has always been the time lapse between clicking the shutter and seeing the result. Sometimes it's agonizing.

This picture is the antithesis, really, of all I stand for. Mostly I am concerned with preconception, craft, being in control of the medium.... In this case the only real control was when I scanned the print, cropped it a bit and increased the contrast. The problem with Polaroid as a serious medium has always been that it is a one-off. Small print, no negative. Before digital technology, if you wanted a bigger print you had to copy it on a 5 x 4in camera to make a negative that you could print. Now it's much easier to scan it and enlarge it digitally.

This was a totally unplanned picture taken in my kitchen during an evening of good conversation. The Polaroid 'toy' was brought out and we each took some pictures. During a long exposure I fired a small automatic flash gun with Bjorn's head in profile and again facing straight on. Technically, that's it really.

I would normally feel it demeaning to the medium of photography to compare it with a painting, but this picture has all the intensity and torment of a portrait by Francis Bacon, and in a way it almost ceases to be a photograph, at least in the sense that I would normally understand it. The image has been manipulated to the point that it is several steps away from the real, first in the camera and then in the computer.

This was a time in Bjorn's life when he was grappling with the universal life problems of family, love and mortality, and expressing these eloquently in his own work.
Polaroid SX70; hand flash; digital print

contacts and proofing

Now you have taken the pictures, you will probably go through that awful nerve-racking period before you see the results. With photography, even if you have made Polaroid tests, you can never be 100 per cent certain of the results you are going to get unless you are using digital capture, and even then all you see is a small (albeit zoomable) image on the back of your camera. Although you have taken the pictures, you haven't yet made the portrait.

If you are working in black and white, you should make every effort to process the films yourself. Only very good, specialist labs will make a good job of it – most of them will put the films through a machine and will probably overdevelop them.

Having developed the film (or had the film developed), you need to store the negatives in clear, archival print-through negative files, annotated with subject, location and date, ready for contact printing.

making contacts

The first stage in the final realization of the portrait is to make contact prints. The contact sheet editing process is an important one and you should facilitate this by making as good quality contacts as possible. The negatives should all be the same way round to make them easy to read and, if they are black and white, they should be printed a bit on the soft side, so that you can see as much tonal detail as possible.

If you are working in colour, it is likely that you will not be making contacts and prints yourself, but if you are, it is worth getting the colour balance as correct as possible. Recently I have been using a scanner with a 10 x 8in transparency drawer, and a basic inkjet printer, to make quick digital contacts, especially in colour.

Take your time to examine the contacts, preferably with a magnifying glass, and mark possible exposures with a felt-tip pen or chinagraph pencil. You may want to use L-shaped cards at this stage to determine possible cropping. Depending on how confident you are when assessing the contacts, and how many films you exposed, you will probably make a selection of two to four for enlarging as proofs on 10 x 8in paper. The final decision will be made from these.

Never show the contacts to your sitter, although you may show the proofs that you think best represent him or her and that you would be happy to represent your work. You would never ask a portrait painter if you could see some different options – you would hopefully accept their artistic vision. I remember I once gave a photographer friend a set of contacts, against my better judgment, and I had to make around 12 different proofs, some of which I felt weren't very good pictures and – disastrously – including one that had a bad scratch on the negative. Very embarrassing.

File proofs and marked-up contacts carefully with your negatives. I use large envelopes marked with the subject's name, relevant details and date(s) when the portrait was made, and file them in a cabinet in alphabetical order – nothing complex.

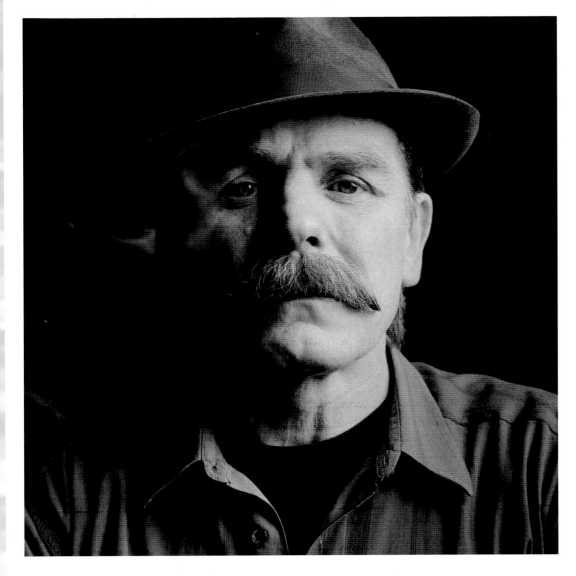

◄ Tam White, Blues
Singer, 1989
In this studio session it was
necessary to work hard at
getting the expression I
wanted within an 'alien'
environment. Unusually, I
shot ten rolls of film to get
the picture I wanted, where
the smoke was in the right
place and the expression and
head position were
appropriate to the message.
This was virtually a straight
print on Forte Polywarmtone
developed in Agfa Neutol
WA. It was toned in
selenium 1:9 for a very
slight colour change.
HASSELBLAD; 150MM LENS; STUDIO
FLASH; ILFORD FP4/D76, 1:1

◄ Tam White Contact
Sheets
Two contact sheets from
the ten rolls that were shot
that day.

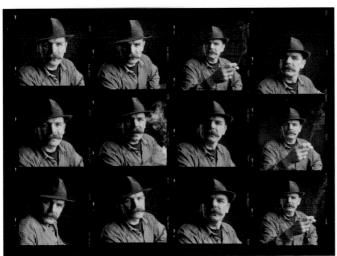

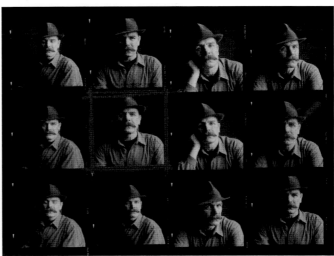

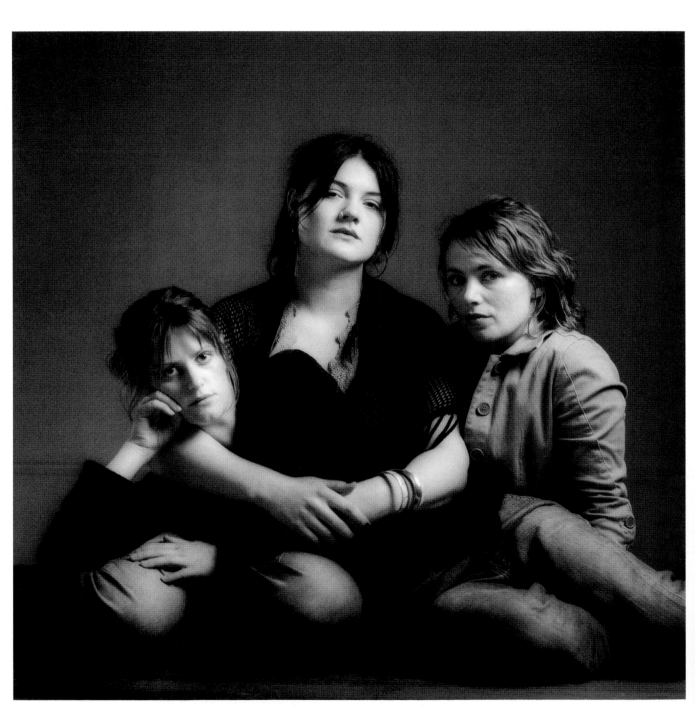

⬇ Birgitte, Hilde and Astrid, 2003
This is a black-and-white version of the picture on page 57. The print has been diffused slightly using black stocking over the enlarger lens. The knees and hands were darkened by about 50 per cent. The print was made on Agfa Multicontrast Classic developed in Agfa Neutol WA. I find this version more expressive than the colour.
HASSELBLAD; 150MM LENS; STUDIO FLASH; ILFORD FP4/D76, 1:1

gradation. Here then, I am mainly considering traditional black-and-white printing. I'll deal with digital outputting in more detail on page 136.

basic techniques

I do not consider myself a first-rate printer – I don't really have the patience to spend hours in the darkroom perfecting one print and, as with film development, I don't experiment much with chemistry, new processes, printing techniques or fancy print colouring and manipulation. Having said

that, I've often employed subtle soft focus or toning; take it too far, though, and it looks like cheap tricks, in my opinion. A really high-quality black-and-white print, made with care on a good-quality fibre paper is an object of great beauty in itself.

If you are really keen to investigate all the nuances of fine printing, consult the Further Reading section on pages 140–41 and, in particular, Les McLean's *Creative Black and White Photography*. For what it's worth, my working practice is as follows. I use a De Vere 504 enlarger with an Ilford Multigrade

head. With so many studios and labs going digital, you can buy this top-of-the-range equipment secondhand for a fraction of what it once cost. The Multigrade head, while still quite expensive, is a joy – no changing fiddly filters – and you can even change grades midway through an exposure if you really can't decide between grade 2 and 2.5.

These days, I mainly use variable-contrast paper (tending generally to prefer the warmer-toned types), of which there are some excellent examples on the market. Ilford Multigrade Warmtone is very good and easily available. The Forte range of papers is the closest I have come across to the print colour of a traditional, graded, chlorobromide paper such as the old 'blue label' Record Rapid (if anybody remembers this lovely paper). The Polywarmtone (VC), which is a very heavyweight (300 gram) paper, is excellent and tones beautifully in selenium toner. It's slightly eccentric, though – it fogs easily and the grades aren't well spaced. I've often had problems with a sort of posterization (tonal separation) at low grades. But when it's good, it's very good – if you can get hold of some. I use resin-coated papers only for proofs or contacts.

The developer I use is Agfa Neutol WA, which is fairly warm-toned, or, if I want very warm tones, I use the old Kodak D163, which is a public domain recipe, no longer marketed by Kodak, but which some specialist suppliers will make up if you don't have the inclination to attempt It yourself.

soft focus

Occasionally I use soft focus at the enlarging stage, and very rarely at the taking stage, although I have been experimenting with an Imagon soft-focus lens for 5 x 4in, which gives beautiful soft and controllable results. Obviously, at the printing stage you can decide whether you want softness and to what degree without altering your negative, and you can see exactly the result you are getting. Virtually all of Robert Mapplethorpe's portraits in the 1980s employed subtle soft focus at the printing stage. The main difference is that in the camera, highlights spread into the shadows, whereas under the enlarger it's the opposite. Be careful, though: you shouldn't overdo soft focus or it can just look muddy. I use a piece of black stocking (15 denier), stretched over a hole in a piece of card and held in position over the lens for the whole or part of the exposure. The exposure will be longer and up to a grade harder paper will be required, depending on how much diffusion is used.

toning

The only toner I use these days is selenium. It's relatively cheap and quite easy to use, although results are variable and depend on the type of paper, development time of the print, and of course toner dilution and immersion time. Chlorobromide papers and the Ilford Multigrade Warmtone and Forte ranges all tone well. Personally I avoid too much of a colour change and dilute the toner 1:9, which is generally enough to provide a rich density in the blacks with a slight shift to deep purple. As with all printing techniques, it is important to experiment and practise to find what suits you.

An additional bonus with toning is that it provides considerably more archival stability – a rinse in selenium, even with no colour change at all, will convert the unstable silver into silver selenide, which is far more stable. But beware: your prints must be fully washed for at least an hour in an efficient washing system before you tone, or they will stain, giving you an overall pinkish tint to the base white.

➲ Soft Focus Examples,
Sam Sills, 2003
1. No soft focus.
Ilford Multigrade Warmtone;
Grade 3.
2. Soft focus in camera. You
can see a slight spreading of
the highlights into the
shadows, with less tonal
separation in the highlights
and shadows.
Hasselblad Softar No.1 (they
come in three strengths, 1–3;
1 is the weakest); Grade 3.5.
3. Soft focus under the
enlarger; black stocking
stretched over the enlarger
lens. You can see a slight
spreading of the shadows into
the highlights and less tonal
separation, particularly in the
shadows. Grade 3.5.
HASSELBLAD 150MM LENS, STUDIO
FLASH

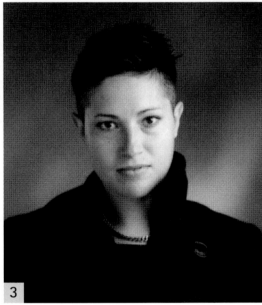

◀ Selenium Toning
Example, Sam Sills, 2003
This print was made on
Ilford Multigrade
Warmtone and toned with
selenium toner diluted 1:3
for one minute. This has
fully toned. Normally I
would not take the toning
to completion like this. The
print has also been
diffused with black
stocking.
HASSELBLAD; 150MM LENS;
STUDIO FLASH; ILFORD
FP4 D76, 1:1

mounting

It is not so common these days to dry mount prints on to board, unless they are very large (over 20 x 16in), when extra rigidity for ease of handling and flatness in a frame is necessary. Dry mounting is irreversible, so it's better not to do it unless you are sure this is what you want. An alternative to dry mounting is to use an adhesive spray called Photo Mount – it is not as efficient as dry mounting, but then not everybody has access to a dry-mounting press. Do not confuse Photo Mount with Spray Mount – the latter is intended for graphic arts paste-ups and is useless for mounting photographs.

⊘ June Tabor, Singer and Musician, 1989
This was intended for publication for an album cover, not for framing, and was printed at 10 x 8in size unmounted with a 1in border. Strong side lighting coupled with soft focus in the camera has provided a glow to the image.
HASSELBLAD; 150MM LENS; STUDIO FLASH

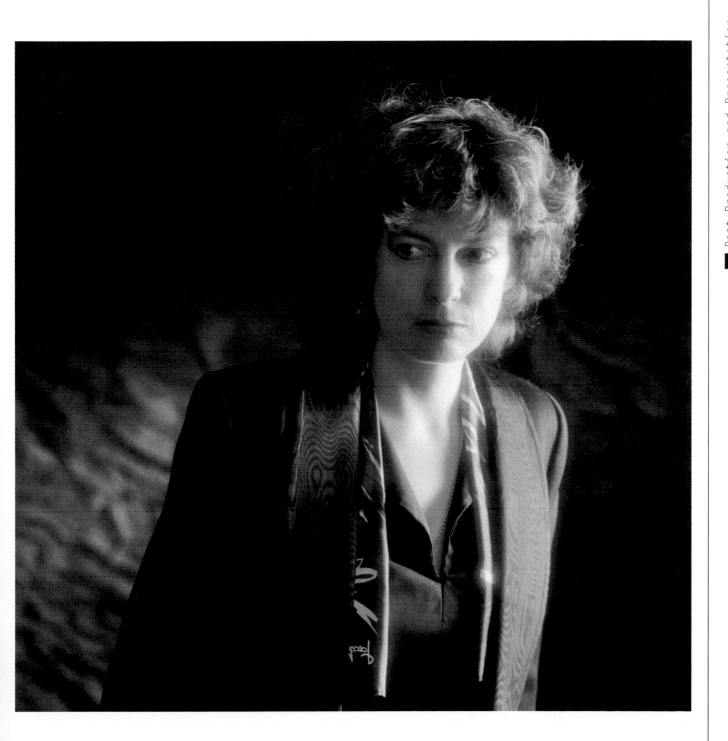

Self-Portrait, 1994

The portrait is an artist's humble attempt at understanding humanity. The self-portrait, by extension, is about attempting to understand the self. Motives can vary – many will picture themselves through simple narcissism, a vanity that seeks to confirm their own status in the same way that Karsh photographed the famous in a manner that confirmed theirs.

I have, over the years, made many self-portraits. Some are consigned to the bottom drawer, rarely if ever brought out for an audience, but there as a reminder of 'how I was', and bookmarking periods of my life. The date that a portrait is made is always important in photography, fixing as it does the changing topography of the face at a particular time.

This portrait is not deeply profound or self-analytical in that way. It was made during a workshop on the calotype process (invented by Fox Talbot in 1835), the first photographic process to produce a negative that could be printed *ad infinitum*. A calotype negative has a base of thin paper, often waxed on the back to make it semi-transparent. This enables shorter exposures when it is contact printed in sunlight on to another sheet of similarly coated paper to make a 'salt' print. Exposures in the camera in bright sunshine are about two minutes. We think of photography as being instantaneous – the capturing of a moment – and I was interested in the notion of the passage of time as the picture is exposing.

Besides that, the medium has interesting aesthetic qualities. Tonally it provides broad brushstrokes of light and shade, is blue-sensitive so skin tones tend to be quite dark, and is not particularly sharp (although you wouldn't normally notice since it is a contact printing process).

To make the portrait, I used a 5 x 4in camera, dark slide loaded with a sheet of paper that I'd sensitized earlier, and composed the stage, which was William Turnbull's sculpture, *Gate*, at the Gallery of Modern Art, Edinburgh, its stainless steel scintillating in the sunshine. I opened the shutter, walked into the shot and sat down for two minutes, then got up, returned to the camera and closed the shutter.

I subsequently made a salt print by contact printing, but the print here is made by enlarging the waxed paper negative on to conventional photographic paper. It exhibits the grain or texture of the paper negative from which it is printed. I then decided to tone the print in selenium diluted 1:3, which is relatively strong. The tones have split so that the shadows have coloured but the lighter ones haven't.

I haven't done anything with calotypes since. It's hard work. I have, however, been experimenting with using ordinary photographic paper as a paper negative in order to produce similar effects.
Toyo 5 x 4in; 150mm lens; bright sunshine; calotype negative

matting

Matting (or window mounting) is rather out of fashion these days, unless the print is to go into a frame where, besides the aesthetic of the window mount, its main function is to hold the glass slightly off the surface of the print. Unless they are large, prints will not be dry mounted on to the back board but tacked in with photo corners and the matt hinged on top. Fibre prints usually need to be flattened in some way unless they are dried very carefully; I use a dry-mounting press for this. You should use conservation or museum board, not just because it is acid-free and therefore archivally stable, but also because within a few months cheap board will discolour where it's been cut.

If you are traditionally matting prints, do avoid coloured mounts, even for colour prints. Pure white is good for colour and 'antique white' for warm-toned black and white. Sorry to sound dogmatic here, but I've seen so many good images ruined by coloured – or black – mounts. The rule, as ever, is when in doubt, keep it simple.

storing unmounted prints

The convention is to make prints with a sizeable white border and put them, unmounted, into clear polyester sleeves, then store them in a portfolio box. Simple, professional and relatively lightweight (have you ever felt the weight of fifty 20 x 16in mounted prints?). Various firms produce them or, if you can afford it, you can have them custom-made to your specifications. Try bookbinders or book restorers – they should also be able to emboss your name on the front if your ego or your wallet extends to that. Personally, I have a title sheet in the box, printed on an inkjet printer and mounted on thin board the same size as the prints.

framing

As suggested above, the traditional form of framing photographs is to matt them first and then to put them in a frame with a simple (usually square section) moulding, using dark brown wood or black for black and white, and light wood or white for colour. Avoid the temptation to be too clever or fancy with framing unless you have a very good reason. Let the photograph speak for itself.

When I have the time, I make my own frames. It's not difficult and the equipment isn't expensive (except for a router to cut the rebates and I get a joiner to do that for me). It's good to be completely in control of your image-making from start to finish. You can select unusual timber profiles and stain them to precisely the colour you want. The financial saving is considerable – suffice to say that the most expensive element is usually the glass.

1

3

4

5

◀ **Frames**
1. A traditionally matted print in a dark oak frame with a simple moulding.
2. No matt, but a print with a wide border. The frame has shallow slips or spacers to separate the glass from the surface of the print.
3. A box frame in light-coloured wood, which is ideal for colour. This time the print border is much narrower and the slips are about two centimetres deep.
4. Here the print has been mounted flush on to three-millimetre aluminium with battens on the back to hold the print proud of the wall.
5. You can be inventive with frames. Here I've used a 10 x 8in vintage contact printing frame, *circa* 1910.

flush mounting

In recent years it has become fashionable not to frame prints for exhibition, but to flush mount them, borderless, directly on to a variety of rigid materials. Foam board is the cheapest and easiest to cut – but it looks cheap. MDF (medium density fibreboard), a composite wood material, comes in a variety of thicknesses – the bigger the print, the thicker it needs to be or it will warp. Edges can be lightly sanded and painted for a smooth finish. A relatively new alternative is PVC – it's flat, fairly rigid and doesn't warp as readily as thin MDF does.

Aluminium sheeting is probably the most successful material for flush mounting. It is totally flat and very rigid, even at only a few millimetres thick. Wooden batons are glued to the back of the sheet so that the print will stand proud of the wall. It looks good with very large prints, but it is probably not something you would want to attempt yourself and it is expensive to have done. The trouble with all these

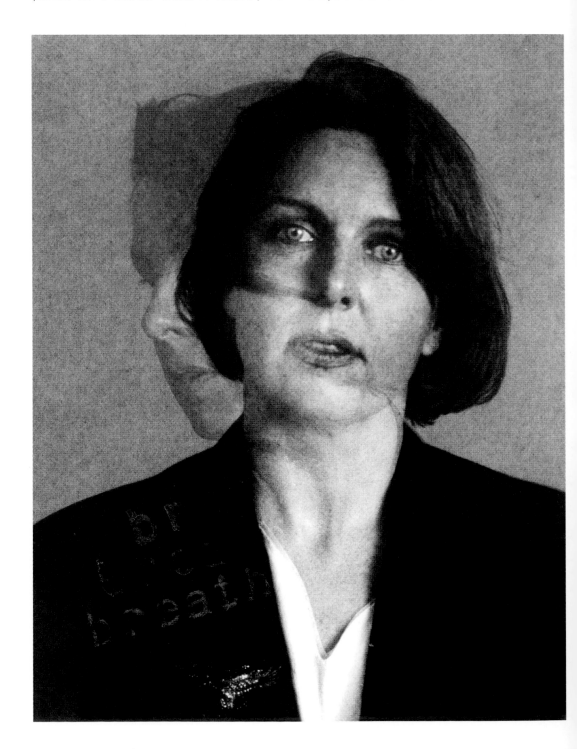

➲ Marjory Wilson, 1998
This was produced by loading black-and-white photographic paper, the speed of which is only about 2 ASA, into a 5 x 4in camera. It produces an interesting compressed tonal range and is only blue-sensitive, meaning that warm skin tones become quite dark in the print. The back of the negative provides a 'tooth' for writing on to integrate text with the image before printing. The text was applied with a child's rubber printing kit. The image was a double exposure in camera.
TOYO 5 X 4IN; 210MM LENS; KENTMERE DOCUMENT ART PAPER NEGATIVE, DISH DEVELOPED IN D76; PRINTED ON AGFA MULTICONTRAST CLASSIC

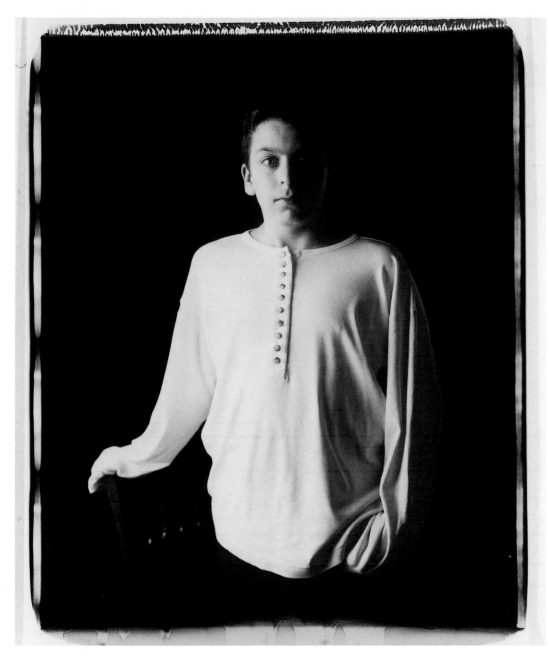

⬅ Roberto Wilson, 2001
The nature of the Polaroid print, with its unusual border, calls for it to be tacked into a box frame where the whole of the print can be viewed and preserved without dry mounting and with the glass well away from the surface of the glossy print.
POLAROID 20 X 24IN

flush-mounting methods is that if you knock the edge of the mount, the mount *and* the print are ruined and you have to start again, whereas with a traditional frame, the print is at least protected. Also, the mounting is irreversible, so if the print itself is valuable and you can't easily make another one, don't do it, if only because you can't change your mind afterwards.

box framing

One contemporary method of wall presentation is framing without matts, with the border of the print reaching the edge of the frame. The glass is kept away from the print surface with a slip or spacer, usually between 0.5 and 2 centimetres (a quarter to three quarters of an inch) deep. This is sometimes known as a box frame. The only drawback to this method is that any print over about 12 x 16in really needs to be dry mounted because so little of the border of the print is held flat by the frame (unlike the matting method where usually several centimetres of the print are sandwiched in the matt, which in turn is held flat by the glass). This type of frame is particularly good for very large prints, where you would want only a narrow border round the image and you would find it difficult to source large enough conservation board for matting. The print would generally be mounted on PVC or foam board, which comes in large sheets, prior to framing.

books

Besides wall presentation and portfolios, you might consider presenting portraits in a book. There has never been a better time to produce handmade books, facilitated by digital processes of type and quality printing on double-sided photo-quality inkjet papers. So if you have a cohesive series of portraits, perhaps leaning towards documentary, with which you might wish to include some text, the book form may be the most appropriate.

If you have the time, patience and inclination you could produce the whole thing yourself. As I've said, it's good to be in total control of your medium and how your work is presented. And you can be much more inventive than if you give the job to a bookbinder. If you do get your pages bound professionally, though, it's not as expensive as you might think. Try shopping around locally for an affordable price.

digital printing

When audio CDs first appeared, the quality was relatively poor, and even today some hi-fi experts prefer analogue sound, via a top-class amplifier and vinyl records, for its 'musicality' – a subtlety of musical tonal gradation. There is, I think, a parallel here with digital photography – there will always be adherents to analogue capture and outputting, but as the years go by they will become fewer, preferring convenience (at least for the lab) to the increasingly minimal advantages of analogue in terms of quality.

Before long, there will be little choice in the matter, certainly as far as colour printing is concerned. The technology moves on rapidly and is improving all the time, but at the time of writing, and from recent research that I've done, the quality of a top-class analogue C-type print still beats a scanned negative (or transparency) and digital print for tonal detail. Having said that, colour pigment inkjet prints can be made on a variety of (non-resin-coated) surfaces, including some lovely watercolour papers. They have a very attractive quality all of their own.

In black and white it seems that there are even more problems of digital matching the quality of a top-class black-and-white print made on a good fibre paper (you can't get fibre colour paper). And in terms of archival permanence, a properly processed monochrome print will last much longer than any colour print, especially a basic (dye-based) inkjet. The

jury is still out on this, but it seems that an archival C-type colour print will last about 80 years – not really archival by monochrome standards. A pigment-based inkjet on archival paper may last about 120 years (see Further Reading, pages 140–41).

One of the big advantages of digital colour is that you can print at home up to the size of printer you can afford (but currently using only inkjet technology, since continuous tone printers are prohibitively expensive). If you want the best-quality prints (which come from a continuous tone laser or LED printer, like a Durst Lambda or Epsilon) or very large ones, you have to use a lab. Here, digital allows you to have control of print manipulation and colour balance, but only provided that you have a high-end computer, good digital-imaging skills and, importantly, that your workflow is fully calibrated from scan to print, so that what you see on your computer monitor will replicate the print that the lab will produce – and that's not easy to achieve.

If you want to make a large exhibition print, a top-quality scan from a high-end scanner is essential. To extend the audio analogy: the old adage 'garbage in, garbage out' is relevant here. If you don't have access to a high-end scanner (they are *very* expensive), nor the technical skills, then you will have to get a lab to do the scan for you – it's a good idea to use the same lab that makes the print to ensure a

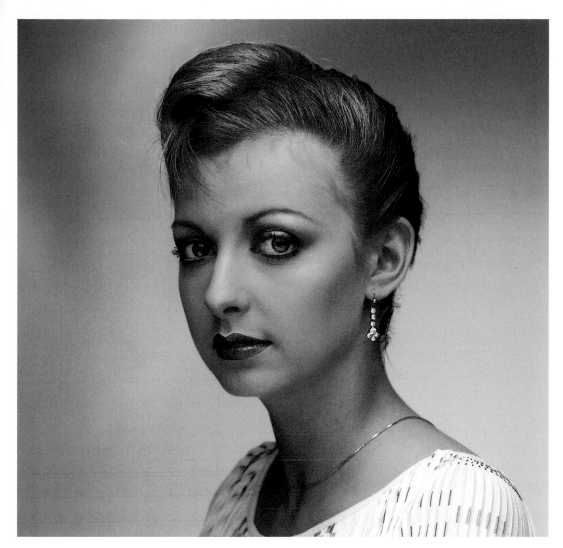

⊗ Jean Rousay, 1982
This print was made from
a scan of a 20-year-old
transparency. This was
intended as a hair and beauty
picture. Digital techniques have
enabled me to retouch slight
skin blemishes very easily, and
remove black marks from the
film. This would have been
a highly specialized and
expensive process before
the digital age.
HASSELBLAD; 150MM LENS;
STUDIO FLASH; EKTACHROME
100; SCANNED ON AN IMACON
FLEXTIGHT; PRINTED ON DURST
EPSILON; HAIR BY CHEYNES;
MAKE-UP BY BRUCE HUNTER

calibrated workflow. If you get all that right, there will be no more worrying about whether the lab has interpreted your instructions properly, as is the case with traditional colour printing.

If you are uncertain about calibration and you are getting a lab to make important digital prints, you should attempt to develop a relationship with the person who is making them. Not all labs will allow you to sit at the computer with the operator while tests are made, and most will simply print the file you give them as it is, feeling it is not their responsibility to make fine adjustments to colour as the traditional C-type printer would. You could get test strips done by the lab before final output.

traditional versus digital

Most of the colour images in this book are from traditional analogue C-type prints, some of which I have made myself and some of which have been produced by a lab – one of the few left that will still print analogue. On balance, at the time of writing, I understand the process and can speak the language with a lab better than with digital. But I had better learn fast because soon there will be no choice for colour. I expect (and hope) that paper and chemicals will be available for black and white for a long time to come – albeit with a more limited range and probably at a cost.

One last personal point about printing: with traditional printing that you do yourself, especially black and white, you not only have control of your medium, but you have an *involvement* with it. Dodging and burning is carried out throughout the exposure, not beforehand on a computer screen; you see the image appearing in the developer and you nurture it through the various stages of production. You develop a relationship with your image that has the warmth of craft rather than the white heat of technology.

Marjory and Roberto Wilson, 1993

I once read a criticism of the American photographer Harry Callahan's work as being 'aggressively heterosexual'. The writer was referring to his extended series of pictures of his wife, Eleanor, and his daughter. It strikes me that it would be a tragedy if, as photographers, we could not record and celebrate those we love. Within the fine art arena, since the 1980s, there has developed, in my opinion, a cynicism and a cold intellectual conceptualism, often tinged with irony. Artists (and perhaps most people) have found words like 'love' and 'beauty', even 'aesthetic', difficult to utter without more than a tinge of embarrassment.

This last picture in this book is about all of these, and of all my pictures I suppose it teeters most dangerously towards the nostalgic and the sentimental. As such it is a private and personal image.

Taken during a holiday in Italy, this was my new girlfriend and her son, who bravely agreed to drive to Italy with me for a month in the sun with some other friends. I had been making some formally controlled portraits in our room. Then when I saw Roberto kiss his mother in that exquisite iridescent glow of light, I quickly moved the tripod and camera and set the shot up again.

Technically, it's right at the limits of the brightness range of what the film could cope with. Had I a flash gun with me, or better still a decent reflector to hand, I would have been tempted to fill in the shadows a bit more to reduce the contrast. But I was lucky with the exposure, which has just allowed enough shadow detail. In situations like this there is really not enough time to carefully calculate the exposure in order to provide a mere hint of detail in the shadows. You have to seize the moment, and, if you do have time, bracket the exposures. There was never any hope for detail in the strong highlights on Roberto and of course in the sky outside – the brightness range would have been well over 10 stops.

It was a difficult print to make, as is usual with high-contrast negatives. I doubt if it would have been possible to make it successfully without a variable-contrast paper, where different areas can be selectively printed on different grades.

Do you ever feel, when listening to an awesome passage in a piece of music, a prickle at the nape of your neck, or maybe your toes curling? It's like looking at an especially good print that *you*'ve made, where form, content and subject all conjoin. Don't be embarrassed.

Five years after I made this picture the three of us married.

Hasselblad; 80mm lens; natural light; Ilford FP4

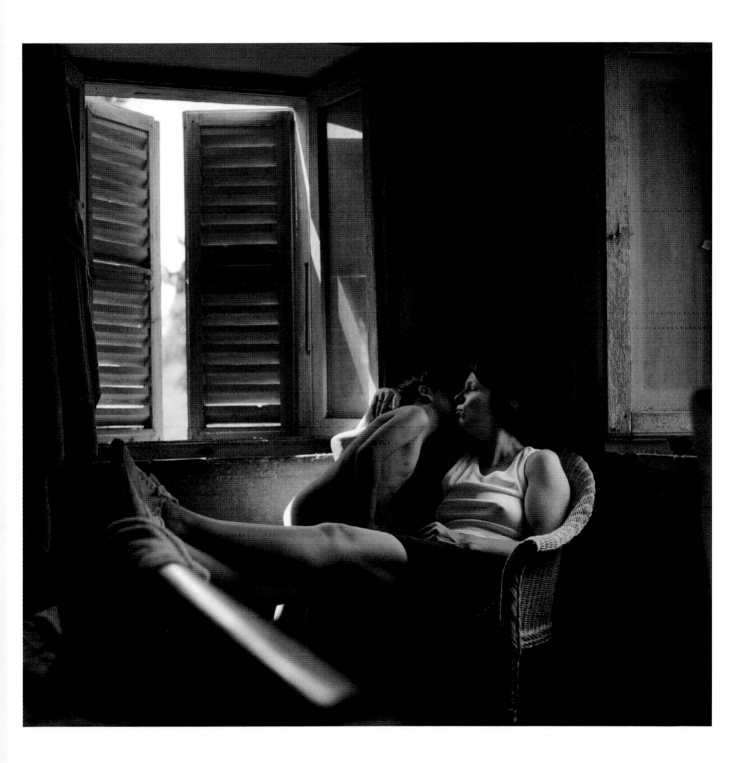

Further Reading

This book is intended as a stimulus for taking the study of photography and the genre of portraiture further. You might like to consult the following sources:

general

David Hurn & Bill Jay, *On Being a Photographer*, Lenswork, 2001. Mainly considers documentary; good chapter on equipment.

Terence Wright, *The Photography Handbook*, Routledge, 1999. Mainly for the photojournalist but a good introduction to critical aspects of representation.

critical theory

General

Terry Barrett, *Criticizing Photographs*, Mayfield Publishing, 1994.

Roland Barthes, *Camera Lucida*, Vintage, 1993. A classic basic text – easy to read and immensely enjoyable. The most accessible of the 20th-century French philosophers.

Victor Burgin, practitioner and teacher – anything by this major figure in conceptual art theory and practice in the 1970s and 1980s.

Bill Jay – anything by him. He writes about life attitudes, humanism, and photographic idealism. May not be popular with academic critical theorists.

Abigail Solomon-Godeau, *Photography at the Dock*, University of Minnesota Press, 1994.

Susan Sontag, *On Photography*, Penguin, 2002. Old (originally published in 1973), but still thought-provoking.

Liz Wells, *Photography: A Critical Introduction*, Routledge, 2000. Basic general primer with a useful bibliography.

Portraiture

Graham Clarke (ed), *The Portrait in Photography*, Reaktion Books, 1992.

Jo Spence & Patricia Holland, *Family Snaps: The Meanings of Domestic Photography*, Virago, 1991.

John Tagg, *The Burden of Representation*, University of Minnesota Press, 1994. For a heavier read.

technical

General

Michael Langford, *Basic Photography*, Focal Press, 2000. Not easily palatable – and don't try to read it from cover to cover – but as a reference book it contains almost everything you need to know.

www.photo.net – a useful website for discussion forums on all aspects of photographic technique.

www.silverprint.co.uk – suppliers of specialist materials, and a plethora of useful information.

Zone System

Ansel Adams, *The Negative*, Little, Brown and Co, 1995. The definitive version.

digital

The technology moves on so quickly that anything I recommend will be out of date by the time this book goes to print, but try:

Martin Evening, *Adobe Photoshop for Photographers*, Focal Press, 2002 (updated regularly for new versions).

Any current basic primer on digital capture.

www.inkjetart.com – invaluable information on digital outputting.

lighting

Steve Bavister, *Lighting for Portrait Photography*, RotoVision, 2001. For examples of lighting techniques by different practitioners.

Michael Langford, *Basic Photography*, Focal Press, 2000. A good basic primer.

monochrome printing
Ansel Adams, *The Print*, Little, Brown and Co, 1995.
Les McLean, *Creative Black and White Photography*,
David & Charles, 2002.

alternative processes
Randall Webb, *Spirits of Salts: A Working Guide to
Old Photographic Processes*, Argentum, 1999.
Calotypes, cyanotypes and so on.

monographs
I'm concentrating on photographers who would
principally describe themselves as portraitists:

Richard Avedon
Probably the most intelligent, sensitive – and
controversial – living portrait photographer.
Highly influential, along with...

David Bailey
Fashion-conscious 'style' portraiture from the
1960s to 1990s that sometimes transcends its
original context.

David la Chapelle
Slick big-budget editorial portraiture. Interesting use
of colour.

Robert Frank
Not strictly 'formal' portraiture, but he presents a
personal life attitude that we could all feed off.

Horst
Classic fashion and portraiture with a precision of
craft that many aspire to today.

Zoltan Jokay
The most interesting 35mm colour 'street'
photography I've seen.

Yousuf Karsh
Mainly studio work. Gape at the technique.

Annie Liebovitz
Big-budget editorial portraiture.

Philip Lorca DiCorcia
Intelligent contemporary constructed 'documentary'
portraiture.

Robert Mapplethorpe
Black-and-white 1980s portraits, mainly celebrities.

Duane Michals
Mainly black and white. Sequences and combining
image with text.

Arnold Newman
Superb environmental portraits – he almost
invented the term.

Nicholas Nixon
Especially *The Brown Sisters*; large-format black
and white.

Irving Penn
Deceptively simple but incisive daylight studio
portraits.

August Sander
From the 1920s but still influential today.

Albert Watson
Stylish, punchy editorial.

Acknowledgments

I would like to thank:

All the people represented in this book for their forbearance.

Marjory and Roberto for their tolerance and support. As ever.

Vannessa Cox at Calumet UK
Mike Dooley at Ilford UK Ltd
Trumps Photographic Processors – Lindsay Swan and Alan Potts

Della Matheson, Douglas May and Andy McGregor for their helpful advice and gentle chidings.

Johan Brand and Sam Sills who were willing guinea pigs.

The editorial and design staff of David & Charles, in particular Neil Baber.

Napier University, Edinburgh.

Index

Page numbers in *italic* refer to picture captions

accent light 115–16
Adams, Ansel 44
ambient light *8*, 50, *85*, 90–91
 mixing with flash 101–7, *106*
 underexposed *42*, *87*
ambiguity 17–18, *18*
assistant, using 31
atmosphere 57–8
Avedon, Richard 11, 21, 34

background 30, 71, 76, *96*, 117–19
backlighting *20*
Bailey, David 21, 118
black and white 82, 122, 125, 126, 136, 137
 lighting contrast 90, 98–9
blinking 54
body language *38–9*
book form, presentation in 136
box framing 135, *135*
Brandt, Bill 37, 71
burning 137
butterfly lighting 34

Callahan, Harry 138
calotype process *130*
Cameron, Julia Margaret 71
candle light 111
captions 18
clothing 26
colour 29, *34*, 82, *120*, 137
 contact prints 122
 lighting contrast 90, 98–9
 printing 125
 reflected *9*, 100
compact cameras 50, 71
composite images *12*
composition 27, 29–30, *30*, 51, 58, *59*, 90
contact prints 51, 122, *123*, *124*
content, picture 27–9
context, importance of 17–18, *18*
contractual portraits *10*, 11
contrast 29, 90, 98–*9*, *120*
cropping *73*, 122, *124*
Cunningham, Imogen *88*

depth of field 76
developer 82, 127
developing *120*, 122
diary, photography as 19
Dietrich, Marlene 34
digital montage 56, *56*
digital photography 77, *77*, 82, 122, 125, *137*
 printing 136–7
dodging 137
double exposure *134*

editing 50–51
editorial photography 20–21
emotional content 29
equipment 50–51, 70–87
ethical considerations 34–6
exposure length *11*, *42*, *112*, *120*
exposure meter 87
eye contact 39

family, photographing 46–9, 62–7
fill-in light 90, 114–15
film 40, 82–3
filters 109, *109*
flare *104*
flash 50, 56, 84–7
 colour balance 84
 hand 87, 106
 mixing with ambient light *10*, 101–7
 radio-controlled *20*, 87, *87*
 rear curtain 50
 snoot *42*, *84*, 85
 synchronization speed 102
 use outdoors 107, *108*
focal plane shutter 76, 102
focus 30, 71, 76, *92*, 94, *96*
format, camera 73–7, *73*
framing *125*, 133, *133*
Frank, Robert 94
friends, photographing 46–9, 57–8, 62–7

group portraits 54–62

holiday pictures 62–7
horizontals *59*
Howson, Peter 11–12

Hume, David 18

incongruity, using 54
intuition 21, 44–53, 71

Karsh, Yousuf *130*

large format 40, 75–7, *77*, *88*, 102
lenses 80
 portrait 80
 telephoto 80, *80*
 wide-angle 35, 42, 56, 80, *80*
 zoom 55, *80*
LeWitt, Sol 12
lighting 29, 50–51, *63*, 84–120
 and colour *34*
 contrast 29, 90, 98–9
 filters 109, *109*
 flagging *104*
lighting stands 86–7
location, choosing 27, *27*, 28, *28*, *29*, *32*
logistics 40

magnifying glass 51
Malde, Pradip 76
Mapplethorpe, Robert 127
matting *125*, 132, *133*
medium format 73–5, 102
memory and photography 13, 16, 19, 46, 57–67, *60*
mirrors, use of *40*
modelling light 84–5, 86, 87
mortality and photography 16
mounting 129, 134–5
movement *6*, *120*

narrative content *11*, 18
Newman, Arnold 35
Nixon, Nicholas 16

objects and living spaces 12, *12*, *68*

papers 126–7, 136
parallax 74
Penn, Irving 54, 71, 93
perspective 80, *80*
Polaroid photography 30, 31, 40, *71*, 75, 76, 82–3,
 82, *107*, *120*, *135*
portfolio presentation 132, *132*
pose, directing 36–9
preparation and planning 20–43, 44, 54–5
previsualization 44
printing 51, 125–7, 136–7

proofing 122

recce 22–3, 26
reflectors 21, *70*, *84*, 86, 90, 98–100, *100*, *101*, *114*, *116*
 minus (black) 87, *96*, 100, *116*
reflex hood 75
research and development 22–6
Rosenberg, Harold 17

selenium *123*, 127, *128*, *130*
self-portraits 18–19, *19*
shadows 55
shutter speed *6*, *8*, 50, *96*, 101–3
significance, recognizing 46–7
simplicity *23*, 36, 74
SLR 30, 70
smiling subjects 37, 67
Smith, Eugene 109
snoot *42*, *84*, 85
Snowdon, Lord 36, 93
softbox *32*, 56, *84*, 85, 86, 97, *101*, *104*, *111*, 114,
 114, *115*
soft focus *84*, *114*, 126, *126*, 127, *128*, *129*
spontaneity 44–5, *48*, 50–51, 71, *72*
spot lights 114, 115
storage 122, 132, *132*
Strand, Paul 19
studio portraits 37, 84, 93–4, 111
sunlight 90, *92*
swing 76
symbolic content 29, *36*
Szarkowski, John 19

35mm cameras 50, 51, 70, *72*, 73, 74–5, 94, 102
tilt 76
time, passage of 16
tonality 29, 73
toning *123*, 126, 127, *128*
trace images 13, *13*
transparency film 31, 77, 82
T setting *19*
tungsten lighting 84–5

verticals 29–30, *59*
viewpoint and status *39*, *49*

Watson, Albert 109

zone system 117–19